Spark the Creative Flame

Making the Journey from Craft to Art

Praise for
Spark the Creative Flame

Spark the Creative Flame is essential for an aspiring artist. . . . Learning from masters who have already traveled this path is a tremendous jump-start for any artist's career. Stankard's sincere commitment to the education and the long-term success of Salem Community College students is commendable. You'll not meet a stronger advocate for the next glass generation.
— Joan M. Baillie, President
Salem Community College, Salem, New Jersey

Spark the Creative Flame [is] really two books woven neatly together. We have the author's aesthetic autobiography together with a collection of compelling mini-biographies of some of his key artistic heroes in the studio-glass world. The opening chapters constitute as fine a discussion as you might encounter on the philosophical and practical realities around the questions—here not at all tiresome—of art *versus* craft *versus* design. If you make fine things, or find the people who do so brilliantly an interesting lot, read this book now!
— William Gudenrath, Resident Advisor at The Studio
The Corning Museum of Glass, Corning, New York

Spark the Creative Flame is a timely book for anyone interested in the evolution of studio glass and the voices of artists who have led its innovations. Stankard's interviews and observations in addition to the collection of essays by prominent artists extends a shared passion for education and deepens the value of curiosity and commitment to the learning process. Stankard's collection is spirited, intelligent, and invigorating. His commitment to education and an expanding field of stars is evident throughout.
— Jean W. McLaughlin, Director
Penland School of Crafts, Penland, North Carolina

[Stankard's book takes on] the difficult task of exploring the creative process in written form by documenting the careers of other pioneering artists in the glass art field, commissioning essays on aesthetics, and sharing personal insights from his own journey of artistic expression. . . . Written in an engaging voice informed by warmth, wisdom, and respect, Stankard sets out to educate, share, and elevate the field — and succeeds on all counts.
— Andrew Page, Editor
GLASS: The UrbanGlass Art Quarterly

Spark the Creative Flame

Making the Journey from Craft to Art

Compiled by

Paul J. Stankard

with a Foreword by

Ulysses Grant Dietz

The McDonald & Woodward Publishing Company
Granville, Ohio

Spark the Creative Flame
Making the Journey from Craft to Art

10 9 8 7 6 5 4 3 2 1
20 19 18 17 16 15 14 13

Library of Congress Cataloging-in-Publication Data

Spark the creative flame / Compiled by Paul J. Stankard ; With a
 Foreword by Ulysses Grant Dietz.
 pages cm
Includes index.
ISBN 978-1-935778-23-3 (hardcover : alk. paper) — ISBN 978-1-
 935778-24-0 (softcover : alk. paper)
1. Lampwork. 2. Handicraft—Vocational guidance. I. Stankard, Paul,
 1943- editor of compilation, author. II. Dietz, Ulysses G. (Ulysses
 Grant), 1955- writer of supplementary textual content.
TT298.S67 2013
745.5—dc23

 2013041711

Contents

Ulysses Grant Dietz

Foreword

Who can say no to Paul Stankard? I doubt anyone with a brain or a heart can.

I met Paul in March, 1984, when I had been a curator at the Newark Museum for all of three-and-a-half years. Somehow I had begun to step timidly into the world of contemporary craft, outside the academic comfort zone of my training — American material culture of the years up to 1900. My museum had been founded in 1909 as a place to collect "the art of today," and that notion — far more radical in its day than any museum in New York City, just 10 miles away — included contemporary glass, ceramics, jewelry, metalwork, textiles. The very idea that craft and art went hand-in-hand was very much in the air in America in 1909, and my museum was among the first to embrace this notion.

By 1984, I had realized this, and also had realized that I needed to embrace this aspect of my institution's history if I was to honor the legacy of my position as curator of decorative arts there. But my initial steps, as I said, were timid. I looked for New Jersey artists working in craft media — *contemporary decorative arts*. I found potters, silversmiths, quilters. Paul was my glass discovery. How lucky I was to have stumbled upon, in all my parochial innocence, a man of international importance. I have no memory of how I heard about him — perhaps he called me and invited me himself. But down to Mantua I drove, and spent a day falling under the spell of this cheery, humble, friendly man; and, of course, under the spell of his magical work.

In the many years since our first meeting, the thing that has most impressed me about Paul has been his relentless desire to teach others. His goal has never been just to impart technical skill, but to try to get across the mental and emotional aspects of his working life that helped transform him from a gifted artisan to an internationally

respected artist. This generosity of mind and spirit is the driving force behind this new book. The book is emphatically *not* a self-celebration, but a celebration of a community of like-minded artists for whom the ultimate reward of what they do is the doing of it.

The dozen glass artists whose journeys are presented here are all doing what Paul himself values most — sharing experience so that aspiring young workers in glass can understand — or at least begin to see — how they got there. They are not all American, they are not all the same generation; but they all work with glass in a way that echoes Paul's own artistic narrative, without being at all like him. The joy with which Paul has learned from his fellow-artists' stories, the sincerity with which he embraces their artistic paths as consonant with his own philosophy, give witness to a heart and mind open to the world.

For Paul, it is imperative that young glass artists understand where what they do fits into the big picture of art history — a realization he himself only attained in fits and starts through his own efforts. To that end, Burt Wasserman's essay lays it all out in a way that offers an essential foundation to understanding Paul's approach to his particular craft as art. Paul doesn't expect every flameworker to be — or want to be — an artist, but he wants all of them to understand the way there if that is where they want to go.

Bruce Metcalf, in his essay in this book, hails Stankard as "the elder statesman of studio flameworking." But Paul was no elder statesman when we met in 1984. He was just 41 (so young!) and a pioneer in the world of studio glass; daring to embrace the format of gift-shop offerings and, from that, creating profoundly moving works of art.

Paul's own dictum, "If you want to do excellent work, you have to know what excellence is," has been applied to his own work and the work of all the artists who appear in this book. You have to recognize good when you see it. And even my inexperienced curatorial eyes in 1984 could see that Paul was not just making paperweights. Even in those days, when the scale of his work was still palm-sized, he had far transcended the intellectual and technical boundaries of the French paperweight makers of Baccarat and Saint Louis at their best. Paul has brought the same sort of wide-eyed wonder with which I discovered his work to the pages of this book, as he shows us excellence in the world of glass artists around him.

Judith Schaechter points out in her thoughtful, provocative essay commissioned for the book, "Pretty is the thing that is only skin-deep. Beauty is much, much deeper . . ." Paul and the artists he celebrates are able to see that difference — that crucial difference between prettiness and beauty. They have all put the torch to the notion of pretty and made it beautiful. I have to confess, I sit here all those years later, pretty pleased with myself for having made that leap of recognition myself when I saw Paul's work at 28. It is moments of clarity such as this that shed light on the real joy of a curatorial career.

Paul's unfailing intellectual curiosity, his ability to differentiate between ego and a sense of self-worth, his spiritual openness, his generosity, and his hard-earned, patiently acquired *skill* are what have given him the ability to produce a volume such as this one. He did not set out to become a master or a philosopher or, even, an artist. But the manual skill that helped him overleap the limits of his dyslexia opened his heart to the intellectual and spiritual worlds that allowed him to become an artist. To use the phrase he taught me in 1984, he "followed his bliss." And nothing makes him happier than to see others following theirs.

That this gentle boy who had trouble reading in school would end up writing with such eloquence and passion about the art and artists that changed his life — to help still other potential artists enrich theirs — is really all the testimony one needs.

Ulysses Grant Dietz
Chief Curator, Curator of Decorative Arts
The Newark Museum

Dedication

To my wife Patricia,
our five children, and our grandchildren.

❧

Pat's emotional support and commitment
to my career has been
the single most important factor
in every achievement
along our life's journey.

Acknowledgements

Jack Sheehan assisted in the writing of this book sentence by sentence, and his participation allowed me to compensate for being dyslexic. When we started the writing process, Jack was an English professor at Salem Community College. Now, at the end of the project, Jack is finishing his law degree at the University of Pennsylvania Law School. Over the past five years, Jack outlined chapters, typed my dictation, questioned my word choice, and asked for clarity and elaboration as an editor. When I think of Jack's role in the writing of this book, I value his commitment to the integrity of each chapter and the overall educational goals of this project.

Special thanks to my brother, Robert Martin Stankard, who read completed chapters out loud and asked questions from a layman's point of view that at times led to additional changes; Beth Hylen, Reference

Jack and Paul reviewing edits on a Saturday morning.

and Outreach Librarian, The Rakow Research Library at the Corning Museum of Glass, who provided important academic research assistance; William Clark, Jenna Efrein, Ron Farina, Douglas Heller, Heidi Fisch Hengler, Pauline Iacovino, Sara Sally LaGrand, Amy Lemaire, Robert Minkoff, Jessica Ohnikian, Andrew Page, Joseph Stankard, Ruth Thaler-Carter, Katherine Wadsworth, Lyndi Sheehan, and Barry Zuckerman, for their individual contributions and encouragement.

Finally, thank you Salem Community College students, faculty, and staff for being a constant source of inspiration throughout my career.

Photographic Credits

I thank the photographers and others who permitted the use of their work in this book, including Ellen Abbot (102 top); James Amos (50, 64 top); Anna Lott Donadel (112 both, 114, 117); Matt Eskuche (130 bottom, 134, 136 both, 139); Ron Farina Photography (iii, 42 middle, 42 3rd glass piece from left; 51, 52 top, 60, 67, 69, 71, 78, 119, 142 bottom; 147, 206 bottom); Jack Fay (189); Ash Ferlito (122); Graziella Giolo (206 top); Norbert Heyl (157 right); Rick Kessinger (198 bottom, 200, 201, 203 both); Joan Kruckewitt (162 top); Gian Mauro Lapenna (209, 212); Iwao Matsushima (88 bottom, 93, 94, 97); Michiyo Matsushima (88 top); William Metcalf (10); Norihisa Mizuno/MIHO Museum (90); Courtesy of Muskingum University (76 bottom); Jay Musler (162 bottom, 165, 167 all, 170); Courtesy of Newark Museum (vi); Marc Petrovic (102 bottom, 105 both, 109, 110); Andrew Pielage (186 bottom, 193); Cecelia Poniscan (174 top); Robert Reynolds (211 all); Courtesy of the Robert M. Minkoff Foundation, Ltd.(51); Bob Roberts (126); Miriam Rosenthal (76 top); Emma Salamon (125); Courtesy of Salem Community College (45, 48); Sibila Savage (169); Douglas Schaible Photography (42 middle and last glass piece on right); Mike Seidl (174 bottom, 178, 180, 181, 182); Joseph Stankard (xi, 42 bottom, 52 middle and bottom, 58, 62, 64 bottom); Courtesy of Paul J. Stankard (42 top); Césare Toffolo (150 both, 153, 155, 157 left, 159, 160); Mary Vogel (145 both); Adam Wallacavage (30 both); Courtesy of Burton Wasserman (20); Courtesy of Wheaton Arts and Cultural Center (47).

∾

Spark the Creative Flame

Making the Journey from Craft to Art

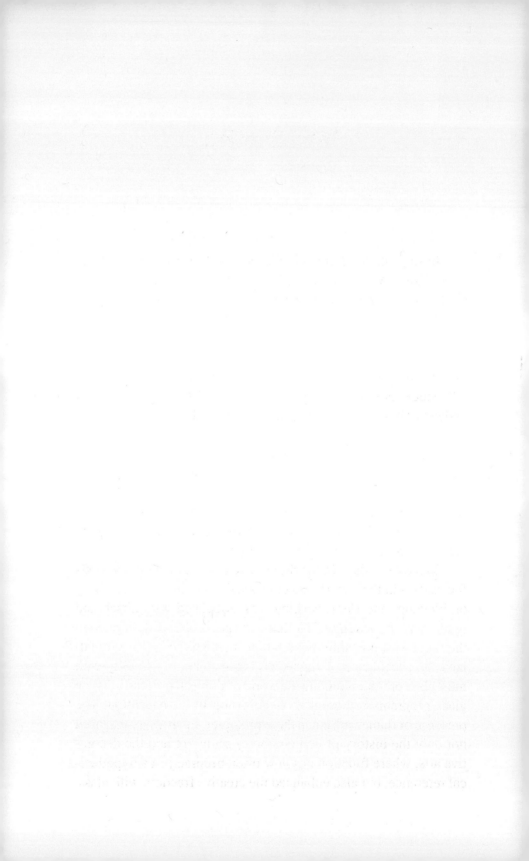

Introduction

In August, 2012, my wife Patricia and I drove a packed van to Madison, Wisconsin, to deliver boxes full of our son Philip's boyhood treasures to his new home. During our visit, Philip and I drove over to the University of Wisconsin-Madison (UW) to visit the historical glass facilities that Harvey Littleton had established there in 1962. The year 2012 was the 50th anniversary of the Studio Glass Movement, and I was curious to see if the UW students enrolled there had a sense of this history and an understanding of how that studio had sparked an international art movement in glass.

When I walked into the facility, nobody was around. I noticed a glassworking lathe and a bench burner on a table, with borosilicate rods and tubes laid out for a project in progress. I was both surprised and impressed to think flameworking had arrived at the epicenter of the Studio Glass Movement, and the glass scene had matured with diversity of processes.

In the early days of the Studio Glass Movement, glass artists focused — in their work and conversation — almost exclusively on blowing, and flameworking was associated with kitsch and ignored as "lightweight." Noticing the generous space allotted to the flameworking equipment in that small studio in 2012, I realized the acceptance of flameworking was the new reality with most glass programs around the world offering all processes. These glass programs represent a phenomenon in art education. The presence of flameworking in these programs, in turn, has advanced not only the history of contemporary sculpture and the decorative arts, where function has now often become just a hypothetical reference, but also enhanced the creative freedom with glass.

Over the last 50 years, most of the artists in the upper echelon of contemporary craft, especially glass, have been academy-trained. Why is this so? Because, in addition to being informed about art history and the contemporary art landscape, they have been trained to start with an idea and then develop techniques to solve the technical problems that arise while realizing their personal visions. For someone like me, who was vocationally trained and mastered an industrial craft in a factory, it took decades to internalize and be challenged by this concept, which is now a basic component of collegiate introductions to artmaking.

Spark the Creative Flame is the book I wish I could have had at the beginning of my creative journey. When I left a successful career as a scientific glassblower to pursue life on the creative side, I had no formal art education. I knew that I needed to learn about art and artmaking, but I did not know what I should study or where I could find information. Ultimately, I didn't know what I needed to know. It's interesting to reflect on the first steps of my journey, taken in the mid-1960s, and realize they were nurtured by three books that lacked any real discussion of excellence in the context of artmaking. At the time, however, they were my dream books and I had pretty well memorized all of the images.

The first book, John Burton's *Glass: Philosophy and Method*, introduced me to the idea of flameworking in a home studio. Burton promoted being creative in a modest space in his home, and I connected — in the core of my being — to his message that working with one's hands in the pursuit of beauty is a noble lifestyle. The next two books, Jean Sutherland Melvin's *American Glass Paperweights and Their Makers* and Paul Hollister, Jr.'s, *Encyclopedia of Glass Paperweights*, documented the history of paperweights. These books were published for collectors and intended to provide a pictorial overview of the category. For me, the books offered a window into contemporary paperweight-making, and I was inspired by work produced by American flameworkers, namely Charles Kaziun, Francis Whittemore, Ron Hanson, and Scottish maker Paul Ysart.

Looking back, I think about these books more for what they couldn't offer me as an aspiring young maker. They didn't talk about articulating an idea in glass (beyond being pretty and sellable) or the creative struggles of advancing one's aesthetic. They lacked an informed point of view about what distinguishes excellent work from average work. Most importantly, they did not promote the idea that studio makers could advance the history of art by creating one-of-a-kind pieces that celebrate a personal vision in glass, as opposed to commercial work.

I wrote *Spark the Creative Flame* in the spirit of sharing my experiences and perspectives with creative people who are setting out on their own journeys and looking to expand their knowledge of artmaking. My teaching experience has been centered at Salem Community College's Glass Art Program in Southern New Jersey, but I have taught, demonstrated, and lectured in classrooms, studios, and museums around the world. This book compiles and expands on themes and ideas that I've contemplated in my studio and discussed with students and artists for decades. In its essence, the book represents a subjective trail guide — not a definitive road map — based on what I believe is the most important principle to a successful career in art: *educate yourself to the things you care about through self-directed learning.*

Spark the Creative Flame is divided into three sections, each containing multiple chapters: (1) Commissioned Essays, (2) Personal Experience and Philosophy, and (3) Artist Appreciations. Leading artists/scholars wrote the Commissioned Essays in which they share perspectives on such fundamental themes as craft, design, art, and beauty, while I wrote the chapters in the other two sections. The Personal Experience and Philosophy chapters provide an overview of my own 50-plus years as a craftsman. Finally, the 12 Artist Appreciation chapters not only celebrate the careers of respected artists whose distinctive works give voice to personal visions, but they also survey and promote the great diversity of great work that is unfolding on the international stage.

Commissioned Essays

When building a strong career foundation, one needs to have a sense of art history. For makers, that means knowing how your category and/or material-focus came to be and understanding the integral role that object-makers play in the history of art. It's also important to engage in the nuances that define an art-approach, a craft-approach, and a design-approach to object-making. Developing a deeper understanding of the subjective philosophy of beauty (aesthetics) equally plays an important role in beginning an artistic career.

When I conceived this book project, I wanted these ideas to begin the discussion. Instead of writing about them from my personal perspective, however, I sought out leading thinkers who have spent their careers considering and writing about these issues. The artists who authored the Commissioned Essays evidence a lifelong commitment to artmaking as well as pursuing and defining these illusive and intellectual concepts. All three of these commissioned essays were prepared by artists who have years of dedicated university teaching experience.

Personal Experience and Philosophy

Sitting at the bench to craft glass has given me an opportunity to connect with my innermost thoughts and feelings. As a result, I believe there is a spiritual dimension to artmaking that can nurture a person's sense of self-worth and help each of us to reach our full potential as human beings.

By committing my professional life to working in the studio, I have gained an artistic authority and sense of self-confidence in what I do that can only come from being devoted to realizing a personal vision. My life in glass has given me strong-felt attitudes about the nobility of working with one's hands to express one's own unique perspective. I am keen to share my experiences for others to use as reference points along their own journeys, and the Personal Experience and Philosophy chapters of this book give me a chance to do so.

Artist Appreciations

Every artist finds her or his own way. The Appreciations presented here are designed to provide an intimate look into the careers of 12 artists who have committed their lives to expressing what they feel passionate about through their glass art. Though their journeys are diverse and offer varied approaches to a life in art, they all exhibit courage in the face of seemingly insurmountable obstacles. Their journeys also begin on different levels and in different environments. On their way to inventing a personal language in glass, however, they evidence many common traits: perseverance, dedication, commitment to the integrity of their work, and a single-minded approach to advancing their creative ideals. Ultimately, learning about fellow artists and how they overcame failures to establish successful careers can challenge the reader to bring the same strength and resolve to his or her own efforts.

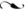

Spark the Creative Flame is a resource for all people interested in understanding glass art work in the context of identifying and reaching for creative opportunities. Exploring the contemporary glass landscape and the artists who are advancing the tradition strengthens one's artistic platform. The chapters tie together my personal philosophy in artmaking with the experiences and insights of other artists in ways that promote excellence. The artists celebrated in this book have inspired countless numbers of people to new possibilities in glass and have rearranged the international glass landscape through their genius. Whether one is a maker or an admirer, *Spark the Creative Flame* will illuminate his or her path to a fuller life through the creative process.

Commissioned Essays

Bruce Metcalf is a jeweler and independent scholar/writer. He is co-author, with Janet Koplos, of *Makers: A History of American Studio Craft*. Metcalf lives near Philadelphia, Pennsylvania. I first saw his art jewelry handsomely displayed at the Renwick Gallery, a branch of the Smithsonian Institution's American Art Museum that features one of the finest collections of American craft in the United States.

I knew Bruce from his writing and had the opportunity to befriend him while we were instructors during the same session at the Penland School of Craft. Bruce has lectured on Craft and Design internationally and at Salem Community College for the Glass Art program.

A Very Short History
of Studio Craft

Bruce Metcalf

There was a time when making things by hand was utterly unremarkable. Everything that was made was made by hand. Craft was so pervasive that nobody gave it a second thought.

There were some attempts to give special status to certain enterprises. During the Renaissance, an argument was made to separate painting and sculpture from all other objects. The argument worked, and that is why we have this special category of stuff called "art." Debate about the exact nature of "art" has continued ever since, but one constant has remained: "Art" is thought to be better than ordinary things.

Meanwhile, the Industrial Revolution changed the way many ordinary things were made. Textiles were woven on vast power looms; cast iron replaced wooden structures; die-stamping pushed aside specialized techniques such as chasing. In glass, freehand blowing was supplanted by blowing into metal molds. Still, no practical distinction was made between making things by hand and making things with machines. It was all regarded as manufacture. Handwork continued to be unremarkable.

Basically, to make objects was to have a trade. Some trades have survived, and they attract no commentary. A roofer installs roofs; a mechanic fixes cars. We do not give their products any special stature. We judge tradespeople on the utility of their work. All we care about is that the roof no longer leaks and the car runs better.

However, I doubt that many people reading this book think of themselves as tradespeople. Any flameworker worth her salt thinks she is doing something that operates on a higher level than a roof that does not leak. She is unlikely to think that the best

thing she can aspire to is everyday utility. Usefulness is part of the craft equation, but only part. She believes her work stands apart from the vast flood of mass-produced objects that we see in the malls. She doesn't think her work should end up in second-hand stores or landfills. She doesn't make junk. She makes something special.

The idea that to make something by hand is to make something special did not happen by accident. It was invented in England in the mid-1800s.

We can trace this idea back to two Victorian gentlemen, John Ruskin and William Morris. Ruskin, the older of the two, loved medieval churches. He particularly loved Gothic ornamental carving, which is often a bit crude. He contrasted Gothic carving with the 19th-century fashion for neo-classical decoration. Neo-classical ornament was completely formulaic. All the details were generated by a set of rules. The carver had no say in the design. In effect, he was reduced to being a human machine.

Ruskin hated this. He hated that the worker had zero creative input. And he hated the result: the cold precision of Neo-classical decoration offended him. Instead, he loved the funky irregularities of the Gothic, which he ascribed to the lack of skill among Gothic carvers. He felt that they had the advantage of creative agency: the power to make their own decisions and then use their hands to make their ideas real.

Ruskin's connection between handwork and empowerment was revolutionary. Craft was no longer beneath notice. Handwork was special because it produced esthetically superior results. More importantly, it dignified the laborer. Ruskin showed that handwork has its own value, even a moral force. In his eyes, craft humanizes us.

Anybody who has flipped burgers for a living and then turned to a life in craft understands Ruskin's point. Today's equivalent to neo-classical carving is all the mind-numbing scutwork that goes on in fast-food joints and call centers.

William Morris was, briefly, a student of Ruskin's, and quickly became a convert to his perspective. Unlike Ruskin, Morris

actually worked with his hands. Over the course of his life, Morris took up embroidery, book illumination, loom weaving, natural dyes, tapestry, printing, and several other crafts. In doing all of this, he learned that making things by hand can be enjoyable.

Victorians were used to thinking of handwork as merely a job — a livelihood for the working classes. The concept of pleasure in labor was almost shocking. No longer was craft a means to an end; it became an end to itself. Working with one's hands can be deeply satisfying, and that satisfaction can be meaningful. Again, everyone who reads this book probably understands this intuitively, but, in 1870, it was a revelation.

In a sense, Ruskin and Morris gave permission to non-tradespeople to work with their hands. Painters took up embroidery; wealthy dilettantes took up pottery; housewives took up woodcarving. Inspired amateurs were an important part of the Arts and Crafts Movement, and several of them went on to start influential businesses. Rookwood Pottery, for instance, was founded in 1880 by Maria Longworth Nichols, whose involvement with ceramics began when she took up china-painting as a hobby.

Glass, however, was not for amateurs. The two companies that produced glass and were most associated with Arts and Crafts were Tiffany and Steuben. Both were essentially factories, in which skilled craftsmen produced objects that were designed by someone else. Glassblowing was done by men working around large coal-fired furnaces. Glass was a material for businesses that could afford the high cost of capital investment. Nobody thought of a way for hot glass to be worked by individual makers.

The Arts and Crafts Movement fizzled and died in the 1910s, but the impulse to make things for pleasure had taken root. Through the 1920s and '30s, a modest number of artists worked in crafts such as batik, ceramics, and woodworking. Amateurs took up weaving and jewelry-making. During that period, though, we can only point to one man who worked with glass in a small studio setting. This was Frederick Carder, who had been the founder and head designer for Steuben. When his designs fell out of favor, the company forced him to retire. They gave him a little

studio in the factory, though, and Carder began to experiment with casting glass. His output was small, consisting of figures and animal sculptures. Still, he proved that a solo craftsman could work in glass.

In the '40s and '50s, Modernism infiltrated the crafts. There was one kind of Modernism in design — functional, straightforward, and usually undecorated — and another in the fine arts — abstract, expressive, and gestural. Modernist design was an import from Europe, where it had national variations. In Germany, it was hard-edged and often intended for industrial production. The Scandinavian version was softer and often used natural materials such as wood and wool. In the United States, the two tendencies were lumped together under the label "Good Design," and were vigorously promoted by the Museum of Modern Art.

As for Modernism in art, its most famous manifestation was Abstract Expressionist painting. Jackson Pollock's drip paintings are a notorious example of that style. Two popular myths about art came out of Abstract Expressionism. The first was that art is a form of self-expression, and is intimately connected to the emotional state of the artist. This idea came under attack for theoretical reasons in the 1980s and most artists no longer speak of their work as being expressive. The other myth was that art emerges in a moment of white-hot creativity, unimpeded by thought or discipline. The painter slashes at his canvas with a loaded brush, immersed in the moment. The problem is that not one of the great Abstract Expressionist painters worked this way. They all spent a great deal of time looking at their paintings and revising them. But the myth took hold, leading directly to vast quantities of bad art. Bad craft, too.

About the same time, small kilns became available for firing pottery. They were not designed to melt glass, but could be used for fusing and slumping. Collectively, these techniques are now known as "warm glass." Ceramist Edris Eckhardt taught herself how to formulate glass and then cast it in a kiln. The husband-and-wife team of Michael and Frances Higgins became experts

in fusing glass and adding patterns in enamel. Their bold, brightly colored plates and decorative screens were wildly popular.

Flameworking has a long history, first for making glass beads and, more recently, in the production of scientific glass. But lab glass was a trade and, in the United States, remained cut off from the world of studio craft for many decades. It is thought that the first American to explore flameworking for expressive ends was John Burton. Burton, an English metallurgist, first saw glassblowing during a visit to a small glassblowing shop in Holland, probably in the 1910s. Inspired, Burton determined to work glass on his own. Back home, he set up a torch and began the difficult process of teaching himself. His method was strictly trial-and-error.

Burton moved to the United States in 1927, settling in California. Although he pursued his craft only in his spare time, he became the leading spokesperson for flameworking in this country. Burton used Pyrex rods and tubes. Most of his work consisted of small vases and containers, along with a few blobby sculptures. One of his most important contributions was coloring clear borosilicate glass with metal oxides.

Until the early 1960s, Americans thought it was too difficult to downsize the furnaces needed to melt glass for offhand blowing. In 1962, though, a ceramist named Harvey Littleton (whose father worked for Corning Glass) built a little furnace in a disused garage on the grounds of the Toledo Museum of Art, and tried blowing. A group of students and teachers accompanied him. At first, nothing worked — they were using the wrong glass — but they soon started using glass marbles that a scientist named Dominick Labino had formulated for Johns-Manville and they were on their way. Studio glassblowing had come to America.

The first results were heavy and awkward — some were downright hideous — but intoxicating. Littleton, Labino, and Marvin Lipofsky, a student of Littleton's, eventually learned how to control molten glass on the blowpipe. All three soon abandoned the vessel format, preferring to make sculpture instead. Littleton's work was lyrical and rhythmic; Lipofsky's wildly funky.

Both taught in art schools, so neither had to make a living from their work. Still, as pioneers of the Studio Glass Movement, they helped develop a market.

The idea of making sculpture from craft media was not new, but it received an energetic jolt in the mid-1950s, administered by a potter, Peter Voulkos. He had the good luck to visit the studios of several prominent New York painters in the summer of 1953, and apparently was much impressed. By 1957, he was making large, gestural clay sculptures. He would roughly stack thrown forms on top of each other, or make them stick out into space. All resemblance to pottery vanished. Voulkos's sculptures were abstract, vigorous, and seemed to completely lack refinement — which was not true. His work conformed to all the myths about self-expression. He was craft's answer to Jackson Pollack.

The craft world was shocked. Having struggled to master their medium, many potters felt he was thumbing his nose at 5,000 years of ceramic history. Others were not ready to acknowledge Abstract Expressionism, even though it had been around for more than a decade.

But many craftspeople realized that the whole game had changed. The spare, simple forms of Modernist design were suddenly obsolete, or perhaps more appropriate to industrial design than studio craft. Ambitious craftspeople were no longer content to make tasteful, useful objects. They wanted to make sculpture, they wanted to make it big and they wanted it to carry an emotional wallop.

This impulse worked best in ceramics and fibers. The scale of ceramic sculpture was limited by the size of the kiln, but that could be a good five or six feet. Initially, weavers were limited by the width of their looms, but soon off-loom techniques such as knotting or coiling expanded the scale of fiber sculpture to entire rooms. Furniture grew to fill rooms, too. In the early '70s, glass artist Dale Chihuly discovered that he could make enormous glass installations by accumulating dozens of blown elements. On the other hand, jewelry, silversmithing, and flameworking were typically small scale, and missed out on the trend.

The studio craft world soon divided into two camps. On one side was the production community: people who typically made functional work and repeated designs for sale. They saw their work as operating in the traditions of craft, and public demand was seen as proof of the quality of their work. The craft-sculpture hybrids, in their eyes, were self-indulgent and pointless.

The trouble is, there has always been a component of craft that is designed for display, not for use. Table centerpieces, trophies, decorative carvings, funeral sculptures, vases made only to be admired: these kinds of objects have been made for millennia. If utility is defined as fulfilling a physical function, such as holding potato chips or keeping somebody warm, none of them are useful. Sculpture made from craft mediums merely continued an honorable tradition of crafts made for aesthetic pleasure.

On the other side of the divide stood the artist-craftspeople; they saw their work as pure and progressive, and considered production work to be imitative and compromised by market considerations. But this view is also wrong-headed. The market is basically a feedback system, and serving people's needs has its own long and honorable history. Nobody disparages industrial design because it is geared to the marketplace.

Perhaps the sense that art is superior to useful things was an outgrowth of a hothouse atmosphere in art schools. Fortunately, teachers now realize that not all their students can become artists, and that educators have to prepare students for making production craft just as much as making fine art. Students in art schools, though, usually want to make art.

Despite these silly arguments, studio crafts grew and prospered. Craft fairs, which started in the 19th century as tiny, informal affairs, grew into a big business in the 1980s. Galleries devoted exclusively to craft started opening in the '70s; by the mid-1980s, galleries that handled only one medium were common.

Of all the craft media, glass was the most successful in the upscale market. Glass objects were already familiar as collectibles, with work by figures like Tiffany and Gallé commanding high prices. Collectors felt no sticker shock when glass artists demanded

a similar price structure. When glass teachers got together to form their own medium group, the Glass Art Society, they wisely invited collectors to participate right from the beginning. By the mid-1980s, collecting glass became a fashionable thing to do, and there were tales of wealthy individuals starting glass collections with million-dollar investments.

Glass had a great success story: Dale Chihuly. A master of self-promotion, Chihuly perfected the art of public relations. He published a series of glossy, full-color books featuring his dramatic works. He named each one of his series. He hired superb glassblowers to produce his work, and reinvented himself as an artist-impresario. Americans loved it. Fortunately, he was also a talented and innovative artist. His nested baskets and Venetian-inspired chandeliers are unforgettable. Chihuly became the first international rock star of glass.

Flameworking has its own heroes: Paul Stankard, Jay Musler, and Ginny Ruffner among them. Stankard came from the scientific glass field, but soon became dissatisfied with the lack of creativity in the trade. Combining great skill with technical innovation, Stankard is now the elder statesman of studio flameworking.

In the 21st century, studio craft continues to change. The established marketplace for production craft is in decline, strangling on its own standards of professionalism. However, a new marketplace has emerged from do-it-yourself (DIY), punk, and political activism. In addition, new ways to market craft like the website *Etsy.com* have evolved.

The definition of sculpture has changed as well. Sculpture used to be three-dimensional objects, but many sculptures are now hybrids, or maybe more accurately, combinations. Video, performance, installation, and social systems are all now deployed as sculpture. In one notable example of how far sculpture has departed from objects, Cai Guo-Qiang is famous for making art that consists entirely of fireworks. All the old boundaries have blurred, and adventurous artists cross them all the time.

Craftspeople participate in the blur. A collaborative performance group called The B Team produced extravaganzas complete

with dancers, music, and theatrical glassblowing. Artists like Rika Hawes make installations — one of her recent pieces is called "Liar Liar," and features a video of several people telling a story about how the artist got a scar above her eyebrow, projected through about 100 hanging glass lenses. Is it craft? Is it art? Does it matter what category it falls into?

What remains constant is attraction to the work itself — getting hands on a material and doing something with it. Ruskin and Morris were right: Craft empowers, dignifies, and satisfies. That much will never change.

Burton Wasserman is an emeritus professor of art at Rowan University. He has authored five books and numerous articles about artists and their work. Within the gallery and exhibition world, Wasserman has long been committed to the pursuit of his own creative efforts. He earned a Doctorate in Art Education at Columbia University.

I recently invited Burt to lecture my glass art class. He's a dynamic speaker who makes art history come alive. After the lecture a student came up to me and said, "Mr. Stankard, there is more to this art business than I thought." When I shared the comment to Burt, he beamed and said, "That's one of the finest compliments I ever received as a teacher."

Craft, Design, and Art

Burton Wasserman

Issues of craft, design, and art inevitably come into focus when people use tools and their hands to make things. As they proceed with their work, they also ask themselves questions about the look and feel of what they are putting together.

These factors have always been addressed, no matter what the specific purpose may have been. An example comes to mind from the time of the Roman Empire. Back then, hot melted glass was blown into the shape of a bottle, because people needed containers that would safely hold pharmaceuticals or cosmetics. Coincidentally, they considered how attractive such a vessel could be and the best way to produce it. Similar questions come into play today if someone wants to structure a dimensional form in glass, whether the underlying reason is primarily utilitarian, decorative, or artistic.

Central to all of these concerns are the talented individuals who are driven by strong internal impulses to make objects that did not exist earlier. A small number of them manage to make the most of their need to be creative, entirely on their own — without attending art school or even pursuing courses at some local venue. Somehow they learn, mostly through trial and error, to exercise the skills needed to become recognized and successful.

A few become apprenticed to masters who help guide their progress in existing studios. They *learn by doing* and eventually reach a degree of maturity that allows them to function as masters in their own right.

Others take specialized study at post-secondary technical institutes, art schools, or two-year community college programs geared to preparing them for rewarding careers devoted to making

objects in glass and other materials. Some undertake formal classes at colleges and universities that provide four to six years of specialized instruction in different areas of the creative arts and award bachelor of fine arts and master of fine arts degrees.

No one single career path is right for everyone. What works best for one person may be inappropriate for another. In addition, while some creative people are determined to be successful on a vocational/professional level, others pursue a life in art purely for their own personal satisfaction.

In the end, what matters most of all is that the talent and desire for making interesting and appealing objects should be honored by those who have been thus blessed, as well as those who appreciate their work. As part of their human makeup, those who can make the works cannot help feeling they have something worth sharing with others. Whether they eventually call themselves artists or not, they have a compulsion to externalize what they are pushed from within to make or say.

Ultimately, they use systems of working in an artistic form called craft and design to implement and evaluate their need for expression. Until all the forces that motivate that drive are satisfied, they simply cannot rest.

In addition, as gifted people go about their work, they often *invent* procedures that combine their ideas and some raw material to arrive at a concrete product. These processes of invention and execution are basic to the creative process. Without them, finished products cannot be brought into being. After all, such objects do not make themselves.

While preparing for a future career as an artist, it may be helpful to duplicate procedures that others have initiated to learn certain working techniques. However, simply imitating the finished work of someone else denies genuinely creative people the opportunity to bring what is uniquely theirs into the world. Unless an object is authentically original, it lacks a distinctive artistic integrity — a true spirit of genuine uniqueness. Such efforts are forgeries; merely imitations of what has already been created by someone else. No matter how cleverly done, at the highest

levels of professional accomplishment, such theft of ideas and practice is not only frowned upon, it is also never justified.

On the other hand, in the area of quantity-production practice, such as the field of modestly priced giftware, the culture of the marketplace does not generally place a high premium on originality. In this venue, it is not uncommon for imitation to be the rule rather than the exception.

Judgments of how well some finished objects are made generally remains in the eye, the heart, and the head of any individual beholder. However, there can be no doubt that the sincerely objective opinions of *informed and experienced* individuals are virtually always regarded with more respect than those offered by people with a merely casual, otherwise *uninformed*, point of view.

Craft

Over the years, the word *craft* has had a variety of meanings. Before the contemporary period, the term referred principally to making objects by hand for either decorative or utilitarian purposes. In addition, from the time of the most ancient civilizations, a special area of craft activity was devoted to making jewelry.

When they were created to fulfill some ornamental function, the appearance of such hand-crafted selections received considerable attention. By contrast, if they were made to merely serve an ordinary need, such as a glass water-pitcher for use at mealtimes, they were frequently produced with relatively little concern for how attractive they were. In addition to glass, such manually shaped products were also made from clay, fiber, metal, and wood.

Across the centuries, in various places, efforts were made by many different craftspeople to improve the status given to their chosen disciplines. The reason for this may have been a desire, going back at least to the time of the Renaissance, to enjoy the respect and recognition accorded people working in the fine arts, namely painting, large-scale sculpture, and architecture.

Many connoisseurs felt that *fine* artists proceeded on a level reserved for visionary poets and brilliant philosophers, as exemplified by such Renaissance-period artists as Raphael Sanzio and Leonardo da Vinci. By comparison, the men and women who pursued handcrafts, such as those who made stained glass windows, were viewed by society as rather menial working people, just a small step above ordinary laborers.

A major change in this outlook came into being in America during the period following World War II. The dichotomy that had long separated the fine arts from handcrafts took a new turn when a development called the *studio crafts movement* evolved and gradually came into its own. This has continued to the present time.

Today, increasing numbers of people focus on making a life for themselves in the decorative arts. They do so with the depth and intensity of purpose once reserved for commitment to a career in the serious fine arts. Whatever academic distinctions may have existed between them has diminished almost to the point of non-existence. Instead, the emphasis is on the making of significant aesthetic objects, regardless of the traditional attitudes and expectations formerly employed in bringing them to fulfillment. Above all, the use of the word "craft" has come to refer to the high degree of disciplined control that individuals apply to shaping a high-quality finished object.

During their period of career preparation, many students try to learn as much as they can about their chosen raw materials and *working techniques*. The emphasis is upon discovering a material's structural potential and limits. The more they develop command over the working characteristics of the raw material, the more they enhance their ability to impart a sense of confidence in the skills used to make their work. At the same time, they try to widen their imaginative horizons and deepen their expressive powers.

Furthermore, they know their creative efforts will have to stand the test of competitive comparison with the working skills demonstrated by others when they present their accomplishments to potential consumers in the marketplace. They also know their

output will be subject to evaluations based on the initial visual impact of what they have to offer.

While it is not, strictly speaking, a craft consideration, a collateral factor adding significance to the overall spirit of a given object is that it be *timely*. Being aware of what is current and not dated may well prove to be a practical fact of life for those concerned with what the marketplace may have to offer.

Ultimately, the *pursuit of excellence* is the principal goal a craftsperson/artist seeks to achieve. This is at the heart of what sound craftsmanship is really about.

Design

At one time, the term *design* referred to some ornamental enhancement of primarily utilitarian objects. For example, a lighting device in the home may have been decorated by adding some pretty leaf patterns to mask the supposed ugliness of the fixture. Today, artists and public alike tend to feel such practice is ludicrous.

Instead, the term design is used to suggest the process of *organizing* a visual piece of work. For practical purposes, this concern with design is the foundation, along with a consciousness of craft discipline, on which virtually all work in artistic form is based.

At its most fundamental level, the language of design consists of a vocabulary made up of different *elements* of visual awareness. Specifically, these are point, line, plane, texture, color, pattern, density, interval, and space. The world of three-dimensional form also includes the elements of light, mass, and volume.

There is no end to how the human imagination can manipulate and distribute these elements to fashion an exciting, fresh, and unexpected form — one able to attract and hold the attention of a viewer.

Certain *principles* are always present in the design of a well-conceived piece of work. Regardless of what medium an artist employs, these basic design principles are universally applicable.

First and foremost, to be considered a soundly finished product, an object must show evidence of having a sense of overall

organic *unity*. Its presence can be felt when all the parts of a two-dimensional composite or a three-dimensional object fuse together into a soundly integrated, seamless whole.

Likewise, unless an object is *well-balanced*, it cannot be said to be successful. This is a matter of equilibrium. Every part of the piece should be distributed so well that each one looks as though it is in its proper place. Without such a total feeling of balance, a piece of artwork lacks stability and promotes a sense of unease or disinterest.

Mother Nature provides a vast range of examples of balanced order from which artists may learn a great deal. When events and circumstances are not balanced in the natural scheme of things, the overall situation is obviously out of kilter — out of proper accord. We can tell this is so because our capacity for *intuitive* awareness and judgment points it out. We can tell an object lacks balance, because it does not feel right. Of course, on occasion, some artists deliberately impose imbalance to make a point, but that is usually jarring to the viewer and can detract from the over-all beauty of the work.

Next, there is the principle of *rhythm*. When present, it animates a piece of work. The energy it contributes can be brought into play in various ways. The most frequent one is probably regular repetition. This occurs when the *same* specific element appears with some frequency. By comparison, irregular repetition occurs when *variations* of an element are used again and again within the overall conception.

A fourth principle is *emphasis*. This refers to the way an element or a particular feature of an overall configuration becomes prominent, because enhanced size or color causes other parts of the total form to appear to be subdued.

Such use of emphasis or contrast also provides a degree of variety that helps avoid monotony in a design. Another way of thinking about emphasis is to draw attention to a particular element, or elements, with the use of an arrow-like shape.

A concern with harmony may be the most useful ingredient of all the virtues in art-making. Unless the different elements in a

total combination can live in peace with each other, a feeling of disorder is bound to rule the scene.

If creative people do nothing else, they have to know how important it is to trust their faculties of intuition. Of course, like everything else about art, this requires endless practice.

Art

Inevitably, when individuals conceive art forms, they integrate feelings, beliefs, attitudes, and insights with tangible materials. The forms that emerge give definition to impulses directed from the center of the artist's being.

These internal sensations do not exist in a vacuum. They are given expression by values reflecting customs and traditions that are part of the society in which people find themselves. This helps explain why individuals feel deeply nourished by the power of art. In a manner that defies simplistic explanation, aesthetic forms have a potential for rejuvenating the human soul. The mysterious internal currents that reinforce one's awareness of *being alive* are quickened by contact with art.

In a world where the corrosive effects of constant exposure to noxious advertising messages and political propaganda tend to wear away a person's sensibilities, time spent with art forms often provides a unique measure of relaxed well-being and peaceful contentment. In addition, as if by magic, contact with art appears to help bring different people closer together when they share art experience across national boundaries.

There is also something remarkable about the way that making art forms frequently provides valuable therapeutic assistance for a creative individual's emotional health. Both making and appreciating art tends to reduce fatigue. In addition, artists have found that nothing else quite equals the profound sense of joyful accomplishment they feel on completion of a given piece of work.

Contact with aesthetic form also satisfies the human makeup in other ways. For example, on studying various floral composites in glass by the famous French designer Emile Gallé, viewers have reported experiencing rare degrees of artistic enrichment.

Interaction with his creative work has also helped them appreciate nature in marvelous new ways. Identifying with his language of vision has provided a measure of perspective for gaining deep, non-scientific insight into flower forms that the direct observation of growing plants many not otherwise offer.

When students of art history speak of the Medieval Period in Western Civilization, they frequently call attention to the fact that this time was a great "Age of Christian Belief." No evidence of this fact rings true with such force as the sheer number of great buildings that were erected and used as monumental centers of prayer and education. The elaborate façades, sculpture, and inspiring interior spaces all sought to instruct the faithful in concepts of spiritual commitment and moral conduct.

The extraordinary beauty and suggestion of welcome, implicit in the cathedral of Notre Dame de Paris, continues to speak eloquently to visitors. In fact, many visitors report being moved to tears as they step from the entry area into the nave of the church. As they do so, they feel a rush of excitement on seeing chromatic light come through the stained glass windows on either side of the sanctuary.

Concentrating on Michelangelo's uncompromising virtuosity, people can see a heroically scaled treatment in carved marble in his representation of the Biblical David. They cannot help but admire how he joined deep thought with extraordinary powers of visualization to produce a poetic metaphor — one able to express qualities of courage, modesty, and faith.

From the same period, Benvenuto Cellini, in his early years an apprentice to Michelangelo, was an amazingly versatile artist. During his lifetime, he completed many unusual pieces of work, ranging from designs for jewelry to a saltcellar with mythological figures in gold for the dining table of the French emperor Francis I. He also served two eminent popes, Clement VII and Paul III, as well as many aristocratic figures in various European venues.

Along very different lines, from the 1930s in the United States, architect Frank Lloyd Wright's Kaufmann House, known as Fallingwater, is an awesome example of creative ingenuity.

Located in western Pennsylvania, a relatively short distance from Pittsburgh, it features an especially unusual balcony cantilevered over a waterfall. Without question, it is one of the most elegant and imaginative examples of residential architecture ever built anywhere. Built of poured concrete, native stone, wood, steel, and glass, the building is, in its own remarkable way, like a non-denominational hymn in praise of the ability of human beings and the natural environment to live together in a state of grace.

So far, no one has thought about preparing an obituary notice to announce the death of the *will to make art* by human beings. With an endless reservoir of expressive drive, people come along who are determined to convert raw materials into objects, with artistic intensity. The world is infinitely the richer because of their dedication.

Inevitably, we wonder what will come next as artists pursue their work. No one really knows. However, it is safe to assume they will not suddenly stop doing what they have always done.

In time, new forms will emerge. Soon afterward, interested parties will hear about them and go to see how they look. By and by, others will follow. In due course, they will seek what creative personalities, in their own special ways, will have brought into the world.

No one single career path is right for everyone. What works best for one person may be inappropriate for another. In addition, while some creative people are determined to be successful on a vocational/professional level, there are others who pursue a life in art purely for their own personal satisfaction.

I first became aware of Judith Schaechter's art work in the late 1980s and have been inspired by her artistic vision and dedication to teaching ever since. Schaechter's tense yet colorful contemporary aesthetic has advanced the centuries-old stained glass window tradition. In 2012, the Eastern State Penitentiary Historic Site invited Schaechter to put on an exhibit. My wife Patricia and I toured the site to experience Schaechter's ambitious new work, *The Battle of Carnival and Lent.* Her 17 stained glass windows, inspired by the prison's dark history, were installed in historic skylights throughout the prison cellblocks. The haunting beauty of her work, illuminated by a bright fall Sunday morning, touched my soul and made a lasting impression.

A graduate of the Rhode Island School of Design Glass Program, Schaechter has been the recipient of an impressive list of honors, among which are a Guggenheim Fellowship, two National Endowment for the Arts Fellowships in Crafts, and a Pew Fellowship in the Arts. She divides her studio time with teaching at the University of the Arts and the New York Academy of Art. Her work is represented in the permanent collections of the Victoria and Albert Museum in London, the Philadelphia Museum of Art, The Metropolitan Museum of Art in New York, and numerous other institutions.

What is Beauty?

Judith Schaechter

The expressions "Beauty is in the eye of the beholder" and "I know beauty when I see it" are bothersome to me — they seem to diminish beauty's profundity and reduce it to a matter of opinion that is beneath discussion. That can seem like a massive abdication — a sort of shrugging it off with "It can't be figured out, so let's just forget about it." At the same time, I don't find beauty to be thought-provoking; on the contrary, I find beauty to be *thought-annihilating*. The real question isn't "Is beauty in the eye of the beholder or a quality in the beheld?" anyway; the real question is "Do we desire something because it's beautiful or is it beautiful because we desire it?"

Because beauty is really not a verbal or intellectual experience, critics, theorists, and philosophers can argue forever that it is irrelevant, that we're *over it* as a culture. We can all even *agree* on that point . . . Basically, you can deny it all you want, and still, the argument continues to rage, unfazed, unabated, and entirely undiminished. So there's your evidence of its importance. When the tide goes out on beauty, enough fools go rushing in to fill the vacuum, or we just switch to a safer word and call it something else, like "sublime" or even "thought-provoking."

I want to be clear that, in discussing beauty, I am distinguishing between "beautiful nature" and "man-made beauty," and between "beautiful ideas" and "beautiful objects."

I am interested in the aesthetics of man-made objects. Nature is beautiful. No kidding — but it's not really very interesting in a discussion of aesthetics,[1] because we are not responsible for creating it. A flower, a tiger, or a rainbow is ultimately utterly without abstract meaning unto itself. A flower can only follow its

own independent destiny, which includes its inevitable demise. But art can address our desires, both directly and eternally; it has nothing better to do, in fact! Art can embody intentional metaphor and narrative. At the very least, art has the potential to address humans on their own terms. And it is lasting.

Beauty is also not pretty. Pretty is nice and it is pleasant, but not a lot more. Pretty is *not* in the eye of the beholder and, as a quality residing in an object, it can be evaluated. These measurable qualities are the formal elements of design and include contrast, range, balance, and radiance. Pretty is the thing that is only skin-deep. Beauty is much, much deeper — ask any ugly person.

Beautiful *ideas* are similarly uninteresting — world peace, caring for others are beautiful ideas that are often easy to come by, since they tend to become clichés. Yet they *still* need aesthetic help in selling them to humanity. Any fool can, and often does, have good ideas, but it's the person who writes the best song who attracts and influences followers.

The Nature of Beauty

We have these *peak, positive aesthetic moments* and we need a word for them. The word we choose is beauty. We try to agree on what words mean so effective communication can take place, but definitions shift, mutate, and evolve, especially words describing emotionally loaded abstractions, such as beauty.

Beauty is the positive principle in aesthetics. For beauty to mean anything else, or to call something that is plain, homely, or ugly "beautiful," is to corrupt the word and see its meaning shift. We would still need to provide a word for that peak aesthetic experience.

Before you get up in arms about your undying appreciation for something hideous, let me qualify that statement by saying the relationship of "ugly" to "beautiful" is an interdependent one — beauty can contain ugliness and vice-versa. They help define each other because they seem opposite, but that is a false dichotomy. They are much more like yin and yang — two complementary forces where each contains elements of its opposite and gives rise to the other.

One thing seems obvious: Beauty is entirely dependent on inspiration to give it relevance and vigor. Without inspiration, beauty would be so bereft and uninteresting that it would hardly be worthy of its own name and exalted status. While inspiration seems to be the key to understanding it all, it also defies description and tends to sound flaky after a few words. Regardless, nothing seems closer to the deepest mysteries regarding our nature as enlightened and aware human beings.

Inspiration is intimately connected to the idea of life force, as one can see from its origins, meaning "to breathe life into." This animation is itself a creative act, as it connects spirit to matter, ephemeral content to physical form. One can see why transference of life force might be seen as sacred activity. Perhaps this is why religious people sometimes see artistic creation as being in competition with God-the-Creator. To actually, successfully turn the intellectual, the emotional, and the inspirational into a *material object* is pretty miraculous. An artwork does this — and, when it does it well, we call it beautiful.

Beauty is Dangerous

The impact of beauty is nothing short of fierce. Nancy Etcoff points out that many of the words we use to qualify beauty are violent: bombshell, knockout, drop-dead gorgeous, rapturous.[2] This is how badly we want it; this is what we are willing to risk to get it. Beauty provokes a gut "Wow!" response, which is why I called it "thought-annihilating" — it doesn't really appeal to the intellect; at least, not initially.

Beauty, being so much about *response*, cannot truly be possessed even in an art object. Because the experience is so glorious, so fleeting, mysterious, erotic, *traumatic* even, it is always calling attention to its own possible or, perhaps, unavoidable loss. It takes courage to risk being involved with beauty, as it embodies a healthy measure of anxiety and fear. If beauty is to art what love is in life, then it is something without which you suffer; something you will go to great lengths to experience.

There are dark sides to beauty. Under its influence, one feels vulnerable, out of control. The desire for beauty defies rationality and common sense. It can cause one to abandon safety and self-interest in its pursuit. Anything that involves desire can bring out our bad qualities — materialism, fetishism, selfishness, jealousy, avarice, the urge to exploit and misuse that which we see as merely a *thing*. An objectification is always perilously close to becoming a false idol. Objectifications can tempt us to exploitation when the object we desire is a human body.

There is a longstanding historical confusion between beauty and goodness — no doubt arising from its positivity — but just because it's positive doesn't make it *moral*. Because the thing we desire makes us feel so good, we hope that it is good *for* us — we struggle to find these desires noble and decent. But anything we desire can be deployed for nefarious purposes, and beauty can be and has been used to sell people just about everything. People, typically, cannot always (or don't want to) put off intense desire, and there are plenty who will provide commodities they think that others need. Many will attempt to create this intense desire as well. Rampant materialism reminds us that we are greedy and using up our natural resources — and beautiful objects often lean perilously in that direction, causing us to feel guilty and to be suspicious of them and, in turn, our desire for them.

Finally, beauty may lead to some odd conclusions, not always in accordance with society's rules. A lot about beauty is open to interpretation — who knows what the brain of the beholder is bringing to the experience? No wonder it's so dangerous and threatening. No wonder it gets abolished from time to time.

Beauty is Inspiring

Beauty is both inspired and inspiring. Without it, objects devolve into something else entirely. Inspiration in an artwork is nothing more and nothing less than the life force, soul, or spirit, whatever you want to call it, that leaps from inside the artist into an object and then into the beholder. This completes a creative

circuit of inception, conception, and reception. Inspiration, in its most literal sense, means to inhale air, the opposite of which is expiration, a synonym for death. Without the animating spirit that inspiration provides, a creative act or an aesthetic experience or object remains, at best, merely pretty and, at worst, a sort of empty housing — a zombie without a soul. We find beautiful things to be inspired and, in turn, they inspire us.

The positivity of beauty comes from its being "life-affirming." The way it accomplishes this is through a positive feedback loop of inspiration and desire. When we are inspired, we feel good — exhilarated, even — and we feel motivated. In other words, we aspire . . . and to aspire is to desire!

Although beauty appears to promise relief and release, it's *not* about satisfaction or satiating at all. As long as we are filled with desire, we are engaged; we are still alert, and seeking and, thus, are hope-*ful*. So, beauty does fulfill. But, rather than silencing need by delivering the object of desire, it fulfills through the type of desire associated with *unconditional* love as opposed to *self-interested* love.

The image of transferring life force with one's breath is part of the original myth of Eros, originally a *creator* who beget the world by breathing life into a barren planet. It is easy to see beauty as the aesthetic expression of this Eros. Inspiring it, in other words. Rollo May, the great existential psychologist, discusses Eros as "the power which drives men to God,"[3] toward one's highest expression; toward mature self-fulfillment and union with the divine. Think of artificial respiration — the idea of a "kiss of life" is no joke. When it comes to inspiration and beauty, with their attendant passion, this is not "artificial" respiration but symbolic. In other words, the reward that beauty delivers is a feeling of being utterly alive and aware and whole. We desire it because it's beautiful and it's beautiful because we desire it.

I think we want a few big things in life. We yearn to be complete and we want to know there is a good reason for suffering and profound meaning in all that seems random and troublesome. Creativity, inspiration, and beauty, like love or truth or God, belong

to the category that addresses these issues because they imply resolution, catharsis, and enlightenment rather than simple pleasure.

"Yearning to be complete" can mean desiring connection or disconnection, in that we need communion and expansion, as well as a sense of contraction and restriction. This can occur on three levels. Within ourselves, we struggle to both unite our bodies with our minds and detach them. In the world, we seek to bond with others, while maintaining our uniqueness — at times, with a sense that this bond will bring two complementary yet incomplete people together to form a united whole — as in the myth of Aristophanes.[4] And ultimately, we may strive to become "at one" with a larger, cosmic context or perhaps, at times, to imagine we *are* the power in charge.

These three levels of completion — the interior, exterior, and "cosmic" — are the bases of allegorical meaning. There patterns are reflected in the life cycle of birth, growth, decay; the creative cycle of conception, inception, and ejection; and the cycle of inspiration, wonder, seeking, and discovery. Beauty, inspiration, and creativity are powerful because together they forge all three connections we seek. We call these connections *beautiful* and, indeed, they are *attractive*. All unification is about attracting, and that we should find it aesthetically so should not be a surprise.

So how does beauty address our need for resolution? By speaking to our united existence — engaging both our senses and our souls, putting them in sync. Think of the word aesthetic. The origins of that word are in the senses — an aesthetic experience is the opposite of an anesthetic one — you are engaged, alive, aware and in the moment, not numb.[5] And although the origin of the word deals with the senses, I think it really describes a synthesis of mind and body. An aesthetic experience is one in which intellectual and emotional awareness is in accord with the physical. The art object has a physical, sensual body and, ideally, a sensibility as well. We bear witness to that and to seeing that as a reflection of our own self.

Because we have a nagging sensation that we are incomplete, we yearn for that long-lost missing thing. This is why we

enjoy being *full* — because being full feels a lot like being whole. The hole becomes a whole, if you will. We like to let the outside in to prove we are not empty and not alone — as in breathing, eating, or sexual union — but also symbolically, as in "full of inspiration" or "full of love." When we are full, our boundaries become fuzzy — we become at-one, or a lot less hungry or lonely. But something happens to one's sense of being a discrete person in these cases.

This brings me to the role of "self" in beauty and inspiration. They are not only thought-annihilating and language-annihilating, but also ego-annihilating. Both allow one to transcend the self, which is another reason why *they feel so good*. When people surrender their egos, they are — for the moment, anyway — *at-one*[6] with something larger than the self. The petty miseries of life seem far less bothersome. "Get over yourself" is more than a glib phrase — it's a path to enlightenment.

To be at-one also implies that there's no longer a rift between one's physical being and one's mind. To be at-one is to marry spirit to matter in the creative sense. It's quite paradoxical — to become at-one, we must surrender ideas of attraction, unity, and cohesion; we must allow our "selves" to expand, or dissolve. We like to define, and confirm our barriers to protect our sense of uniqueness and identity, and yet we also have a need to break down those confines.

For an artist to be inspired, then, is to unite, however briefly, with that long-lost *thing*, in the form of feeling its unearthly breath penetrate and inflate ourselves and inform our artwork, sometimes to the point we feel we may explode. Which is exactly what happens when artwork is disseminated.

Beauty is Transformative

I said earlier that we yearn to be complete, but also that we wish for our lives and our suffering to have meaning. Beauty accomplishes that because it can transform the awful into the awesome. If beauty's inspiration blasts us into the particles that fill up the universe, then beauty's empathy validates our individuality.

This explains why so much of what we call beautiful art must reference heartbreak and tragedy. There's no transformation from joy to joy — obviously, there's no need to change that particular situation! Nor is there any transformation from emptiness to emptiness or ugliness to ugliness; this is just a reaffirmation of our worst fears.

Perhaps beauty's ultimate function is its ability to transform chaos and ugliness into something transcendent and meaningful; to transmute suffering into a beatific state (whence "beauty"); to transubstantiate our mortal flesh into something more eternal, more allegorical.

Beauty's exquisite impact may tear us apart, but it can also confirm our coherence and individuality with its power of empathy. We look to art as a bat uses sonar — to navigate our space by bouncing signals off of other things. The validation and comfort one feels when looking at art is owing at least in part, to the idea that we may feel listened to, in the sense that artwork gives expression to our internal imaginings. We don't look at pictures of saints just to gawk at them or to be judged or lectured — we learn from them how to handle our troubles with more grace and transcendence, because we literally behold ugly ideas transformed into beautiful forms and can imagine how we might do so in our own lives.

Beauty is sympathetic, empathic, and empathetic, and embodies the notion of pathos in every way possible, with the exception of apathy. Beauty makes it possible to face, even embrace, the unbearable and traumatic, which would otherwise be too painful to contemplate. Beauty's power is transformative because it helps us feel our feelings in a richer, deeper way. It is a full-spectrum emotional experience in which all is fair game to express. This certainly explains the appeal of tragedy. One can call "happiness" an absence of pain and sorrow, but true joy can really only exist in contrast to darkness.

Notes

[1] Unless you are talking about interventions like gardening, or our obsession with dog breeds, say. Human beauty, being of paramount fascination to

us, is certainly to be included in any ideas of aesthetics, especially a discussion centered on uniting mind and body.

[2] Nancy Etcoff, *Survival of the Prettiest: The Science of Beauty*. Doubleday, 1999.

[3] Rollo May, *Love and Will*. W. W. Norton and Co., 1969, page 72.

[4] *http://themeaningofmadness.wordpress.com/2010/09/25/platonic-myths-the-myth-of-aristophanes/*

[5] I have read one etymology of the word "aesthetics" that relates it to breathing, and I wish that source were accurate, but alas, I think there's no real connection.

[6] Atonement, in the sense of "to set right with God," was originally a contraction of "at one."

Personal Experience and Philosophy

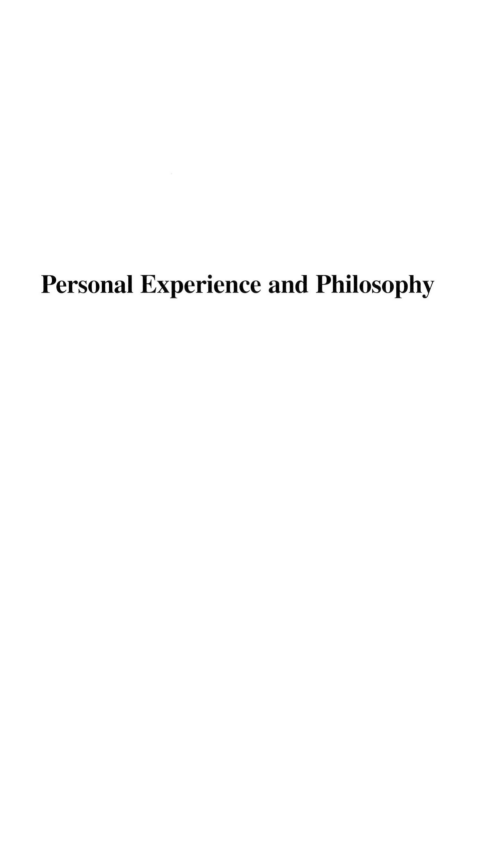

These photographs provide a summary of my 50-year journey from master scientific glassblower to studio artist. The four pieces of glass symbolize stages through which my work passed as it matured.

Reflections on 50 Years of Object-Making

Reading Jean-Jacques Rousseau's *Discourse on Inequality among Men*, I came across an amusingly simple quote: "Some have more than others." When I read that, I thought, "Some flameworkers have more hand skills than others, some have more courage to be creative than others, some have more economic need than others, some have stronger egos than others," and on and on.

But beyond Rousseau's writings, what unites all makers on the creative side is the opportunity to compensate for one's weakness while focusing on strengths in ways that make work significant as we seek to express our humanity.

My journey of seeking and questioning the spirit of artmaking is constantly nourished by visiting art museums, cultural centers and galleries, perusing art history books, and having endless conversations with other creative people. Since the late '70s, I've been interested in the philosophy of beauty and, when I sense mystical energy floating above an object, it's mesmerizing, and I often contemplate how the object visually celebrates excellence in the language of art.

I think of beauty as spiritual energy and labor as prayer. With these metaphysical attitudes in play, I approach the creative process with respect. I believe it takes more than hand skills, dedication, and passion to transform material into a work of art. It also takes ideas, a familiarity with art history, and awareness of where one's work falls on the artistic continuum. Most art schools focus on these concepts in an effort to promote artistic maturity. But, in my case, there was a predicament: I didn't go to art school, so I missed out on connecting with a vibrant community of aspiring

young artists who benefited not only from the school's curriculum but also from sharing of ideas, dreams, and experiences.

My paperweight-making journey introduced me to the artistic possibilities of an object, but, if I had gone to art school, I would have had my interest in paperweights knocked out of my head on the first day of classes. Such practice is not unheard of. I understand the irony of this state of affairs. I don't encourage my students at Salem Community College in Southern New Jersey to make paperweights at the beginning of their studies, because making paperweights is more about mastering certain prevailing vocational skills as opposed to developing ideas that transcend materials. It's important for me, as a teacher, to impress upon my students that art education is more than vocational training; it's about searching within oneself for ways to express ideas. My path has been based on mastering a craft that led me to artistic expression, but I feel the more creative way is to pursue broader ideas that require inventing personal techniques replacing a craft-dominated way of thinking.

In my classes, I promote artwork that is relevant and personal to each individual student. I tell my students that as an artist you have to connect to your own interests and belief system, in the context of the here and now. For most, artmaking is a lonely endeavor that, in the early stages, is about solving one technical problem after another. This effort requires sorting through a zillion possibilities and making decisions that identify while reinforcing one's personal aesthetic. This is one of the magical ways that originality is born — because, regardless of your early influences and derivative efforts, *making repeated personal choices and decisions throughout the process* will lead to original work.

It's important to be attentive to the process and open to the unanticipated, because doing so often encourages further experimentation and discovery. You need to think about what you're doing and ask yourself questions as simple as, "Why is this interesting to me?" or "What am I learning from this process?" Objects can move beyond function into a timeless realm by way of impeccable workmanship. Ideas can be incorporated into one's artwork

As artist-in-residence at Salem Community College, I enjoy demonstrating flameworking techniques to the scientific and glass art students.

by referencing people, places, and things. Ideas can also manifest themselves through abstract discoveries made while manipulating the material or rearranging components of the work. There are endless ways to incorporate and celebrate ideas in one's work.

As you gain artistic maturity, these questions may evolve into "How do I balance the need for money while making work?" or "Do I have the courage to create what's most meaningful to me, regardless of money issues?"

The struggle to resolve these questions in the context of your life and your understanding of what it means to be an artist is difficult, especially at the beginning of a career. The best strategy for confronting this challenge is to continue to make work. Although this may seem overly simplistic, it is the essence of being an artist/craftsperson. Thinking about great ideas and desiring to express them is essential, but not sufficient. The process of making work is primary.

Important artwork, especially an object, reflects our humanness and communicates a sense of the present while engaging the

viewer in a visual dialogue. Ideas expressed with skilled hands are often meaningful to the maker, and resonate outwardly through the maker's competence in working with the material. If you're committed to working in the studio, the next step in the creative journey is to identify your authentic interests and work to layer those interests into your artmaking. I'm not implying that you could jot down a list of your interests and then go to your studio and knock out a masterpiece. Careers are difficult to establish in the short term, and the process of identifying personal interests takes time and a lot of reflection.

Artists/craftspeople benefit from interacting with the creative community around them. It's easy to stay connected and be inspired by the many talented people in your field, especially if you take the time to communicate with them. A good way to get involved is to connect with public-access studios, art schools, and online social media sites. Online social-media activity needs to be safeguarded against unproductive comments, but with care you're able to engage in lively discussions with other artists and connect with interesting people. As you grow into artistic maturity, you'll not only participate in the dialogue but add to it. In my case, I greatly benefited from connecting to Wheaton Arts in Millville, New Jersey, over the years, especially in the '70s. We often went as a family on weekends to watch the paperweight-making demonstrations and visit the Museum of American Glass. Over the course of two or three years, I came to know many people who were also interested in furnace glass working, paperweight making, and contemporary glass.

It's important to seek out and study glasswork you admire. Through the 1970s, I studied examples of antique French paperweights and the German glass flower models known as the Blaschka Glass Flowers. I learned about the glass that interested me through books and by traveling to major collections in museums around the country. I wanted to unravel the technical accomplishments as I sought to understand the spirit behind the work I admired. Initially I was perplexed by the Blaschka Glass Flowers because I was unaware of the material techniques or the packaging

The mystique surrounding the Millville Rose was my inspiration to begin making paperweights.

and shipping concerns that contributed to making the models unique. I assumed they were all glass and constructed with a truth to the material. In reality, they were assembled from glass, wire, water-based paints, enamels, and glues. They also were constructed to withstand shipment from Germany to America.

Similarly, I admired the botanical designs inside the French paperweights, but, the more I studied the category, the more I understood the economic concerns that influenced the designs. Management of the paperweight factories sought profitability, which meant they designed the work to be produced in quantity instead of pursuing unique items of beauty that might be harder to make and more expensive in the marketplace. As you begin to understand the challenges and limitations that other makers face and how they reached their goals, your mind opens up to different solutions to your own challenges.

It wasn't until the late '70s that I became aware of the ideals that dedicated artists who were creating contemporary glass were striving for. I understood the economic concerns that influenced most craftwork. Often, artists armed with BFA or MFA degrees were indifferent to historical glass traditions and were generally influenced by a broader sculptural tradition. Meeting people like Henry Halem, Flora Mace, Tom Patti, and Mark Peiser challenged

me to look beyond the marketplace and understand that being an artist is a lifestyle. I gradually began to set aside additional time in the studio to give more attention to developing special efforts that weren't simple knee-jerk attempts to satisfy the public. Looking back, this focused dedication of time to exploration was vital to my artistic growth over the years.

Another important experience in my effort to educate myself and understand my work from a wider perspective was visiting a Marcel Duchamp retrospective at the Philadelphia Museum of Art. I felt frustrated because his work didn't make sense to me. I realized I needed to know more about contemporary art beyond glass. Before viewing Duchamp's work, I mostly connected art to recognizable realism from an average person's idea of beauty. His work shattered this by celebrating art on a conceptual level and confronting people's basic concept of art as having to reference beauty. I came to realize it wasn't important to like everything in the museums or galleries; if you did, you wouldn't have

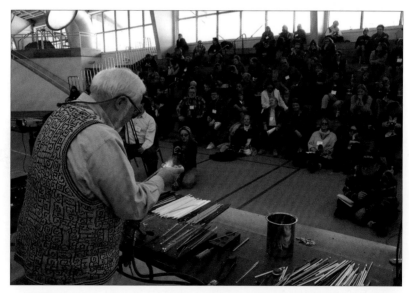

I demonstrated paperweight-making techniques during the International Flameworking Conference held at Salem Community College in 2005.

an artistic point of view. The result of seeing a wide range of good work allows you to identify quality and respect the professionalism that the artist brings to her or his work.

Over the years, while working in the studio to advance my craft, I've felt my self-esteem growing in ways that could not have happened had I stayed in industry. In industry, I was anonymous, making glass apparatus to be used in the laboratory, where the most elaborate and difficult-to-make instruments attracted no more attention than a "thank you" from the chemist who requested the work. From the beginning, working hot glass has been special. Through scientific glassblowing, I was introduced to the hot glass process and loved it. From the beginning I was attracted to the creative side and made solid-glass animals in my spare time. In those early days, the attention my novelties attracted was always more satisfying than comments about my most-elaborate scientific efforts. The fact that people responded to my creative work touched me viscerally and reinforced my sense of self-fulfillment.

What was special about making these novelties was the way they encouraged conversations about the objects and the process of making them. Whether the comments were positive or negative, it was satisfying that my work provoked discussion. During my career, I've come to realize how fortunate an artist is when the work resonates with others who come to see what has been created and on display.

The lifelong process of mastering a craft is about finding ways to transmit one's emotions and ideas through the material that comprises an object. Most importantly, it is about your ability to persevere. If you're sincere and you care about what you're doing, you have to identify what you value. For me, my work was challenged by knowledge of other significant work made in the past. Often, once an object has been made, other skilled craftspeople can replicate it. The material has the memory of that object and, with skill, it can be repeated. Knowing what's been done before will give you confidence to build on past accomplishments and make work relevant to the world of tomorrow. Certainly, the first leg of that journey would be infusing the work

with your personal vision, because we're all human and the more personal the work, the more universal its potential appeal.

From the very beginning of my career in art, I valued quality and sought to build a reputation as a person doing interesting work. Early in my career, when I was making simple floral emblems, I rejected about 30 percent of my efforts. In my mind's eye, I could envision elaborate botanical designs, but did not yet have the skills or techniques to create them. The difference between the two-dimensional floral emblems I was making and the complex three-dimensional designs I envisioned drove me to pursue my dreams with passionate intensity. All objects, even those as humble as a small flameworked animal or flower, have the potential to radiate mysterious beauty while engaging the viewer on an emotional level. This is what I strive for with each new effort.

I begin each day with a prayer, which allows me to look inward. The better you know yourself and your subject matter, the more intense your work becomes. When artists seek information that touches their emotional interests, they grow in many different dimensions. So, while Duchamp's conceptual work initially frustrated me, the challenge of understanding it slowly opened my mind to a greater range of artistic possibilities. This understanding reinforced my appreciation and respect for the full range of possibilities encompassing contemporary glass art, where the

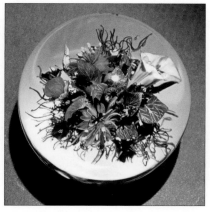

"Pineland Bouquet with Blueberries," 1992; H 2¾", W 3".

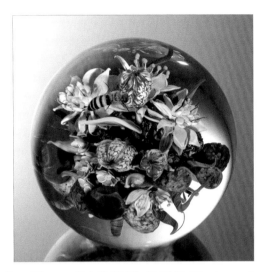

"Fecundity Cluster Orb," 2010; D 3¾". Photograph courtesy of the Robert M. Minkoff Foundation, Ltd.

artists in the Studio Glass Movement were pushing the fine-art possibilities using glass.

At the beginning of your journey, it's essential that you seek out work that is meaningful to you, whether it's aesthetically pleasing, intellectually challenging, highly publicized, or little known. It's a learning experience to seek work that attracts your interest, for whatever reason, and try to understand the challenges associated with it.

By having a strong foundation in art history, celebrating personal ideas, and persevering, you will grow with artistic maturity while learning about yourself. While each maker is inspired by and pursues different directions, the more we demand of ourselves as individuals, the further we advance our artmaking continuum. So when I read Rousseau's idea that some have more than others — I thought about his catchy phrase, and knew instinctively that an artist's creative needs and a personal commitment will easily trump individual challenges. And those personal challenges, complimented by independent studies, are the foundation for one's artistic and intellectual growth.

∾

Work in the studio includes many techniques, including flameworking colored glass components, reheating clear glass in the glory hole, and encapsulation.

A Day in the Studio

5 A.M.

Early each morning before sunrise, when I enter the studio, I begin the day with a prayer or meditation by touching the mezuzah that hangs on the door frame. I thank God for the day and ask Him to bless my workplace. This moment is important because I embrace the idea that labor is a prayer. I'm honoring God by realizing my full potential as a human being. I believe that the spiritual, however you define it, should be an essential component in one's artmaking. The studio is more than a place to work; it's a holy space where the spiritual dimension of artmaking nurtures a respect for discipline while working toward one's personal best.

The tranquility that comes from touching the mezuzah follows me into the studio as I begin the day's activities, which start with walking to the control panel to check the status of the annealing ovens. I'm proud of my computerized controller. When I think back to the late 1960s and early 1970s, it's bittersweet because I controlled the annealing cycle manually. I trained myself to set the temperature and would organize my late afternoon and evening routine around slowly turning down the oven's energy input knob. The dial controller regulated the percentage of electricity needed to hold or gradually reduce the temperature. The three-hour soak time ended after dinner, at which time I would start to manually ramp down the temperature for five hours, to around 11 P.M., and then I would turn off the oven and allow it to slowly cool on its own. I was programmed to walk into the studio every hour to adjust the cycle. Thinking back, it's amazing how committed and successful I was without a computerized controller to anneal my paperweights.

It's always a wonderful moment to open the annealer at the end of the cycle, especially now, at age 70, when being in the studio feels rewarding. When I feel the "cold" glass in my hand and look at the annealed piece for the first time, I'm excited and thank God for the gift of creativity. Regardless of how the work turns out, this quiet moment in front of the oven is central to being an artist/maker, because my labor and dreams are now a reality. While holding the glass, I'm analytical, and it's strange how my eyes automatically go to aspects of the work that are unexpected or off the mark. I'm emotionally connected to the original idea and instantly evaluate how closely the actual work matches what had been my vision.

When I take an orb from the annealer to my swivel work stool, I begin to feel tense. I don't understand why, after so many years, I'm still edgy sitting in front of the torch at the beginning of each day. It generally takes 5 to 10 minutes to quiet down and focus on what I need to do. Simultaneously, I can't take my eyes off of the orb. I've often thought about how strange it is that, at the start of the day, when I'm examining new work, nothing is ever good enough — I constantly see aspects that need improving. But when I look at early work, distanced by a few or more years, I feel no tension; I accept the work and take pride in knowing it was my best effort. It's interesting that I'm not critical or involved in refining the designs; I've emotionally let the work go to be judged on its own merits in its own reality.

6 A.M.

Early mornings at the torch are the toughest time in the studio. Facing the start of another day, I am filled with apprehension. I ask God for the wisdom and insight to do significant work by focusing on a small, metal crucifix that has been attached to my work bench for more than 40 years. As in focal meditation, I'm seeking clarity and spiritual guidance to help map out the day's work. I'm not sure what causes my anxiety, and have often wondered if it's rooted in my childhood, when my failure in school disappointed my father.

The new orb design, just out of the oven, is an arrangement of flowers, fruit, and nuts, clustered together with moss, leaves, and tendrils, with a honeybee hovering over the composition. It takes time to decide if I'll continue with the design or go in a new direction. This effort has new botanical components: moss that my son Joe has been experimenting with (and finally nailed), and bulbous fruit and nuts that move away from the floral vocabulary that has become my signature. Overall, I feel good about this piece, but want to enhance the succulent appearance of the fruit with indentations on the side and adding brownish-red to suggest an overripe section.

Reaching for the striker, bunched with the tools to my right, I light the torch. I've handled this same striker for upward of 50 years and always notice its uncomfortable grip, but I love witnessing the moment that the sparks bombard the gas and ignite the flame. This flash of beauty reminds me of running around my backyard as a child, waving a July 4th sparkler and spending time in the woods striking stones together to see the sparks they would make.

As I add oxygen to the gas, I find the colors — ranging from yellow to blue — soothing to focus on. Beyond the aesthetics of the flame, the color tells me I've passed 2,500° Fahrenheit, more than needed to melt my glass rods. The flame offers the possibility of new discoveries and the start of a repetitive technique that becomes a kind of mantra during my time on the bench.

I start with the material prep, by redrawing the clear glass and overlaying colors onto that glass so I can build components later. What I once thought of as a monotonous necessity for most of my career has recently, within the last 10 years, become one of the comforts of my workday. This tedium has evolved to a new level of consciousness, allowing me to experience the miraculous aspect of hand and mind coordination. The work has become both joyful and metaphysical as I build on years of daily minutia to define a life's work.

I sometimes wonder why working with my hands is so natural and so much a part of my quality of life. Making things has

enhanced my sense of self-worth and guided my approach to independent education. As a child, I built boxes with interesting bits of metal collected from the ruins of a burnt-down jewelry factory. The hours spent building small machines, as I thought of them, from wires, knobs, and metal scraps gave me a sense of well-being. And now, as an old man remembering that small boy engaged in building magic machines quietly in the basement, I've come to believe that the creative process is God's gift to humankind. This gift can become an act of faith that distinguishes our lives while demanding courage.

Early in my morning, I sometimes decide to call a meeting with my studio assistants, Pauline Iacovino and David Graeber, to critique my new work. My assistants start at 8 A.M. and will be in soon. I'm keen to talk about the new piece, along with discussing short-term expectations and studio commitments. Dave has been assisting me for more than 25 years and has become a master craftsperson in his own right. He now divides his time between assisting me up to three days a week and working in his own studio.

My daughter Pauline, who's been working in the studio for 14 years, is an administrator and helps my wife Pat manage the business side. Son Joe comes in a few hours a day. At various times, I've had all of my five adult children in the studio assisting me. Regardless of the occasional bumps in the road that come with families working together, I'm blessed and feel privileged to have been able to work with my talented children, now adults.

8:15 A.M.

During our morning meeting, we focus on discussing the internal forms, contrasting colors, and techniques to enhance the glass fruit and nuts. It was in the early 1980s that the cubes and rectangles appeared in my work, and now these forms as components have become interesting options for my sculptural presentations. We discuss the merit of various shapes, and I decide to continue with an orb form for this new series, tentatively titled "Flowers, Fruit, and Nuts." With a wider floral parameter and

new organic information, I'm psyched by the still-unknown possibilities. We talk about adding new floral components and adjusting the colors.

This critique centers on adding a stronger green to the moss and exploring the variety of colors and forms by adding a stylized fruit that mimics a red pomegranate. This lush red fruit will enliven the composition and contrast nicely with the pastel colors in the glass orb. For me, it's all about organic intelligence. We talk about splitting the fruit open and having seeds spill out. Looking back, I was, and still am, a little obsessive in the way that I've spent countless hours meditating over the glass to decide how the illusions can be enhanced.

Our 15-minute meeting is over and I walk back to my bench, pumped up emotionally, with a fresh approach to the new design.

The emotional energy and attention I give today's effort is the same attention I gave my early work. In fact, in 1969, working to encapsulate a single glass flower in a 1¾-inch floral paperweight was more difficult than the 4-inch orb being created today. What my present and past work has in common is the unknown. Starting out, I didn't have experience with the material, so everything was a technical challenge. Today, I'm comfortable with the techniques and materials, but I'm still searching for ways to invent illusions in glass. The same effort that went into learning how to craft a simple glass blossom has evolved over the years into a visual vocabulary by solving one problem after another and learning from endless mistakes.

Somewhere along the journey, probably in the late 1970s, I had an epiphany about my floral designs. I wanted to engage the viewer in a visual dialogue that went beyond the question "Wow, is that really glass?" My artistic goal and greatest challenge is to capture metaphors in glass that celebrate the lifecycle of nature. This artistic need comes from my heart and soul, and has motivated me to educate myself. Visiting museums and reading books considered classics have complemented the work and, more importantly, allowed me to connect the dots in life. In the studio, I strive to bring what I've internalized from independent studies

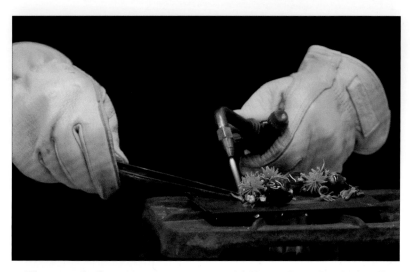

Flameworked components are assembled on a hot plate before being encapsulated in clear glass.

into a glass focus that matches the same depth of feeling articulated by the written word by masters of confessional writing such as Walt Whitman, Jean Jacques Rousseau, and Saint Augustine.

By studying great works from the past, I am inspired by artists, especially those whose work has touched my soul. When I consider the hardships and challenges that many had to overcome during their artistic lives, I derive emotional strength and motivation from their accomplishments.

At the bench, the materials have been prepared for making a design featuring Pineland Pickerel weeds with fruit and nuts; the Pineland Pickerel weed is a yellow, stylized flower that currently holds my interest. Based on the results of my last effort, I decide to add a heavier coating of clear glass over the colored rod. To do this, I hold the colored glass rod in my left hand, parallel to the flame but close enough for the heat to splash the area I need to coat. In my right hand, I melt a clear glass rod in the flame. While the end of the rod is softening and starting to sway, I lay a 2-inch-long strip of clear glass onto the colored rod, repeating the process as I go around the diameter of the yellow glass until it's

completely encased. At this point, when the colored glass is cased in clear crystal, I thoroughly reheat the entire 2-inch section in a hotter flame. The goal is uniformity. Before I pull out the glass rod 12 to 15 inches, the section has to be heated evenly to ensure quality results.

I have internalized the technicalities of this process over 40 years, but there is still a level of risk. The challenge is to uniformly heat the 2-inch section by keeping the piece constantly turning to offset gravity's pull. The redrawn rod, 1/8th-inch in diameter, is needed for pressing petals for the Pineland Pickerel weed. As it heats and rotates, the glass rod softens and begins to flop around. To protect the integrity of the material, I need to be totally focused. At this point in my career, when redrawing a glass rod, pulling it longer and thinner, I'm graceful as I offset the sagging rod with fast and efficient hand skills. When I was first beginning, the glass was stiff and I was clumsy. Only after years of repetition did I acquire control over the process, to the point of appreciating the poetry of glass in motion.

To incorporate flowers, fruit, and nuts (hence the title of this series), Dave and I will spend upward of seven hours completing components. I'm working on pressing rods into petals and building the center florets (the center component of the flowers) with the material I prepped out earlier. I like to make more petals and florets than needed so I can have a selection when assembling the blossoms. Each blossom requires six to eight florets and about 20 petals. When laid out, these components may appear similar, but I see variety and select petals for different sizes, thicknesses, and shades.

Every aspect of the material preparation, from the mundane redrawing of heated rods to balling-up crystal, affects the beauty of the results. I think of my flowers as native and untamed, as opposed to cultivars, which are bred and prized for being pretty. To me, representing nature is to suggest the infinite variations within the plant kingdom.

Once the blossom is made, I carry it to the lower level, called the hot shop, and put it in the blue oven, where it soaks at 970° Fahrenheit. Around 10:30 A.M., with three Pineland Pickerel weeds

soaking in the oven, I start making the glass nuts and fruit. In previously testing the colors, encapsulated in clear glass, I noticed a wonderful effect from the brown and red colors blotching the white opalescent base glass. This turned out to be a delightful surprise. I don't know how long this new direction will keep me high or where it will lead, other than to say the over-ripe edibles are sucking me in.

While I'm working on a variety of fruits and nuts, Dave is working on honeybees, blueberries, and leaves. I've always felt fortunate to have had talented assistants throughout my career who help me push my boundaries with ambitious efforts.

Over the years, my emotional response to sculpting glass plants has evolved into an intuitive process of editing and/or layering on detail. My artistic goal is visual unity and organic credibility. Over the course of the morning, as my energy level grows, I introduce minute changes through experiments in color and the configurations. The success of these modest variations will give me the confidence to make them a more prominent part of the next design.

Molten glass is being dropped into a cast iron plate with a collar. This encapsulates one half of the design in clear glass.

At the beginning of my career, making money was essential to my family's well-being. Because of the high demand for a particular design, I felt I had less latitude and found myself constantly making subtle refinements as one way to dilute the boredom of repetitive work. The need to keep the work fresh began to distinguish my designs from their historical context. When I was introduced to an attitude articulated in Zen philosophy, affirming that the more personal one's work becomes, the more universal its appeal, I reveled in it because it gave me confidence in my obsessive approach to artmaking. Making work personal and continually changing minute aspects of the work kept it interesting and allowed me to grow in the early days.

11:30 A.M.

We break for lunch and, when I get back, I have my half-hour "executive meeting" (my nickname for a nap). I jokingly tell my friends that this is when I make my serious decisions.

1:30 P.M.

I'm back at my bench, sculpting more fruit and nuts for the afternoon's effort. The components are growing in number and soaking at the annealing temperature in the blue oven, waiting to be assembled into a design and finally encapsulated in clear glass over the two or three hours left in the day.

3 P.M.

When all of the components are finished, Joe lights the glory hole; then he and Dave take a break, waiting for it to heat up. I transfer the colored glass components soaking in the blue oven on a stainless steel plate over to a gas/air Bunsen burner to keep the colored glass hot and stable. I keep the temperature above the annealing point and, with tweezers and a hand torch, arrange and melt the components into their final design. I then transfer the design on the plate into what I call the "pick-up" oven in preparation for its encapsulation. This is my favorite part. I love flameworking and work to push my need for spontaneity against

the natural inclination of the process to produce certainty of re-
sults. This is where it all comes together as organic intelligence
and my idea of fecundity comes alive.

While I'm arranging the floral design on the hot plate, Joe
helps Dave take the gobs of clear glass out of the preheating oven
to be melted in the glory hole. When I finish the design to be
encapsulated, I transfer it to the vacuum oven. It's important that
Dave heat the glass gob to a high temperature so it will be soft
enough to encase my colored glass design. This step requires con-
centration; it only takes a second or two for Dave to swing the
molten glass gob away from the glory hole and hand it to me. I
then guide that fluid glass into the cast-iron collar that surrounds
and centers the design. This is a high-risk technique — if it goes
wrong, I lose a day's labor. With the deep concentration that I've
honed as a result of being dyslexic, I've occasionally experienced
this sequence in slow motion, much like a professional baseball
slugger focusing on a 95-mile-an-hour fastball.

Now that half of the floral design has been encased in clear
glass, I go back to the hot plate to retrieve the second half of the

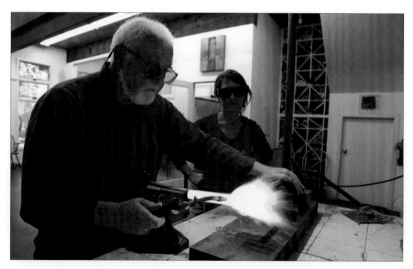

Near the end of the process, flameworking is used to shape and
firepolish the spherical form.

design and repeat the process. When the design has been encased by the second pickup — the dropping of the molten glass into the collar containing the colored glass — we preheat the interface and seal the two halves together. At this point, we use the bench burners and graphite tools to shape the work into a ball (this all can be seen in a YouTube video: *http://www.youtube.com/ watch?v=CvrzUWoEerk*).

4 P.M.

It's now late afternoon, and the orb is glowing with beauty. A celebratory atmosphere is permeating the studio. It's the end of the workday; the anxiety and uncertainty of the morning has transformed into a satisfaction that comes from a sense of accomplishment. I welcome this brief high that I call creative bliss. After the orb is knocked off the puntil into the oven, I walk to the control panel to advance the annealing cycle. The piece in the oven is my best effort; it will be 40 hours before I'll be able to evaluate the magic.

When I develop a new design, there is a higher failure rate of the individual efforts. With each attempt, though, the resulting refinement adds new discoveries that slowly evolve into a resolved effort. Once the orb is cooled and in my hands, I decide whether to finish the piece. If I reject it, I set it aside with other pieces to eventually be reheated to 1,000 degrees Fahrenheit and then dropped into a barrel of water. Through the years of deconstructing work that I've rejected, I have found this process to be the most effective way to crush the various glass forms into fragments that have ended up as fill around my property.

<center>꙳</center>

Over the years, I've enjoyed the flow of my daily routine in the studio. What begins with prayer or meditation at the bench to dilute feelings of nervousness ends in joy and a thank-you prayer for the opportunity to make work that brings joy to people.

<center>⌒</center>

Conducting field studies of local flora has been a very pleas-
ant part of my self-directed learning. In the upper picture, I am
examining the blossom of a wild azalea, later to be modeled
into glass. The lower picture shows me and my good friend Dr.
Michael Diorio photographing water lillies in the pine barrens
of New Jersey.

Reaching Your Full Potential through Self-Directed Learning

Since 1972, my mantra has been "If you want to do excellent work, you have to know what excellence is." Here, I will introduce the reader to my experience and beliefs as to how and why independent studies can enhance the quality and integrity of creative expression.

It's Crucial to be Informed about Your Field

At the height of my involvement as an adjunct faculty member in the glass art program at Salem Community College, I designed an overview of contemporary glass course called "Contemporary Studio Glass Survey." The course was a counterpoint to the Sculptural Flameworking course I taught during alternating semesters. One of the goals was to introduce the students to respected glass art that could guide them closer to their authentic interests in artmaking. Another goal was to introduce the students to, and engage them in, the language of art as it related to glass.

I composed a thoughtful list of 100 glass artists whose work was respected by the Studio Glass community. Even though I personally knew most of the artists who were included, I conducted Internet research to gather images and compile formal biographies. I was amazed that all but three or four of the artists on my list had formal art-school backgrounds, most had BFA degrees, and a surprising number had MFAs. Formal education was never part of my selection criteria, yet there it was — having a formal education seemed necessary to making the list.

Achieving upper echelon status in the Studio Glass canon as a self-taught artist seemed to be a long shot. For me, this was a fascinating discovery, because I didn't go to college and didn't

have an art-school background, but my work had reached this status. Most artists who pride themselves on being self-taught produce naive work that lacks a formal design foundation. The qualities that advance an art tradition have to do with originality and relevance to contemporary society. I'm not saying that formal art education will guarantee your success, but education will challenge you to be bolder in your artmaking efforts and to articulate more compelling ideas in your objects. It's about advancing the historical tradition of art by articulating contemporary issues in original and personal ways.

Being Informed by Following Award-Winning Artists

Listed here are names of non-profit organizations that bestow grants and awards to studio artists/craftspeople. The focus of this survey is glass art; however most of the organizations divide the awards and grants into various disciplines. I encourage my students to be familiar with the names of artists who have received grants along with the organizations awarding them and to follow the careers of these recipients. These awards typically are based on a jurying system composed of curators, educators, and fellow artists, all of whom often work anonymously. Searching the Internet for images and additional information on these artists allows one to be engaged in the ongoing conversation swirling around the craft world.

Keep current with the awards given by:

- The Rakow Collection, Corning Museum of Glass
- American Craft Council, College of Fellows
- Urban Glass
- James Renwick Alliance
- U.S. Artists
- Louis Comfort Tiffany Foundation
- National Endowment for the Arts
- State-level arts councils
- MacArthur Foundation

The Courage to be Creative

Today, there are thousands of enthusiastic people working at the torch doing production glass in small shops. I would venture to say a large percentage of them hope to be known for creative work that would identify them in the glass art community. That was my situation in the late '60s. Starting out I believed making giftware to earn extra money was being an artist. I would come home after eight hours of making scientific glass apparatus, have dinner, and then go into the utility room and work a few hours at the torch. After four years I stopped making small glass animals and focused on paperweights. I gave up earning extra money with the small glass animals and worked nights and weekends on developing floral paperweights for three years before going full time. Setting aside time to experiment in order to develop a marketable item is a tough gig, especially when there's no money coming in to pay for the material.

It was strange in the first year trying to develop ways to flamework paperweights because of my lack of knowledge and failures. Slowly thereafter, the work began to improve technically. The glass efforts were becoming more ambitious with more recognizable designs. With very modest results I was deriving enormous emotional dividends from technical and compositional successes.

Early paperweight designs were essential to my emotional and artistic growth.

After three years of hard work, my pieces started to sell based on my progress. Once I began to experience success with the glass, new possibilities became apparent that suggested further refinements and new designs, most notably the life cycle of the plant. There were — and still are — endless technical problems to be solved which led to new discoveries that directed additional experiments. I started to dream of great work as I focused on native flowers, and my personal take on the plant world was suggesting new and exciting illusions. To realize this dream, I would embark on a life-long journey to educate myself about the things that were meaningful to me.

Strengthening Your Foundation

Artmaking is a journey and, to do important work, you have to bring a heightened sense of purpose into your studio. Creative need is a desire to express the depth of human emotion or feelings through one's work, and that need is a part of our human makeup, to varying degrees, depending on the individual. While it cannot be taught, once you feel it, you can build on it through education.

Intellectual curiosity is another important ingredient that facilitates good work. This advances artwork by adding contemporary information — political, social, and cultural — to the object's visual reality. The more in-depth and complex the object, the more expressive it becomes. The visual information paired with the viewer engenders a conversation. The result is a nuanced intimacy layered onto the material, reflecting personal attitudes in ways that make one's artwork unique.

As I started to earn money from my work in the studio, I felt I needed more financial security. Working as an artist is an emotionally insecure journey, and I constantly worried my income would drop and I'd have to go back to the factory to support my family. In the late 1970s, my wife Pat and I invested in several residential income properties. At that time, we believed real

"Rocky Mountain Bouquet," 2011; H 7¾ ", L 4¼ ", W 3 ". ▶

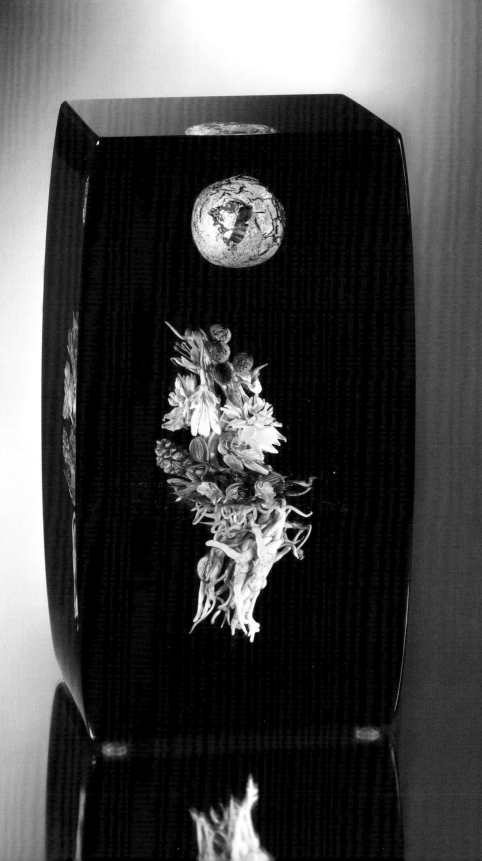

estate would be a good investment and could supplement my income as a glass artist. I had excellent credit, a good reputation, and there was a local bank that supported my mortgage applications.

Five years into this real-estate side-venture, my moment of truth arrived. I was invited to be involved in a major real estate project that required a full-time commitment. After a lot of soul-searching, I decided that I didn't want to dilute my creative energy and spend time on anything other than being an artist in glass. This introspection helped me realize that I genuinely wanted to work in the studio, expressing myself through flameworked glass. Making money in real estate, as important as it was, didn't satisfy my creative need or enhance my sense of self-worth as much as being a studio artist.

When I made the commitment to reach my full potential as an artist in glass, I began to educate myself in earnest by immersing myself in art history and classical literature. I was challenged by the past. I realized that the great works from the past were crafted by people with two hands; like me. If I wanted my work to achieve this level of excellence, I needed to heighten my creative expectations and compete with art history.

Initially, my attention was devoted to the 19th-century French floral paperweight tradition. To continue this tradition, I developed designs based on keen historical observations (the past) combined with discoveries during woodland walks (the present). These woodland walks also brought a personal perspective to my work from the beginning; by focusing on my close environment and interpreting native flowers, I approached paperweights from a very different perspective than 19th-century French makers. During the winter months, when nature was dormant, I researched the esoteric virtues of the plant kingdom by traveling to various museums and libraries, especially the main branch of the Free Library of Philadelphia. On these excursions, I would take notes and make sketches of unusual botanical information.

Learning about the history of flowers offered me a varied introduction to floral symbology, including the virtues of flowering plants used for medicines. I spent many hours studying floral

designs that referenced attitudes from ancient cultures with a special focus on myths and ceremonies. Another goal that evolved during my research was to create floral motifs that celebrate native flowers in ways that communicate environmental themes. The theme that was paramount in my consciousness was that God was evident in natural beauty, so it was essential for us to resist the urge to mindlessly develop and shrink open spaces. And yet another area of interest that challenged me, spiritually, during this period was Native American beliefs that Mother Earth was sacred and should be celebrated.

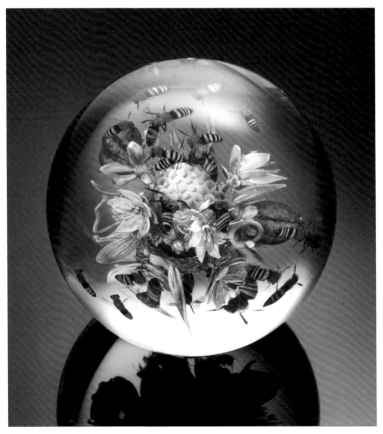

"Honey Bee Swarm with Flowers and Fruit," 2012; D 6".
This piece is in the permanent collection of the Art Institute
of Chicago.

This intellectual exploration allowed me to bring a 20th- and 21st-century perspective to a 19th-century traditional art form and make this art form speak to issues of today. By layering personal attitudes to interpret nature and using metaphors about spirituality, sex, and dying, I've nuanced my work in ways that put me in touch with mystical insights, suggesting that God is evident in nature.

In the mid-1980s, I was anxious to push my work further. When I discovered poetry, especially the words of Walt Whitman, I came to understand poetry as a gift that can elevate human consciousness. In Whitman's work, I felt how he stripped away the superficial and went straight to the essence of the subject matter. I was particularly touched by his poignant comment on mystical power behind the use of human hands to make things: "The narrowest hinge of my hand puts to scorn all machinery."

Learning Made Available through
Technological Advancements

I'm fascinated by the philosophical notion that the magic in artmaking is about infusing the material with emotional and intellectual energy. In my case, this was achieved through audio books. By identifying the timeless thoughts articulated in the literary classics, I have become informed in ways that have enhanced the significance of my work and boosted my self-esteem.

One of the main challenges throughout my career has been dealing with dyslexia. I feel fortunate that technology has now made vast amounts of educational information available in audio format. I encourage independent-study students to connect with their authentic interests through the volumes of books available online or as text. Technology affords artists/craftspeople the ability to tailor individual educational programs specific to their own unique learning interests. This will enhance their creative efforts and nurture artistic maturity. I've always appreciated how technology opened new doors for me and countless others with reading challenges. With the advent of companies like Amazon Kindle's text-to-speech software, *Audible.com*, and *LearningAlly.org*, and books made available through smartphones,

tablets, and laptops, I can barely keep up with the books I continually download.

In the '60s, '70s, and '80s, when I was researching French floral paperweights, floral motifs, symbology, and environmental theology, the travel and time investments to access information were often substantial. Nothing was easy about researching the esoteric field of floral art in the pre-Internet age. In contrast, most of today's artists can access near limitless information on their computers, phones, and tablets in the comfort of their own studios. It's amazing how the Internet connects people with like minds and can make available volumes of information that can be downloaded in seconds. Google and YouTube searches are formidable resources for independent study opportunities.

I was recently introduced to the Google Art Project, which was "created to preserve and promote art images online in collaboration with acclaimed museums and institutions around the world." The Google Art Project connects anyone with an Internet connection to juried images selected by museum curators. *Artsy.net* is another online source that serves as a visual banquet. *Artsy* consists of tens of thousands of art images juried from galleries, museums, private collections, foundations, and artists' estates worldwide, with a particular emphasis on contemporary art. These projects are about informing viewers to quality works. They connect interested people to a visual and creative rhythm of thousands of interesting art images that comprise a loosely juried contemporary art landscape.

Perhaps the most helpful technological advancement in terms of independent studies is currently growing at an extraordinary rate — university courses or lectures available online, often with no charge. E-learning platforms such as *Coursera*, *iTunesU*, *TED.com*, and *Open Culture*, along with many others, share knowledge taught at the world's leading educational institutions available for free to all who are interested. Additionally, companies like Great Courses offer more traditional learning plans, also organized by professors at leading universities, for a fee. Access to information is no longer a problem.

The Internet age does bring a set of new problems, most notably credibility/integrity of information and the potential to become overwhelmed and distracted.

One of the big challenges for a person engaging in online independent studies is being cautious and critical when selecting information. The resources I have identified as reliable sources of information have a transparent and defined process for selecting their content, are sponsored or created by reputable organizations, and cover material in depth.

Another challenge is to develop strategies to engage this near-limitless information without becoming overwhelmed or distracted — to avoid dabbling here and there without going in-depth in any particular area. The first step to effectively engage in independent studies is still the same as it was before all of these technological advancements: You have to identify what you care about and develop ways of learning that will correlate your studies with your artistic goals.

Harnessing the Ego in the Service of Doing Significant Work

Another major ingredient in a successful career is the artist's ego, which plays an important role in one's sense of self-worth. I tell my students it's all about the artwork; it's not a personality contest. Regardless of an artist's promotional efforts, if the work is not collectively respected and discussed independent of marketing, it's unlikely the work will be documented in books, included in museum collections, and/or exhibited in national and international surveys.

Doing what feels emotionally and spiritually right isn't necessarily an easier road; in fact, the creative journey is fraught with endless anxiety. A career as an art maker demands dedication and focus. When discovering creative ways to nuance one's personal vision, the artist often experiences a wide range of emotions, including highs, which, in some cases, lead to intense mystical insights. These insights can translate to fresh thought visualized through art, adding to humankind's body of knowledge.

After I posted this excerpt on Facebook, my friend Randy Strong, a highly respected West Coast glass artist, e-mailed me to say, "Paul, you left out the intense lows." He went on to say, "It's a journey to understand what you truly love and what motivates you and what you find on your path leading to understanding." When reading Randy's e-mail, I thought, "Dear God, I put a happy face on a life journey that was fraught with emotional pain and serious mental health issues, requiring occasional visits to the therapist." Maybe this is nature's way of putting the pain and struggles out of mind in old age and focus on the golden memories.

In reality, the low points, along with the ordinary, dominate most artistic careers. Reading Randy's e-mail was almost embarrassing. How could I neglect this aspect, knowing what I know and having experienced what I experienced? Ego will distort a career if it is focused on the self-image — achieving fame and fortune. If your ego is focused on your reputation, when you hit a low, it is often connected to issues that have little to do with the integrity of the artwork. This includes not being invited to a particular show, included in a museum survey, or documented in a book. The problem with a reputation-focused ego is that it can pollute your personal vision; instead of focusing inward on the commitment to advancing the quality and integrity of your work, you focus outward on pleasing other people's tastes.

It's important to fortify the inward development of your ego to believe in your creative vision. This will lead you along the path toward self-realization through the work — as an artist. The benefit of quality-focused ego is that, when you are at a low point, you can defend yourself from the creative community's slings and arrows. The way I was able to redirect my ego to focus on my creative goals was to be inspired by past masters who overcame monumental lows in their lives as artists. I was inspired by the journeys of Walt Whitman, James Joyce, and Morris Graves, along with many others.

When you read or listen to thought-provoking books about the challenges that other artists had to face to reach excellence, you become inspired to match their heroic efforts. When I think about the suffering caused by poverty and other hardships that

In the spring of 2006 I spoke at the Smithsonian's Renwick Gallery about how the poetry of Walt Whitman has influenced my art.

In the spring of 2007, after receiving an honorary doctorate degree from Muskingum College, I delivered the commencement address to the Masters of Arts in Education graduates.

past artists endured, I am motivated to work harder, knowing that my walk is, in many ways, a lot more comfortable.

Informed reading will complement your hours of labor, and make your experiments and failures more bearable. Reading about the struggles of past artists has given me courage to demand more from myself, because it has helped me realize that my challenges are no more burdensome than what others have faced across the ages. Developing this kind of empathy can free you from the extra burden of negative self-judgment and comparison with others, and perhaps also free you from any jealousy you might feel toward peers who seem to be more successful. Experiencing the truth that we are all human beings on the same journey is a powerful insight that can increase your ability to admire the efforts of others. Ultimately it's taking pride in your persistence and struggles to advance your own art work.

Expressing Your Ideas in Public

Art enthusiasts enjoy hearing artists talk about the ideas and motives behind their creative processes. As my artwork attracted notoriety and my audience grew, I was increasingly asked to share my glass with art and nature organizations. I realized that, as a respected artist, I was asked to speak in public about my work like any other successful professional in my community. I learned to talk about my work in the context of contemporary glass art and how I've translated native floral designs into flameworked glass. As with other challenges in my creative career, I educated myself though audio books which complemented my communicative skills and gave me the insight to place my work in an artistic historical continuum.

As artists, we might easily experience in our mind's eye just what we think and feel about our artistic ideas, but putting all of that into words, so others can appreciate our visions, can be much more challenging. It takes practice. It's important to be able to communicate your ideas effectively, and to do this requires intimate knowledge of your subject matter.

∾

These are some of the books that have touched my soul and inspired my creative vision.

A Reading List

As an artist, it is important to read books that will complement your vision and allow you to be more knowledgeable in the areas about which you have strong curiosity. Your childhood likes are excellent markers along your journey that will lead to your authentic interests. An artist's level of emotional and intellectual maturity will show in his or her work. Everyone's list will be different, but, by reading books that complement your personal interests, you'll continue to be challenged by more potent ideas. I believe that, if only one idea from a book sparks off the page into your consciousness and broadens your perspective, that book has been a gift. When I write about artistic maturity, I'm thinking of building on the past in ways that advance the continuum of your category within the history of art.

The 10 books recommended here represent some of the literature that has nurtured my intellectual growth as a maker. This list is a mix of philosophical attitudes about artmaking, the technical challenges involved in artmaking, and the depth of human emotion expressed and celebrated by the written word. Many of these books were recommended to me over the course of 40 years or were discovered through my own curiosity. Each engenders important ideas that I have internalized in ways that have helped me grow as a person.

Art & Fear: Observations on the Perils (and Rewards) of Artmaking by David Bayles and Ted Orland

Art & Fear is a straightforward, easy read geared toward artists at the beginning of their journeys. *Art & Fear* is rewarding

because it touches on the many unique variables that studio artists deal with daily. Most creative people live in the first-person singular and feel overwhelmed by their struggles at times. *Art & Fear* connects its readers to a variety of problem-solving scenarios and advice about the joys and perils of artmaking. As someone who spent much of my adult life in the studio, it is reassuring to know that others share my fears. The authors also offer practical advice for coping with these struggles and maintaining personal goals and self-worth.

Zen and the Art of Motorcycle Maintenance: An Inquiry into Values by Robert M. Pirsig

When I heard that *Zen and the Art of Motorcycle Maintenance* was required reading for all students graduating from Cranbrook Art Academy, an institution for which I have great respect, I immediately sought the book out. To my delight, it was available on audio CD. After listening to this book, I felt exposed to the most sincere philosophical discussion of quality ever articulated. As an object-maker, my awareness was heightened to the nuances and the mystical potential in my work.

Although I felt a personal connection to the narrator and absorbed many meaningful concepts, it's difficult to explain other than to say, as a maker, I could feel and relate to the depth of emotion and dedication to quality it offers. Just as I read or listen to a poem more than once, I listened to the book twice and the soliloquy on quality more than twice.

The Nature and Art of Workmanship by David Pye

In the late 1970s, I met Mark Peiser at the Heller Gallery in New York City. He mentioned having read David Pye's *The Nature and Art of Workmanship* and recommended it to me. I had a tremendous respect for Peiser and his work, and purchased this book the following week.

Pye was a woodworker, and reading his book was exciting because he expanded my understanding of the nuances of quality

craftsmanship. I intuitively understood his ideas, which, until then, had been completely outside my frame of reference. One of the strong points in the book for me was the division in expectations between the craftsmanship of certainty and the craftsmanship of spontaneity. Pye invited me into the esoteric world of his craftsman's philosophy. As a person who also works with his hands, I related to his ideas put into words. From my experience as a maker, I could identify with his philosophy and felt I had been given a special gift to express my abstract feelings as a maker with words.

Makers: A History of American Studio Craft by Janet Koplos and Bruce Metcalf

I recently finished listening to/reading *Makers: A History of American Studio Craft* and felt fortunate it was available to download to my Kindle. Thank you, Amazon.

This book was a long read and well worth the two-month journey into the craft highlands along the originality trail. *Makers* represents a herculean effort in identifying the flow of significant objects that celebrate a thriving social and creative culture across the 20th century.

Makers has a material focus — fiber, clay, glass, wood, and metal — from craft's roots in 19th-century reform movements to the rich diversity of expression at the end of the 20th century. This craft history book is designed to be a college text and provides a scholarly overview of the craft/art scene that may promote the merits of craft on the American artistic landscape. I believe the book is valuable because it shows how studio craft fits into art history as whole and, as a maker, it's important to know the diversity of personal visions executed with the highest standards being presented on a par with other fine art surveys.

The Story of Art by E. H. Gombrich

Through my decades-long involvement with the Wheaton Arts Creative Glass Center of America, I have befriended several

hundred glass artists who were selected for its Artists in Residence Fellowship Program. These friendships have remained a treasured part of my career. One of the 1984 fellows was an artist named James Van Deurzen, whom I met when he was fresh out of art school with an MFA. In one of our many conversations about contemporary glass art in the context of art history, he recommended the writings of art historian E. H. Gombrich.

There are times when the material I'm reading goes over my head and I have to read (or listen) a second time. *The Story of Art* was an example of this. As I persisted, and sensed the value of the information, I worked past the frustration and questions about whether parts of it were important. As I continued reading (listening), I felt fortunate to have been exposed to this wonderfully well-written arts survey. Trust me when I say it's worth the effort and time needed to understand Gombrich's overview of art history.

Gombrich's scholarship led me to a broader understanding by reading his other books, including *The Sense of Order: A Study in the Psychology of Decorative Art*. *The Story of Art* gave me a sense of pride in knowing that, as a maker, I was continuing a great tradition that contributed to the well-being of society, whether my work is applauded or not.

❧

The Autobiography of Benvenuto Cellini by Benvenuto Cellini

Shortly after I quit my job as a scientific glassblower to be on the creative side full-time, I read an article about a local sculptor, Dave Caccia, who worked in metal. I was eager to meet other artists and went to visit Dave at his studio. This visit was the beginning of a lifelong friendship. During one of our conversations about art, he suggested that I read *The Autobiography of Benvenuto Cellini*. I took his recommendation seriously because I was hungry to learn anything I could about art.

Benvenuto Cellini's autobiography is an informative window into the lives of artists who lived in Renaissance Italy in the 1500s. His autobiography has given scholars a sense of the culture during that period. I found it interesting that, despite his personality

flaws and with all of his political intrigues, the greatness of his sculpture protected him. As long as he was making his artwork, nobility and others in power put up with his ugly behavior. Few pieces of Cellini's work have survived into the present, and many historians believe that his most significant contribution to art history has been his autobiography, detailing the extraordinary time period in which he lived.

Cellini's life was entwined in the rich history of Renaissance Italy because of his work. I relate to his career from an object-maker's perspective and am inspired when thinking of the power that the creative process has to influence society.

Walt Whitman: A Life by Justin Kaplan

In the mid-1980s, I felt that I had hit an invisible wall with my glass and began looking for other avenues to express myself. I had always loved poetry, and began writing poems to celebrate the plant kingdom. On Saturday mornings, I would often go to

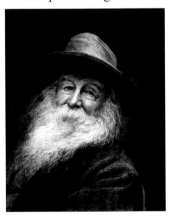

the Reading Terminal Market in Philadelphia to buy produce and browse around the kiosks. During one of these outings, I purchased a copy of Justin Kaplan's *Walt Whitman: A Life* from a used-book store. Reading Kaplan's book expanded my interest in Whitman and his poetic accomplishments. I was fascinated to learn that Whitman was considered America's greatest literary genius by most literary scholars. Whitman's courage as a creative person and his belief in this poetic worth is inspiring, especially when understanding his struggle to protect the integrity of his poetic vision by refusing to dilute his poems to be more acceptable to the fashion of the day. His stories inspire and strengthen my resolve to protect the integrity of my own work.

Steve Jobs by Walter Isaacson

After reading Steve Jobs's biography, I was excited to real-
ize how beneficial this book would be for my students. Isaacson,
in a straightforward way, illustrates Jobs's commitment to qual-
ity, innovation, and creative problem-solving. There's also a spiri-
tual dimension to his approach to life. I believe Jobs's strongly
felt attitudes are relevant to studio artists. He balanced a creative
vision with good design while protecting the integrity of his prod-
ucts with indifference about the demands of the marketplace —
demands that he reinvented. He invested his emotional energy
into creativity and educated the public to have higher expecta-
tions for what technology could deliver. After a lifelong commit-
ment to quality in my work, it was sweet to read how Jobs worked
his commitment to excellence and originality and to realize how
it changed the world.

<p style="text-align:center">❧</p>

Sister Wendy's 1000 Masterpieces by Sister Wendy Beckett
 with Patricia Wright

When I go to a bookstore, I always visit the art section. In the
year 2000, I noticed **Sister Wendy's 1000 Masterpieces** on the shelf
and was struck by the boldness of its survey — 1,000 master-
pieces compiled by one person was quite an ambitious effort. I
had recently seen an exhibit of Anselm Kiefer's work at the Phila-
delphia Museum of Art, and used him to check the depth and
power of Sister Wendy's survey. I opened the book, found him in
the table of contents, and flipped to her coverage of his work.

The merit of the book is in Sister Wendy's description of
particular paintings and artists. In just a few short paragraphs —
with great word choices — she is able to convey the intensity,
drama, and technical execution of her selections. For example,
she describes how Kiefer used color, material choice, and com-
position to communicate a theme: critiquing the Nazi regime's
destruction of art they considered "degenerate." Over the past 13
years, I have used the book to visually reconnect with great work
and feel enriched by Sister Wendy's explanations.

༄

A Whole New Mind: Why Right-Brainers Will Rule the Future
by Daniel H. Pink

In a conversation with my younger brother, Robert, about the success of Apple computers, he suggested that Steve Jobs represents a new paradigm for our country's future and recommended I read Daniel Pink's book. The book deals with right-brain/left-brain aptitudes and how our educational system is going to have to reinvent itself to nurture right-brain thinkers.

My heart fluttered when I read Daniel Pink's prediction that corporations will put more value on MFA degrees than MBAs. As I listened to the book on my iPhone, I found myself saying "Yes!" out loud more times than I can count. What made the book so personal was that I am predominantly a right-brain thinker. I built a career with aptitudes that the educational system didn't understand and couldn't recognize. With my uncomfortable memories of being a poor student, I totally agreed with Pink's observation that traditional education is designed for left-brain, logical, sequential learning.

My experience has been echoed in conversations I've had with many other artists. If Pink's predictions are right, which I believe they are, creative people with strong design backgrounds will have greater opportunities to have an impact on society. Pink predicts a new right-brain paradigm for the future, one that celebrates good design, the creative spirit, innovation, and thinking outside the box. What makes Pink's book so emotionally attractive is its subtheme of hope — hope for the future, and respect and trust for creative people, especially the ones who did poorly in schools.

Artist Appreciations

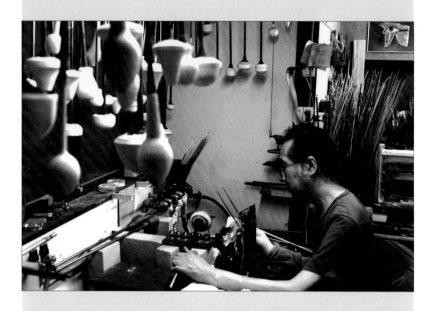

Top: Iwao Matsushima in his studio.
Bottom: "Rainbow-Colored Vessel," 2011; H 50 mm, W 162 mm.

Iwao Matsushima:
Dialogue with the Ancients

At the time of this writing, two Japanese museums, the Miho Museum and the Okayama Museum, were hosting a traveling exhibition entitled *Ancient Glass: Feast of Color*, showcasing ancient glass dating back to 2,000 B.C. The show was groundbreaking in that the pieces were arranged by color, rather than the usual region or period. Focusing on color brings the exhibit closer to the societies of ancient Egypt, Mesopotamia, and Greece, where one of the main purposes of glass was to mimic precious stones like lapis lazuli, jade, and ruby.

One of the exhibit's other goals was to invite interested museums and archeologists to study specimens to advance contemporary understanding of ancient glassmaking. It seems unlikely that Iwao Matsushima,[1] when he began experimenting part-time with core-forming in the mid-1970s, would have imagined he would play an integral role — and produce the center piece — of this major artistic and historic show. It makes good sense, however, that the museums commissioned Matsushima to replicate a spiral lace bowl created in the eastern Mediterranean region in the 2nd century B.C. that is a prized example of ancient glass in the British Museum's collection.

Matsushima's approach to replicating the spiral lace bowl exemplifies his dedication to understanding ancient core-formed vessels and the patience that has guided him through the many challenges and failures associated with discovering, reinventing, and surpassing past masterpieces.

Matsushima started this project by studying photographs and reading archeological comments on the bowl. After his initial experiments failed, Matsushima traveled to the British Museum

to hold and study the bowl up close. It was this careful inspection that caused him to conclude that his suspicions were right and the archeological descriptions, identifying the bowl as having been created by a flat disc slumped in a mold, were wrong. His intimate knowledge of core-forming confirmed that a piece with such complexity in its execution and uniformity in its pattern could not have been slumped.

When he held the ancient bowl, Matsushima also could feel the mastery of its maker and marveled at its near-flawless execution. He describes the experience in spiritual terms, stating, "The existence of such masterpieces of ancient glass provides vital learning experiences for me and, as evidence of what human hands have created, is a huge source of encouragement to me in my creative work." His emotional response to the spiral lace bowl highlights the universality of a maker's experiences when connecting to the essence of work well-made. This spiritual connection unites all contemporary masters with the past in a way that advances tradition. It also identifies the commonality of commitment and attitudes needed to reach the master level as an artist/craftsperson.

"Spiral Lace Bowl," 2013; H 65 mm, W 113 mm. This bowl
is a reproduction of an original in the British Museum.

Ultimately, Matsushima's replicated bowl is an exquisite work that demonstrates his mastery of the lost-glass process of core-forming and evidences a lifelong commitment to understanding and pursuing excellence while reconstructing and discovering ancient glass process secrets.

<div align="center">࿔</div>

Matsushima graduated from Okayama University in 1970. While there, he studied graphic art and design and experimented with many materials, except glass, which was not offered. In 1971, he began working at an architectural design firm. Two years later, Matsushima accepted a job at the Kurashiki Ivy Square Hotel in Okayama, Japan, that would allow him to be a maker, as well as connect him with an expanded community of artists. His job in the cultural section of the hotel incorporated organizing exhibitions and workshops in the hotel, including teaching ceramic classes, and overseeing the high-end gift shop, which sold fine Japanese crafts. He worked at Ivy Square for eight years, and his responsibilities there would prove essential to his journey as a maker.[2]

Beyond ceramics, Matsushima led workshops in textiles and iron crafting.[3] Working hands-on with a variety of materials day-in and day-out gave Matsushima confidence as a craftsperson, so, when he saw a piece of ancient Egyptian core-formed glass in the hotel's Ohara Museum Annex, he thought it looked "simple enough" and that he could easily figure out how to make it. The reality — to Matsushima's surprise — was that reproducing this seemingly simple vessel required a major commitment to researching ancient glass, inventing techniques, and developing tools.

In the mid-1970s, Matsushima found little to no information about how ancient core-formed glass was made. Early in his experiments with glass, he spent hours looking at a catalog with over 300 pages of glass artifacts from ancient times. This catalog, titled *Pre-Roman and Early Roman Glass in the Corning Museum of Glass,* was his only resource and became his dream book. The beauty and timeless quality of the objects documented in the catalog inspired him to persevere through the many failures he

encountered as he struggled to discover and develop techniques for core-forming.[4] He describes the process of "discovering . . . methods and devising [his] own tools" as a "fresh and exhilarating experience." Compared to his background of working with other materials, Matsushima at first found core-forming to be "restrictive and inefficient," but as he "cleared one technical hurdle after another . . . , [he] became aware of the tremendous potential for expression in core-formed glass."

A significant early hurdle was learning how to make a core that would accommodate the contraction of the glass during the annealing process. The challenge was to come up with a material that would give so the glass would not crack. Matsushima's major breakthrough was building the form out of steel wool (on a short puntil) and then coating it with clay. He then would bake the core to provide a firm, stable surface on which to wrap the glass.

Matsushima also set aside a modest workspace to use for experimenting when he got home from work at the hotel. He didn't have elaborate tools; most of them were homemade or found in a local hardware store. To this day, his studio is very simple. Matsushima still uses a handmade kiln that can only anneal one piece at a time, and he relies on domestic propane gas. Starting out, he used the Japanese Satake glass, a soft glass with a low melting temperature that he still uses today. As a result, he did not need a gas/oxygen mix, or the high-temperature bench burners designed to melt glasses with higher melting points.

At the beginning of his experimentation, Matsushima was fortunate that the core-forming process was suited to his modest space. He devised low-tech tools, purchased a basic gas/air burner, and used available glass manufactured in Japan. That core-forming was such an economical process would eventually allow Matsushima to leave his job at the hotel and pursue a creative career without the stress of making a significant investment in space and equipment.

In buying fine Japanese craft for the gift shop and organizing exhibitions for the museum, Matsushima befriended important curators, collectors, and artists around Japan. As they learned about

"Five Palm Flasks," 2008; H 150-180 mm, W 40-50 mm.

Matsushima's dedication to resuscitating core-formed glass, they became a valuable resource. One of his friends, Takashi Taniichi, an archeologist who specializes in ancient glass, became curator of the Okayama Orient Museum. Taniichi provided Matsushima with the museum's ancient glass publications and resources, which deepened his interests even more. Matsushima also befriended a collector of ancient glass, who gave him access to his collection of ancient beads and mosaics. This opportunity to handle and examine authentic pieces strengthened his resolve to replicate the techniques.

Matsushima was presented with a career-altering opportunity in 1981 when the National Museum of Modern Art in Kyoto, Japan,[5] invited him to show his experimental core-formed glass in an exhibit on *Contemporary Glass: Australia, Canada, U.S. & Japan*. For Matsushima, this was an "inspiring experience." It was important because it gave him his first exposure to contemporary glass art, as well as his first opportunity to interact with established Studio Glass artists. Becoming aware of an international community of full-time glass artists "renewed [his] resolution . . . to revive the core technique in . . . modern times as one of

the techniques to be creative in glass" and led him to believe that he could distinguish himself with this forgotten technique. Ultimately, with a newly gained confidence in his vision and courage to be creative, Matsushima left his stable job in 1982 to pursue his new career as an artist in glass.

Leaving his position at the hotel at age 36 with a family of four to pursue a career in glass was a leap of faith. Matsushima and his wife, Michiyo, faced many unanswered questions; mainly, he didn't know whether there was a market for his newly resuscitated technique. When he first started on his full-time journey to master core-forming, the experience was all trial and error, with many failures. Because Matsushima may have been the first artist to attempt reinventing this ancient process,[6] there were no teachers or workshops from which he could seek out information, and he "struggled with simple problems that could have been solved

"Mosaic-Bottom Lace Bowl," 2000; H 75 mm, W 142 mm.

easily if [he] had someone to teach [him]." On the other hand, Matsushima credits not having formal guidance with "deepen[ing] his spirit of inquiry" because "when you are self-taught, even a tiny discovery brings so much joy."

For almost two decades, while continuing to research and experiment with core-forming, Matsushima invested a lot of time into crafting flameworked beads that Michiyo would arrange into necklaces. These bead necklaces allowed Matsushima to support his family while continuing to produce serious core-formed efforts. Although the beads were produced in quantity for economic support, Matsushima's skill and interest in Japanese culture are evident — the bead necklaces were a contemporary reference to adornments on Buddhist statues that were considered family heirlooms.

In 1984, Matsushima's leap of faith was rewarded when the Keio department store gallery[7] invited him to exhibit his work in what would become an annual solo show. Matsushima core-formed glass and bead work introduced an ancient glass making process to a growing number of Japanese art and craft collectors, and over time the exhibit attracted increasing numbers of admirers who looked forward to this cultural event. This commitment was an important part of Matsushima's development and financial stability. As his audience became more familiar with his work, they developed stronger and stronger interest in his more ambitious core-formed pieces. This allowed Matsushima to grow artistically and move beyond replication to make his work personal.

A turning point in Matsushima's artistic growth occurred when he accepted an invitation to do a demonstration at the Nijiima International Glass Art Festival in 1993. The festival featured contemporary glass artists from around the world, primarily glassblowers. Matsushima was inspired by how these artists were pushing the creative limits of their process. To compete with these ambitious artists, Matsushima lined up all 14 of his burners and, with an assistant and two hand torchers, produced a 45-centimeter-long core-formed cone. This was Matsushima's first attempt to go beyond the usual core-forming scale and produce

a non-referential, contemporary design. The effort led to the "Cone" series, which are considered his master works by the glass community.

While Matsushima is dedicated to replicating and advancing the core-forming process, his results are not mere imitations. His personality and Japanese cultural identity advance this tradition in a very personal way. He describes his dialog with ancient glass as involving a series of decisions. Each decision presents him with a technical, creative, or aesthetic choice and, to make each choice, he channels the "sensibility and appreciation of beauty that had been nurtured in [him] in the Japanese cultural setting." In this way, he connects a technique invented and refined thousands of years ago in Mesopotamia and Egypt with contemporary Japan.

Matsushima's objects also celebrate the Japanese craft tradition, although glassworking is not a part of Japan's historical craft culture.[8] He does this by drawing inspiration from respected traditional masterworks. His father, Ayao Matsushima, collected Japanese antiques, especially *makie* lacquerware and *shippoyaki* enamelware. Living with and experiencing these revered examples allowed Matsushima to internalize the subtle nuances of these art forms. Matsushima also draws inspiration from the color-rich and somewhat abstract illustrations in the *Heike Nokyo* scrolls, which were completed in A.D. 1164 and depict the Lotus Sutras.[9] In the scrolls, he finds a source of "endless beauty where [he] see[s] something new every time [he] look[s] at them." It is this quality he hopes to bring to his vessels — "depth that cannot be captured in one glance."

Another major influence was getting to know one of the Living National Treasures of Japan: Fukumi Shimura. Shimura is a textile artist, who dyes silk with organic natural dyes and weaves them into kimonos. Matsushima is inspired by Shimura's ability to find new expression within traditional techniques as the basis for her creative success.

"Spun Cone," 2011; H 300 mm, W 90 mm. ▶

Ultimately, Matsushima's glass represents a confluence of the qualities that unite these diverse craft traditions in a way that Yoko Azuma, curator of the Miho Museum, describes as "open[ing] up a completely new realm ... with the aesthetic of Japanese Arts." It is interesting to note that Azuma considers Matsushima to be the "heir" to the artistry and beauty found in these culturally significant craft traditions, because he was inspired by ancient works that have no connection to Japan and uses a medium not traditionally associated with Japan. It is the quality of his work — their subtle use of color, as well as gold and silver leaf — and his artistic approach — uncompromising commitment to mastery — that allow him to stand at the forefront of Japanese tradition.

Matsushima's inspiration goes beyond Japanese craft culture. He is a student of Western fine art and philosophy, particularly the paintings of Odilon Redon and German-Swiss painter Paul Klee, and the writings of Walter Benjamin. Redon's work is both mystical and colorful, with many references to spiritual icons. The most noticeable influence of Redon's work on Matsushima is the concentration of colors in his dramatic floral designs. Matsushima's core-formed vessels also evoke Klee's mastery of line, pattern, and color. The works of both Redon and Klee represent an ethereal celebration of color that attracted Matsushima's attention and challenged him to be more expressive in his use of color.

All of his influences — Japanese craft and traditional art, Western art, and philosophy — strengthen Matsushima's artistic platform, resulting in contemporary works of art in glass that transcend their ancient process. As opportunities to exhibit his work and demonstrate his intriguing technique arose, he continued to seek out significant examples of ancient glass in his never-ending quest to learn. In 2004, while exhibiting his work in northern New Jersey, Matsushima made arrangements with Dr. Christopher Lightfoot, associate curator in the Department of Greek and Roman Art at the Metropolitan Museum of Art in New York City, to experience a private tour of their collection, including access to

their artifacts in storage. Then, in 2005, when he was the featured artist at Salem Community College's International Flameworking Conference, Matsushima visited the University of Pennsylvania's Museum of Anthropology and Archaeology to observe a piece of Iranian mosaic glass from the 8th century B.C.[10]

After almost 40 years of seeking knowledge and mastering ancient techniques, Matsushima still considers ancient glass to be "a treasure trove of diverse techniques that are full of mysteries." Matsushima credits his need to unravel the mysteries of early glass with allowing him to "maintain his energy to keep on creating."

Master object-makers aspire to reaching a level of excellence that transcends culture, time, and material, and makes questions of process irrelevant. In his latest creative victory, successfully replicating the spiral lace bowl, Matsushima shows that he has achieved this goal. By focusing his career on patiently advancing the best of the past, Iwao Matsushima has created a piece that, along with the rest of his diverse and distinct body of work, radiates universal beauty that seems suspended in time.

Notes

[1] I first became aware of Matsushima through *Vetro* magazine's cover story on his work, "The Color of the Rising Sun" by Ruriko Tsuchida, curator of the Suntory Museum of Art.

I was taken by the beauty of the work and fascinated with the idea that an artist had rediscovered and mastered the core-forming technique in a way that built on ancient traditions. A few years later, in 2004, I received a catalog from Sami Harawi, director of Mostly Glass Gallery in Englewood, New Jersey, which featured the full range of Matsushima's artwork. I remember thinking that this was a wonderful new development for flameworked glass and then being amazed to learn scholars believe core-forming to be the root of flameworked glass. I finally had a chance to meet Matsushima when he was invited to be the featured artist of Salem Community College's International Flameworking Conference in 2005.

[2] During the interview, Matsushima talked about interacting with collectors, and having the opportunity to be close to excellent work in the Ohara Museum Annex. This access allowed Matsushima to inspect work up close and develop an understanding for the nuances of the work over the duration of

the exhibitions. In my case, to experience significant work within my interests, I had to drive 270 miles to the Corning Museum and was limited to short visits. Whatever access you have to serious work, actually seeing and studying it is essential to developing expertise in your field.

[3] While interviewing Matsushima, it was fun to learn that he was a paperweight maker before he discovered core-forming glass. His iron workshops focused on melting metal and casting paperweights.

[4] Three books inspired me within a short time early in my goal to leave scientific glassblowing to be on the creative side. The first was a book that my wife purchased for me as a gift — John Burton's *Glass: Philosophy and Method.* Next, I acquired Jean Sutherland Melvin's *American Glass Paperweights and Their Makers.* Finally, I was enthralled by Paul Hollister, Jr.'s, *Encyclopedia of Glass Paperweights.* I thought of these books as my dream books and nearly had the images memorized. It's fascinating to think how makers fixate on a book or books in their areas of interest at the beginning of their career and how the images remind you that there is more work to do — that achieving your artistic goal is not an easy task.

[5] Matsushima currently has three pieces in the National Museum of Modern Art Tokyo's collection.

[6] On the American glass landscape, Kisao Iburi was long considered the preeminent core-forming artist, as well as the pioneer of the process. He gained notoriety in the United States with the exposure he received by teaching at the Pilchuck School of Glass and having his work shown at the Heller Gallery in the early 1990s. Because I thought Iburi was the only maker using core-forming, I was fascinated and surprised to discover Matsushima's work on the cover of *Vetro* magazine in 2001. As a maker, I love following the evolution of techniques and how one artist can influence others, so, when I began this chapter on Matsushima, I was curious to learn about his relationship with Iburi and who influenced who in terms of process. Matsushima told me he showed an early prototype to Iburi in 1975 and shared his process, including his innovative clay-slip application — brushing the clay onto a steel-wool ball, with Tsuneo Yoshimizu, founder of the Tokyo Glass Art Institute (where Iburi was a faculty member) in 1983. This gave me respect for Matsushima's modesty and lifelong success with technical innovative efforts. I'm sure that, in the early stages of his career, he was disappointed not to be documented as the pioneer. Now, his extraordinary work and depth of knowledge about ancient glass demonstrates the magnitude of his talent and innovativeness. Matsushima has a deep respect for the scholarly focus on ancient core-formed glass and is especially appreciative of the interest and encouragement from Yoriko Mizuta, assistant director of the Hokkaido

Museum of Modern Art. When Matsushima credited a museum curator, Yoriko Mizuta, I thought of Dwight P. Lanmon, director of Corning Museum of Glass, whose scholarly writings on antique French paperweights and interest in my work was a source of inspiration to me.

[7] Unlike American department stores, Japanese department stores have featured art galleries for more than 100 years. These department store galleries are serious, and play an important role in introducing and promoting significant artwork by both Japanese and international artists. Many famous artists have solo shows in these galleries.

[8] Unfortunately, because glass was not used historically by Japanese makers and has no standing in ancient Japanese roots, Matsushima is not eligible to be honored as a Living National Treasure.

[9] *Encyclopedia, http://www.britannica.com/EBchecked/topic/259614/Heike-nokyo.*

[10] When Matsushima realized Salem Community College was in close proximity to the University of Pennsylvania Museum of Anthropology and Archaeology, he made arrangements to meet with the curator and view specific examples from their collection. I drove Matsushima and Michiyo to the museum, located less than twenty miles from my home, to examine their collection of core-formed ancient glass. I marveled at the sincerity and attentiveness of Matsushima and Michiyo while examining the fragment. They introduced me to a world of glass of which I had been totally oblivious throughout my career.

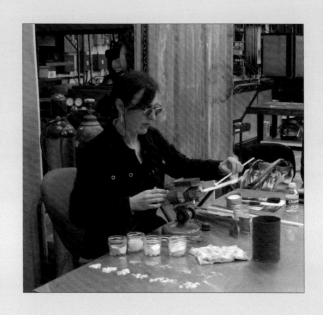

Top: Kari Russell-Pool in her studio.

Bottom: "With All My Love" — Gardener's Valentine Series, 2006; H 18", W 18".

Kari Russell-Pool:
Beauty's Place in Contemporary Art

Kari Russell-Pool's glass journey has connected her childhood memories, concerns about the world her children will inherit, a fascination with beauty, and an intellectual passion for objects that people imbue with sentimentality. Russell-Pool[1] balances a successful career as one of the pioneering artists taking advantage of flameworked glass with the roles of mother and wife. She blends these various roles in the studio by nurturing a feminine aesthetic that filters beauty through contemporary issues and historical keepsakes.

Since they met at the Cleveland Institute of Art (CIA) late in the 1980s, Russell-Pool's husband, Marc Petrovic, has assisted as her gaffer, collaborator, critic, and inspiration in addition to maintaining his own career as an independent artist. Their lifestyle and work arrangement has helped both Petrovic and Russell-Pool be better makers without diluting their individual aesthetic identities and artistic visions.

Russell-Pool's flameworked glass is a vehicle for her natural motifs. She often references everyday functional objects, such as teapots and vases, as well as crafted mementos celebrating love and longing, like narrative quilts and sailor's valentines. Russell-Pool infuses artifacts of our material culture with her interests in William Morris's decorative patterns, Impressionist paintings, and a fine arts background that elevates her work far above the sentimental roots of the objects' original intent. In her peaceful studio setting[2] (with the exception of when the ventilation system is running full strength during those cold New England winters), she finds comfort in the repetitiveness of flameworking the finely detailed components that make up her ambitious and wide-ranging

body of work. Through her glass, she has developed a recogniz-
able aesthetic that seduces the viewer with beauty, then gives way
to a conversation that can be both historical and contemporary,
personal and social.

§

Russell-Pool's artistic journey in glass began at CIA. As in
most other art programs around the country, CIA instructors placed
less importance on technique than on being inventive. In her sec-
ond year, Russell-Pool took a glassblowing class with Brent
Kee Young.[3] She fondly remembers Young's "go-to phrase;"
When students asked him how to do something, he would say,
"I don't know; you tell me." This attitude is not in any way
designed to discourage; in fact, it is designed to encourage
students to solve their own technical problems and discover
nuances of the process that will lead to more innovative and
personal work.

One of the primary ingredients of artmaking is being curi-
ous. To highlight the importance of this style of art education,
Russell-Pool contrasts Young's teaching technique with today's
world of YouTube tutorials and highly specialized workshops fo-
cused on technique. While being shown step-by-step is the easi-
est way to learn, it often handicaps creative adventurousness and
stymies inventiveness.

As a student, Russell-Pool experimented with casting mul-
tiple components into larger forms. Because she was undertaking
these experiments in the CIA glass department's cooperative en-
vironment, she benefited from the ideas and feedback of her fel-
low students, especially the upperclassmen. It was in this spirit of
sharing that Brent Marshal, a graduate and night school teacher,
pointed Russell-Pool to Ginny Ruffner's work and the possibility
that lampworked glass could be a solution to her technical prob-
lems. The feedback Russell-Pool received from the collaborative
community at CIA highlights the benefit of connecting with a
community of creative people. Whether the group works exclu-
sively in glass or with a variety of materials, being able to bounce
ideas off other makers complements artistic growth.

Left: "Peach Trophy," 2003; H 15.25", L 17.5", W 9.5".
Right: "A Touch of Zest," 2003; H 17", W 9".

After a little research, Russell-Pool applied for and was accepted into a class being taught by Ruffner at the Pilchuck School of Glass in the summer of 1989. She learned the basics of flameworking — melting both ends for a good seal, turning the glass evenly to ball it up, and preheating the area you are working on to avoid cracking — but what she "loved most about [Ginny] was her spirit." Like Young, Ruffner encouraged students to design whatever they can imagine and then figure out how to build it. Russell-Pool instantly connected to the flameworking process and the creative opportunities it offered. She felt an intuitive connection to flameworking small components that could be fused together for larger-scale works. Russell-Pool also felt that flameworking gave her more creative freedom because she could "come back to a flameworked project, unlike the finality [she had] experienced with hot-working."

Under Ruffner's guidance, Russell-Pool strengthened her commitment to the flameworking process as a vehicle for expression. At Pilchuck, she completed an 8-inch by 12-inch 3D bed with a mattress in clear borosilicate glass, comprising rows of vegetables and roots that referenced bed springs.[4]

While Russell-Pool was enamored of the aesthetics of her small, flameworked sculpture, she was unable to achieve the scale she wanted for the cast-glass process, but found her newly acquired skills translated quite easily to CIA's hot-glass facilities.

At that time, her blowing partner in the hot shop was Petrovic. CIA had a gas/oxygen hand torch in its hot shop, used for fire-polishing pontil marks. Because of her experience at Pilchuck, Russell-Pool instinctively understood the creative possibilities of using the gas/oxygen torch in combination with blowing and casting. This cross-over technique was under-explored in the Studio Glass Movement at the time, so it was unusual for Russell-Pool and Petrovic to set up a torch on the bench to add more detail and visual information to the work.

While artists like Mark Peiser, Bill Bernstein, and Flora Mace and partner Joey Kirkpatrick were known for cane drawing onto a gather of hot glass still on the blowpipe, Russell-Pool's approach was different. She experimented with a gas/oxygen torch to attach furnace-pulled canes to the body of hot-worked pieces. After a piece was annealed, she used these extensions as connection points to attach flamework components to the cold piece at the bench, and re-annealed the final, more ambitious, sculptural effort when finished.

Russell-Pool's discoveries with the torch continued as she began to color her furnace-pulled canes with glass powders and encase them in clear glass to make "full-colored works" and achieve a unique look "as far as flameworking was concerned."

In this super-charged creative environment, Russell-Pool and Petrovic found ways to be inventive by taking advantage of each other's skills. Russell-Pool brought something contemporary to an ancient process. Little did they know that the techniques they explored at CIA would predict their future and allow them to contribute to the glass landscape in a highly innovative way.

In her final year at CIA, Russell-Pool and Petrovic went against the collective wisdom of the glass department's faculty and solicited known galleries in the glass world to represent her artwork. She had become a student of the Studio Glass world and

noticed many art school graduates making production pieces for craft fairs at the expense of one-of-a-kind pieces. Although these glass artists were prospering, she "was afraid that if I took that route, I would be trapped into making enough money to pay the bills so I could make the work for the fairs, and it would be a hard habit to break." By focusing energy on creating one-of-a-kind pieces to sell in galleries, she was less susceptible to the economic demands that drive the craft fairs. Ultimately, by choosing the gallery path, Russell-Pool gained confidence and established herself as a studio artist driven by innovation.

An objective overview of the glass landscape makes it clear that the community has a tendency to be tribal. This is because most of the conversations among makers relate to the technical challenges and techniques associated with a particular process, whether it be blowing, casting, fusing, flameworking, or enameling. There is, however, a handful of highly accomplished artists who see glass as a vehicle for artistic expression and don't have any tribal affiliations. This attitude is more prevalent among artists with formal art training, where values articulating contemporary ideas over technical prowess are promoted.

Russell-Pool is such an artist. She views glass as a material, with her main concern being "how glass works," not the restrictions of any one process. This attitude results in an approach that takes Russell-Pool from the bench, to the glory hole, to fusing, to being assisted by Petrovic at the furnace and then back to the bench. And Russell-Pool uses clear glass from the furnace, instead of borosilicate, as typically used by flameworkers.[5] Working with borosilicate gave her the opportunity to invent a new language to express her interests in glass.

Much of Russell-Pool's work is influenced by memories and experiences that are rooted in her youth. The "Tea Pot" series represents how she can combine a number of her core interests into a unified creative vision. These referential tea pots celebrate beauty through pattern, line, flora and fauna, and respect for finely crafted objects. As a child, Russell-Pool loved her grandmother's tea cup collection. As her artistic interest matured,

she recognized that her grandmother's delicate treasures were attractive because they combined beauty with timeless design. She built on these aesthetic virtues in high school by setting up still-lifes composed of metal bowls, fruit, and striped cloths, drawing them over and over again in different compositions. Finally, Russell-Pool connected with 19th century designer William Morris's floral tapestries and wallpapers. All of these elements come together in her tea pots (and much of her other work), which are delicate, with an emphasis on nature's strong lines and colorful patterns.

Russell-Pool's work also blends historical and contemporary social commentary with her interest in folk art. Her "Safety Mom" series draws inspiration from narrative quilts and today's divisive political climate. These works are fascinating because they use flameworked glass to mimic two-dimensional quilted patterns. The result of this exploration offers the viewer a deceptively attractive view of challenging social issues. Russell-Pool does this through symbols — some traditional, like keys, flowers and fruit, and the alphabet, and some new, like a handgun, which brings an unnerving reality to an otherwise idyllic message. Russell-Pool also explores the sentimentality and meticulous, repetitive craftsmanship of sailor's valentines in her series "Gardener's Valentines." She updates and transforms this tradition into contemporary art designed to be mounted on the wall. With the flameworking process and selection of colors, Russell-Pool explores the idea of objects becoming heirlooms. Through this series, she asks the question, "[W]hat makes an object dear; dear enough that it transcends the original owners, and acquires its own magic?"

Artists reinterpret what they experience and feel through material. In Russell-Pool's case, that material is glass. Her approach to flameworking may seem unorthodox — what she calls the "cowboy way"[6] — but, through her commitment to excellence, she has invented techniques that place her in the upper echelon of craftspeople. An astute viewer of Russell-Pool's work could create a seemingly disparate list of influences, such

"Tonic" — Tonic-Aromatic Series, 2008; H 24", W 14". ▶

"Dahlias – Red Mix" — Ivory Tacoma Series, 2012; H 17", W 11".

as rococo-style art and design; impressionist painting; William Morris; and the virtues of the Crafts movement, American folk art, and decorative collectibles. However, these items are filtered through Russell-Pool's mature artistic point of view and result in a signature body of work and an instantly recognizable personal aesthetic. Even more impressively, her work engages in and contributes to conversations about beauty's place in contemporary art.[7]

Kari Russell-Pool's career as an artist demonstrates courage and discipline. She is dedicated to reaching her full potential as a maker and has educated herself by experimenting and collaborating in the studio; seeking out work that inspires and challenges her; and reflecting on her life as an artist, woman, mother, and wife. This brings an honesty and depth of feeling to her work that denies fashion and trends and makes it significant and timeless.

Notes

[1] Unless otherwise noted, information in this chapter is derived from interviews with Kari Russell-Pool conducted through e-mail and telephone, Russell-Pool's website (*www.karirussell-pool.com*), and Russell-Pool's lectures and demonstrations delivered at Salem Community College's 2003 and 2010 International Flameworking Conferences.

[2] The studio is made comfortable by the heat radiating from Petrovic's glassblowing facility.

[3] Ironically, while Brent Kee Young is highly respected for his large-scale, flameworked "Matrix" series, Russell-Pool did not learn flameworking from Young. She was enamored of his "Fossil" series, which incorporated flameworked components, but she did not see Young flamework during her five years at CIA. It's interesting that many art teachers prefer to separate their personal techniques from the skills they teach.

[4] I first saw Russell-Pool's work at the Heller Gallery in 1994. Heller presented an exhibit in January called *Contemporary Glass Invitational* that invited submissions from emerging artists and new work from established artists. During this time period, I was actively collecting contemporary glass and enjoyed following Heller's exhibits. It was at Heller that I saw, and purchased, Russell-Pool's blown beehive with flameworked bees fused and affixed to the hive. It was an innovative celebration of honey bees. Once I lived with Russell-Pool's work, it was exciting to follow her career through gallery announcements, especially because the major galleries were showing very little contemporary flameworked glass.

[5] University of Connecticut, University Library, "Kari Russell-Pool & Marc Petrovic," *About the Libraries* (last updated February 28, 2013). "In an unusual approach to flame working, Kari melts and pulls all her glass rods from the same glass furnace that Marc uses to sculpt his components. This allows for compatibility between the blown glass birds and the flame-worked structures. Flame workers seldom use soft glass in large-scale work."

[6] Jerry Silverman, "Meet the Maestro: Kari Russell-Pool," *Glass Alliance New Mexico* (November 15, 2012), *http://glassnm.org/2012/11/meet-the-maestro-kari-russell-pool-saturday-december-1st-from-10am-12pm/*.

[7] Shannon Sharpe, "Marc Petrovic & Kari Russell-Pool," *American Craft Council* (May 15, 2008), *http://www.craftcouncil.org/magazine/article/marc-petrovic-kari-russell-pool*, quoting Russell-Pool as saying "I have a beauty aesthetic; there's enough ugliness in the world."

❧

Top: Lucio Bubacco at work.
Bottom: "Nymph, Eros, and Satyr," 2000; H 19", W 4".

Lucio Bubacco: Humanity in Glass

Lucio Bubacco[1] has distinguished himself on the international glass landscape with an endless variety of flameworked glass figures. His most ambitious scenes are skillfully miniaturized Judeo-Christian iconography portrayed as theater celebrating human drama. However, Bubacco's figures cover a range of human experiences and suggest the full spectrum of human emotion, particularly lust and desire. Bubacco's interpretation of dreams and fantasies beyond the routine of daily living would make an interesting discussion between Carl Jung and Sigmund Freud over a glass of good cognac. Bubacco's glass celebrates both the angelic and demonic; carnivals and festivals; fantasy and sexuality; and mythology.

Bubacco's emotionally charged idiosyncratic work is unparalleled in the history of glass. A distant second to Bubacco's body of work would be the masterworks from the 18th-century Nevers figurines of France. Although not a touchstone for glass artists working today, these figures are mainly religious icons presented in a serious manner to celebrate a virtuous lifestyle. They are also fully garmented in robes and togas. Bubacco's figures, on the other hand, are nude, with the exception of the costumed "Carnival" series, to bring the viewer's attention to the softness and subtlety of the human body. Bubacco's forms are also kinetic – they gesture and stretch and twist in celebratory motion. Ultimately, while the Nevers figurines live on as historical curiosities, Bubacco's work celebrates the timeless sensuality and lyricism of humanity. This chapter chronicles Bubacco's journey, from a young boy watching craftsmen work in Murano's glass factories out of his classroom window to his current place as one of the world's most-recognized glass artists.

"Vergine" — Zodiac Series, 2010; H 22", L 9", W 24".

Bubacco's father, Severino Bubacco, was a master glassmaker who established a business in Murano, Italy, in the 1950s. Severino was distinct among Murano's glassmakers. At a time when few people left the island of Murano, Severino traveled the world, demonstrating glassmaking and selling his own creations as well as other Venetian glass. In 1958, Severino was selected to represent Italy in the Universal and International Brussels Exposition, the first major World's Fair after World War II, which attracted more than 42 million visitors. Later, he often worked in the Philadelphia area and eventually established a small shop on the Atlantic City boardwalk in the 1960s–1970s.[2]

Severino was known and respected for inventing the technique of making leaves appear as if they were wet with dew. The technique is known as "rugiada," which means dew, and is still popular today. Severino was nicknamed "Rugiada" because of this innovation, and some of the old Murano masters affectionately call Bubacco the same name out of respect for his father.[3]

Because Severino had established businesses outside of Murano, Bubacco had to find his own way in glass. When he approached employment age, he knew he would work in glass, but he had choices. The traditional path was production furnace work. The furnace industry was thriving on the island. The shops were small factories with a hierarchal tradition. At the top you

had the master, and below him a team of workers, each specializing in a different phase of the production process. Bubacco was not at all attracted to this approach to glassmaking, which he described as "a chain of production workers with up to 40 people working . . . [in] insane heat, sweat, dirty shirts [doing the] same [task] day after day: the master with his assistants in an unaltered hierarchy." Bubacco found an alternative in studying flameworking, which provided "a more intimate environment, like a painter in his studio [that was] more humble" and better suited his personality. As time went on, Bubacco realized he could explore and express his talent far sooner in the flameworking community than he could have if he pursued furnace work because, in the furnace setting, workers at the bottom had to wait for the "hierarchy to exhaust itself" before they had opportunities for creative freedom.

At age 14, Bubacco could have continued in school, pursued fulltime work at the furnace or a lampworking studio, or attended drawing school. Bubacco opted to do lampwork full-time, assisting a Murano master, Maestro Buccella. This job entailed mixing colors and heating up glass for the master eight hours per day. Though this might sound mundane, Bubacco saw immense value in the experience: he was able to "learn how to handle the force of gravity . . . and observe the master [as he] tamed glass."[4] By 16, Bubacco was working on his own, making small glass objects popular among the tourists. When Bubacco's father came home from working abroad to find his son supporting himself with lampworking, he was impressed and began to bring Bubacco along on his glass engagements. While working in Paris with his father, Bubacco took live-model drawing classes. This started Bubacco's lifelong passion for using the human form to express his emotions. When he returned to Italy, Bubacco continued his drawing studies with artist Alessandro Rossi.

In his late teens, three components — his formal training in drawing, interest in the human form, and his lampworking proficiency — gave Bubacco passion to pursue special work. His idea was to make human forms that closely resembled his initial sketches. More and more, Bubacco took time away from making

work for the tourist trade to "satisfy [his] ideas," abandoning profitable work to explore a personal vision as an act of creative determination. Bubacco was criticized on the island for his, at the time, unusual work, but it was these personal efforts that began to attract the attention of early collectors. Over time, Bubacco stayed committed to lampworked human forms, and his reputation grew.

During the 1980s, Bubacco became familiar with the American Studio Glass Movement through magazines and meeting American artists who were visiting Murano. This information and experience introduced Bubacco to the numerous artists doing innovative work independent of the marketplace and tradition. Because of his desire to pursue personal work, he started to identify with the movement and think beyond the Murano glass tradition. This led him to apply for a six-month fellowship at the Creative Glass Center of America (CGCA) at Wheaton Arts in Millville, New Jersey. He was accepted into the program in the fall of 1993, which ultimately became a major turning point in his career.

Bubacco arrived in Millville as someone who was primarily experienced with lampworking techniques, but, on his first day, he began to collaborate with the other fellows, Kelly McClain, Leslie O'Brien, and Benjamin Edols. When Bubacco teamed up with this group, which included blowers and casters, he immediately recognized the artistic possibilities. His willingness to be exposed to new ideas and techniques, as well as the benefit of being out of his comfort zone, strengthened his courage to take higher artistic risks. The result was applying his signature human forms to goblets, vases, and castings. These new possibilities introduced him to the benefit of working with other professionals whose passion, technical skills, and experiences challenged him to explore more ambitious work.

After leaving CGCA, Bubacco had confidence in his new body of work and first-hand experience with the spirit of the American Studio Glass Movement. His intense six-month fellowship expanded his approach to glass art making and enhanced his comfort level in pursuing his most ambitious work in collaborative situations.[5]

"Musici e Lirici," 2009; H 18", L 6", W 10".

The CGCA experience set the stage for the next phase of Bubacco's career, starting with an invitation from Ferdinand Hampson, director of Habatat Gallery, one of the glass world's most prestigious galleries. This would be Bubacco's first major exhibition in the United States. The show included 23 examples of Bubacco's new, more ambitious work, and the attention garnered by the exhibition launched his career. Bubacco's glass art attracted widespread interest throughout the contemporary glass world and over the years, His art work has become increasingly sought after.

While Bubacco was establishing his identity as an innovative flameworker within the spirit of the Studio Glass Movement, the island of Murano carried on her centuries old glass tradition focused on furnace glassblowing. In the late '90s, Bubacco moved from a small studio to his present, more attractive and spacious Murano studio, which is designed to accommodate displays of his ever-growing body of work. He can also host up to eight eager students for his occasional workshops. In addition, he continued to experiment with and combine lampworking with other processes such as casting, using wax and plaster (similar to working in bronze), and fusing. However, in Murano, Bubacco was still just one of a few lampworkers. He found this lack of interest in lampworking "distressful." There were many good lampworkers who "remained on the sidelines" because the work is on a small scale, "even if the richness of the idea blended harmoniously with the technique and the work is magnificent."

His career, propelled by gallery exhibitions, museum survey shows, and coverage in contemporary glass magazines, led to teaching and artist-in-residence invitations in glass centers around the world. Teaching and traveling to places such as Japan, Australia, Turkey, and the United States have become an important part of Bubacco's professional life. He is a gifted teacher and enjoys the professional interaction with his students. He is comfortable working with people with different cultural and personal backgrounds, and finds common ground through glass to communicate with his students.

"Dante's Boat," 2013; H 15", L 6", W 17".

Bubacco's traveling engagement has strengthened his commitment to his personal vision. He understands the benefits of observing and being challenged by other artists' approach to glassmaking. This is one of the ways he has integrated the Venetian glass tradition with all he has learned around the world.

Aesthetically, Bubacco's foundation is the Murano tradition, where goblets and chalices have been crafted for centuries. The chalices are true to scale and blown with traditional furnace-working techniques, yet they are not the focal point of the work, but serve as armatures for Bubacco's fantastical human forms. Bubacco also benefits from Murano in that he is able to walk to the glass factories, such as Effetre Murano, to select colored glass rods with a coefficient of expansion of 104.[6] He also has relationships with master blowers, engravers, and painters and is able to bring their unique skill sets to decorating his chalices.

While Bubacco is able to use Murano's masters to create his underlying armatures, he reserves the idea of the work – the story told by his figures – for himself. The story starts on paper. Bubacco's proficiency for drawing adds clarity to the construction of his groupings. He is sympathetic to the Renaissance masters and strives to bring the fluidity and beauty of two-dimensional art

into his three-dimensional glass installations. At the most basic level, Bubacco's figures are adornments for the chalices. Because of his imagination and artistic freedom, however, the human forms overwhelm the chalices, creating entire imaginary worlds that communicate myth, sexuality, lust, festiveness, spirituality, and other aspects of the human experience. Bubacco has explored endless variations on the basic human form, all the while protecting the emotional integrity of each figure. While an individual work may be composed of hundreds of figures and celebrate ambitious human themes, every detail of each individual form is intact. This is evidence of his level of mastery and commitment to excellence.

More recently, Bubacco has been working on large-scale commissions, which are site-specific installations, chandeliers, and groupings of his chalice-based work. His international stature was elevated when his most ambitious efforts were displayed in 2008 at the Sculptural Object Functional Art (SOFA) fair in Chicago, the world's premier decorative/fine art venue. The Litvak Gallery of Israel sponsored an unprecedented display and built an environment that housed the full range of Bubacco's output, including the multi-piece installation, *Eternal Temptation*, which included a monumental chalice grouping depicting the battle between good and evil, with life-sized human silhouettes composed of lampworked rods and *paté de verre* masks, and chandeliers housing colorful figures. The Litvak display was the perfect theater for Bubacco's visual drama. Though the pieces are motionless, they are not static. His figures are kinetic and interact with one another in a way that creates dynamic scenes that can be viewed on an individual scale or absorbed as a whole.

Though Bubacco's work celebrates the cacophony of humanity, his success is based on giving glass the "study time and complete dedication" it requires. Bubacco tells his students that lampworking is among the most complicated techniques for making the transition from craftsperson to artist. He believes it is crucial to master the techniques required to materialize your thoughts. As is evidenced by his revolutionary body of work, Bubacco has

gone beyond the imaginable to expand the boundaries of what is possible with lampworked glass.

Notes

[1] Information in this chapter was derived from a decades-long friendship with Lucio, co-teaching experiences at Penland School of Craft and the Corning Museum of Glass, formal interviews conducted via e-mail, Lucio's website (*www.luciobubbaco.com*), and the Litvak Gallery's website (*www.litvak.com*) for detailed information and images on "Eternal Temptation."

[2] While teaching with Bubacco at the Corning Glass Studio in January of 2012, my old friend Jim Friant and I recalled a trip we made in the late '60s to the Wanamaker's department store in Philadelphia to watch Severino demonstrate his process. During his demo, I was fascinated by how he combined flameworking techniques with gathering hot glass from a small crucible. The conversation was documented in a blog post at the Corning Museum of Glass's webpage (*http://www.cmog.org/blog/2012/05/*).

[3] To me, this says a lot about the Murano tradition, made up of families who have worked in glass for generations, and whose family legacies are passed down through the oral history of the island.

[4] When Bubacco and I teach at Corning, I'm always amazed at how he uses gravity to shape his figures. He melts glass rods into a ball with a hot, oxygen-rich flame. Then, as he pulls the ball, he allows gravity to control the direction and shape of the body parts. At the end of the process, the result is a poetic human form with soft, flowing gestures. It's interesting for me to believe his first year as an apprentice made him aware of gravity's influence on glass, allowed him to take advantage of it, and, over the years, to create immediately identifiable work.

[5] In 2004, I proposed to the Penland School that Bubacco and I co-teach a class that combined flameworking and casting hot-glass panels. The goal was to take advantage of the two processes in ways that would demonstrate the decorative and architectural possibilities of glass. The theme of the workshop was Dante Alighieri's *Divine Comedy*, interpreted into three panels. To my amusement, most of the artists developed imagery for the Inferno.

[6] Coefficient of expansion measures the compatibility of glasses. Makers are careful to work with glasses that are compatible. What makes Bubacco's situation special is that he can interact with glass technologists at the factory to ensure that all of his glass is compatible and to place special orders for colors he seeks.

Amber Cowen and "Spike," 2011-2013; H 11", L 6', W 4".

Amber Cowan:
Flamework Recontextualized

Amber Cowan[1] represents an ambitious, non-traditional approach to flameworking. In using cullet[2] and recycled industrial glass, she is doing something innovative materially and, at the same time, making a social statement. By flameworking small components to be used in large-scale installations, she is pushing both the scale and process limits. Cowan's work is about an idea, not about the marketplace or mastering skills on a vocational level. That said, her process is labor-intensive and she has become an expert at expressing ideas within her body of work. At 30,[3] Cowan's glass experiences have allowed her to build a strong platform on which she is launching her career as a sculptor. Perhaps Cowan's future was predicted when she was 5 and wrote this sentence on a folder full of drawings: "I want to be an artist." Being creative was a strong part of Cowan's adolescent years. She was given permission to spend after-school hours in the art department, where she was excited by opportunities to throw clay pots and to cut and lead colored glass into panels.

In 2000, when touring colleges with her family, Cowan noticed a glass studio in Salisbury University's art building and, as a result, decided to pursue her education there. Although Salisbury did not offer flameworking classes, Cowan bought a torch and set it up in a grinding room next to the ceramics studio. After being shown how to make a bead, she began experimenting and spent a large portion of her college time dedicated to learning about hot glass.

Cowan's commitment to pursuing life as an artist soon outgrew Salisbury University's program. In her sophomore year, she applied for transfer to Temple University's Tyler School of Art,

but was not accepted. However, this did not deter her and, in her junior year, she was accepted to Tyler's Study Abroad Program in Rome.

When she returned to Salisbury from Rome, Cowan worked hard in a newly established major – a BFA in 3D Design – with a glass focus, and was the first woman to graduate from Salisbury with that degree. Her senior show took advantage of both blown and flameworked glass. This is impressive because the facilities at Salisbury were very modest; in spite of that, Cowan stayed dedicated to her creative vision. Immediately after graduating, she rented a U-Haul truck and moved her life to Brooklyn to make glass and live as an artist.

Cowan heard about a small glass studio in the Williamsburg section of Brooklyn, where the owner needed help. The studio turned out to be One Sixty Glass, and the owner was artist/designer Michiko Sakano. Sakano produced light fixtures and architectural decorations for restaurants and other businesses. Cowan started by charging the furnace and cleaning the studio in exchange for blowing time. This soon evolved into working as Sakano's assistant, teaching workshops, and giving private glass-blowing lessons at the studio.

Shortly after becoming established with One Sixty Glass, Cowan connected with the artistic community at Urban Glass. Relying on the flameworking experience she had gained at Salisbury, Cowan began teaching flameworking classes and acting as a teaching assistant for respected artists such as Eric Goldschmidt, Steve Sizelove, Karen Willenbrink-Johnsen, Jasen Johnsen, and Paul Stankard when they taught at Urban Glass.

It is interesting that, at One Sixty, Cowan was in front of a furnace teaching glassblowing and working as a glassblower's assistant, while at Urban Glass, she was at a torch teaching introductory flameworking and assisting master flameworkers. This is indicative of today's young glass artists, who are versed, and feel competent in, a variety of approaches because they were trained to be expressive in glass, not necessarily to master a particular process.

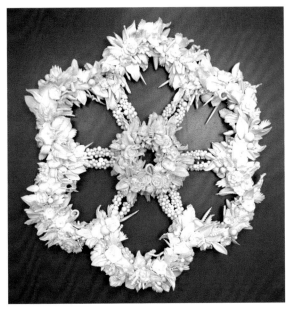

"Rosette in Milk and Ivory," 2013; H 34", L 4.5", W 32".

After five years in Brooklyn, Cowan realized that the energy and resources required just to stay ahead of the cost of living were stifling her creative output. Although she had established herself as an integral part of the glass community, she knew this was a make-it-or-break-it moment. She needed to be in an environment where she could focus on her sculpture and be more isolated, to spend less about worrying about how to support herself. Ultimately, Cowan chose the path she believed would lead to greater creative freedom: applying to MFA programs.

In 2009, Cowan was accepted to Tyler's MFA in Glass program– one of only two students accepted that year – and her pent-up creative energy was set free. She was directed to new ideas and challenges, guided by a group of seasoned artists/faculty members. A new list of superstar sculptors – women like Eva Hesse, Petah Coyne, Tara Donovan, and Lynda Benglis – dominated her conversations. She loved the weekly interactions with her professors and thrived in the competitive spirit celebrated by the students.

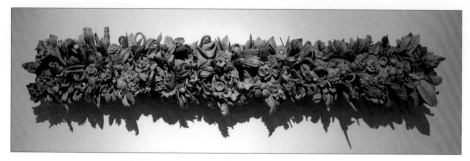

"Chocolate," 2013; H 11", L 8", W 57".

Cowan spent her first year at Tyler primarily on building on the work she had done at Salisbury – combining flameworked forms and blown vessels – aided by the stronger skills and artistic wherewithal she gained in Brooklyn. After discovering a barrel of opaque white cullet that been donated to the program years earlier, she focused her attention on flameworking. This discovery gave her a large amount of material for experimentation. She heated and redrew the cullet into rods, which became small components. She then combined the components to make large, armature-mounted installations.

To secure the components, Cowan hot-sealed one end of an inch-long piece of Nichrome wire into the base of the flameworked pieces. This was a labor-intensive process; a single installation contains hundreds of these small components. Beyond that, the single, large installations that Cowan began experimenting with contained multiple islands of what appeared to be organic matter and could span the length of a wall.

The individual components are not technically complex, and the idea that small components could be mounted on an armature is not revolutionary. Cowan's work from this period is significant because of its conceptual nature, scale, blend of beauty and tension, and ambiguous meaning. This ambiguity challenges viewers to bring their own ideas and experiences to the work to connect with it. Cowan's art, which offers viewers a rare experience that transcends the material and process, has evolved with experimentation.

Tyler's glass program brings students from different media, visiting artists, and faculty together to critique each other's work. This fine-art critique model emphasizes the idea of moving away from visual evidence of a material's tradition. Cowan gained further artistic authority by taking sculpture courses and having her glass pieces critiqued in an environment that was oblivious to material and technical concerns.

As a result of her strong background in art history and theory, Cowan's installations contain a depth of visual information that reinforces her artistic vocabulary. This is seen in her color harmony, texture, and non-referential patterns. Additionally, her commitment to flameworking glass creates a sense of anxiety, caused by the viewers' associations with her sharp glass points, which communicates a sense of drama. Since graduating from Tyler in 2011, Cowan has been running full throttle –exhibiting, teaching, participating in prestigious residencies and fellowships – all while making significant advancements to her body of work.

She has taught and continues to teach glass art courses at Salem Community College, Tyler, and Urban Glass. In addition to teaching, Cowan assists national and international masters at workshops around the country. In 2012, she assisted Lucio Bubacco and Paul Stankard at Corning and was scheduled to assist Andre Gutgesell at Penland School of Craft. Teaching and assisting allows Cowan to earn money to support her own sculpture while staying connected with the glass community.

Recently, Cowan was juried into a prestigious residency at the Toledo Museum of Art's Glass Pavilion[4] to honor Harvey Littleton's seminal glass workshops of March and June of 1962.

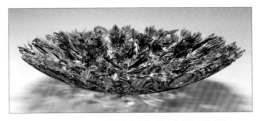

"Bottle Bowl," 2012; D 15", H 2".

The residency sought to pay homage to the past by recreating a furnace used during the 1962 workshops and melting the original Johns-Manville formulated glass marbles to create contemporary work. Cowan used this opportunity to "reconstruct and reform glass from the Libbey Company," which was founded by Edward Drummond Libbey who later went on to establish the Toledo Museum of Art.

Cowan's Toledo experience marks a shift in her approach. Now, in addition to using found cullet, she has developed a keen interest in early American industrial glass. She seeks out products, such as tableware and decorative vessels, often at thrift shops, and reworks them into contemporary sculptural pieces that reference the identity and characteristics of the manufacturer. She also researches the history of the factories. Cowan translates her material and historical knowledge into work that engages viewers both visually and intellectually.[5]

This approach led to amazing results in Cowan's 2012 Procter Fellowship[6] at the Australian National University[7] (ANU), where she created a series out of recycled green wine bottles. She had to overcome two major obstacles to succeed at ANU. First, ANU had no flameworking facilities or equipment, so she borrowed a torch from a local public-access studio to set up a work space. Second, Australia didn't have a pressed glass industry for Cowan to appropriate for her sculptures. Intent on using local materials, she resorted to collecting green-glass wine bottles from the local college campus and area restaurants. By overcoming these obstacles, Cowan positioned herself to make major artistic progress in her process. ANU's glass program emphasizes slumping and fusing, and Cowan took advantage of the "many fascinating fusing and slumping molds accessible around the studio." Amber Cowan's interest in and use of recycled and production glass has uniquely positioned her work. It advances the American Studio Glass Movement and American production glass, two streams generally thought to be incompatible. Using glassware that has fallen out of use and can now be found in second hand shops, her art makes a social statement about consumption.

Notes

[1] Information in this chapter was derived from a personal friendship with Cowan, formal interviews conducted via e-mail and telephone, and Cowan's website (*http://ambercowan.com*).

[2] Cullet is broken or crushed recycled glass added to a new batch to complement the melt. Cowan makes significant glass art for $1 per pound. She makes rods by melting and redrawing cullet, and periodically drives 300 miles to a West Virginia business that sells cullet to the glass industry by the ton, picking out a few hundred pounds to take back to her Philadelphia studio. The batches usually consist of varied shards of different pastel-colored glasses.

[3] I first met Cowan at Urban Glass in Brooklyn, New York, a nationally respected, Brooklyn-based public-access facility, in the spring of 2007. I was invited to teach a weekend flameworking class and Brian Kibler, the director of education, enthusiastically recommended Cowan as my teaching assistant. When I showed up early to meet Brian and prepare for the class, he walked me over to the furnace area where Cowan was finishing an ambitious, multi-colored blown-glass vessel. As we watched and waited for her to knock the vase off the pipe into the oven, I was impressed when Brian told me Cowan teaches introductory flameworking courses for Urban. When I saw her glass artwork and how she integrated flameworked components into her blown forms, I felt fortunate to be the beneficiary of her youthful, high-energy talent.

[4] This 50th anniversary celebration of the Littleton workshop was co-sponsored by the Robert M. Minkoff Foundation.

[5] For example, Cowan describes her "Avon Goes South" series as follows: Flameworked and hot-sculpted reconstructed Avon glass. This red glassware from the 1876 Cape Cod Collection was made by Wheaton Glass Company exclusively for Avon beginning in 1976. The pattern was inspired by an old Boston & Sandwich Glass pattern called Roman Rosette. The entire line was named the Cape Cod Collection since that is where the original Sandwich Glass was produced and refers also to the 1876 Philadelphia Centennial.

[6] The Procter Fellowship is a prestigious fellowship given out once per year and rotated yearly between bringing an international artist to Australia and sending an Australian artist overseas. The fellowship involves a six-week residency.

[7] ANU's glass program, founded by studio-glass legend Klaus Moje, is considered the top school for glass in Australia.

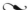

Top: Matt Eskuche at the torch blowing glass.
Bottom: "Bulgaria," 2012; D 38", H 19", W 35".

Matt Eskuche:
The Ordinary as Extraordinary

Matt Eskuche[1] is an innovator whose relatively new body of work, "White Trash," has gained attention not only within the glass community, but on the larger sculptural landscape. His glass groupings have edgy, provocative social themes, made explicit by titles such as "Tastes Like Applebees," "Dude, Mom's Going to be Pissed," and, of course, "White Trash." These works evidence a high level of skill, dedication, energy, and creative independence.

Eskuche focuses his energy on developing big ideas, instead of producing individual objects that would appeal to the market-place. His creative courage has been rewarded by numerous invitations to travel and demonstrate his process at glass centers throughout North America, Eastern Europe, and Asia. These experiences have given Eskuche the time, resources, and formal feedback that both challenge and strengthen his ideas. This intellectual engagement with the creative glass community pushes his flameworking process into more ambitious and experimental arenas.

Growing up, Eskuche was surrounded by his father's car-racing activities in a garage full of tools and equipment. His father was educated as an engineer and was a self-taught mechanic who created small metal sculptures that Eskuche enjoyed helping him build. As a child, Eskuche played with these tools to build gadgets out of whatever interesting materials he could find.

This childhood exposure to working with tools and creating things became part of his identity. When he was a high school student in Milwaukee, Eskuche found some metalsmithing equipment in the storage area of the art room. Intrigued, he took the initiative to seek permission to do an independent study. His request was granted,

and he spent his junior and senior years working to create metal jewelry. Eskuche connected with the process of exploration, discovery, and experimentation to make tangible objects, giving him the motivation and confidence to pursue a career in metalworking.

Near the end of his senior year, Eskuche began researching craft centers around the country to continue his studies in jewelry. He settled on the Worcester Center for Crafts in Massachusetts. At 19, he drove a U-Haul from Wisconsin to Massachusetts to begin his journey as a maker. He enrolled in Worcester's associate's program in nonferrous metals. He completed that program and then worked with metal for the next five years, fabricating production jewelry for other jewelers.

In 1998, after nine years in metalworking, Eskuche discovered the flameworking process and was excited to try his hand at melting glass at a torch. Like thousands of other young people, Eskuche was introduced to flameworking borosilicate glass through "garage-style pipe making" and was excited by "the organic nature of the material and its plastic working properties." For the first year, Eskuche experimented with limited knowledge of the flameworking process to make small pipes and vases. He enjoyed working with glass and realized that the creative potential of glass as a material went far beyond what he saw happening in the garages where glass pipes were being made.

At Worcester, Eskuche was exposed to the idea that materials have a rich history and that craftspeople both look to the past and survey the present to learn from and be challenged by what already has been done. It doesn't matter how a maker gains this perspective; once the maker understands how great work builds on the past, it changes her or his approach to learning. Ultimately, Eskuche's artistic maturity led him to pursue in-depth workshops with masters of the broader flameworking tradition, as opposed to the more focused decorative techniques of the glass pipemakers.

As an interesting side note, Eskuche intuitively connected to the idea of working with glass through the flameworking process and did not pursue other approaches such as blowing, kiln-casting, or fusing. He found the scale and intimacy of the flameworking

process to be similar to that of nonferrous metalsmithing. Like metalsmithing, melting glass allowed him to work independently with a high degree of interaction with the material.

In 1999, Eskuche made a serious commitment to glass art by attending Emilio Santini's two-month concentration offered at the Penland School of Craft. Because Santini's approach to glassmaking is rooted in the centuries-old Venetian glass tradition, Eskuche was exposed to refinements that put flameworking in a historical context.

This workshop focused on blowing goblets and vessel forms, and touched on the incalmo technique. Learning these techniques introduced Eskuche to the specialized tools and approaches used in the Italian traditions by both flameworkers and furnace workers. He was excited by what he learned, especially by the incalmo technique, and returned to his Milwaukee studio to experiment with making figurines and blown forms.

With the Penland concentration behind him, Eskuche felt more comfortable with flameworking hot glass at the torch and quickly began to advance his skills. Within a year, he was invited to participate in the American Craft Council (ACC) shows and began to feel a growing commitment to glass and its creative community. During this time, there were very few flameworkers exhibiting at the ACC shows or at the larger, more commercial Rosen Group's Buyers Market of American Craft wholesale show in Philadelphia. Coming from metalsmithing jewelry, traditionally a larger juried craft category, Eskuche enjoyed promoting his work to the smaller glass audience.

After attending Santini's workshop and investing long hours at the torch, Eskuche was excited three years later to return to Penland for a class with Venetian master Césare Toffolo. The two-week workshop included a focus on incalmo techniques that Eskuche wanted to perfect and later found ways to incorporate into his first series. He found the incalmo technique a comfortable match for his skill set, and enjoyed prepping small components to be melted and fused together into large works with distinct bands of color.[2]

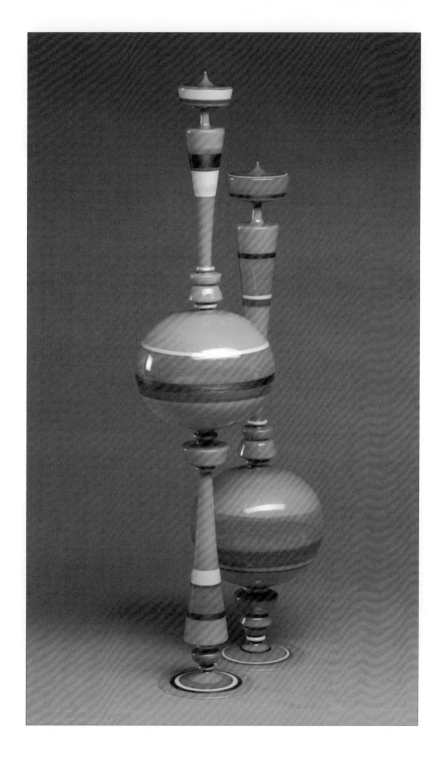

Eskuche continued to improve his glassblowing skills while experimenting with the incalmo technique in terms of color harmony and pushing for larger scale. His confidence grew as his technical proficiency allowed him to develop a personal aesthetic and, ultimately, a distinct body of work. His most successful work of this period was the "Jetsons Apartment Bottles" series — flameworked glass that combined opaque bands of colored blown glass and featured vessels ranging in sizes upward of two feet tall with five- to six-inch widths.

What made the "Jetsons" series so distinct were Eskuche's color choices — the pieces comprise multiple colors that reference 1960s fashion. These blown vessels evidence a high level of control in the intricate geometric patterns that define their profile. The combination of the title's playfulness and pop culture reference, along with the high level of skill in execution of the forms, predicted the path of his career into the present.

In 2003, Eskuche relocated his studio to Pittsburgh and moved into an old brewery that had been running as a nonprofit arts organization since the late 1990s. He also connected with the newly opened Pittsburgh Glass Center and the broader Pittsburgh art community. Eskuche's sense of community and belief in community as an artistic resource gave him the courage to continue developing work in line with his creative vision. His commitment was rewarded early on when the Philadelphia Museum of Art acquired a set of two Jetsons Apartment Bottles from him at the 2006 ACC show in Baltimore.

As he was gaining notoriety in the glass community with his art, Eskuche continued to push and expand his technical and intellectual reach. He saw the Pittsburgh Glass Center as the resource that would allow him to continue to grow and network — by both teaching and participating in workshops.

From 2005–2008, Eskuche took five workshops from a diverse group of upper-echelon artists: the de la Torre brothers, Boyd Sugiki, Gianni Toso, Andre Gutgesell, and Judith Schaechter. From

◄ "Jetsons Apartment Bottles," 2005; D 5", H 25", W 5".

Left: "29 Hours of Television," 2008; D 34", H 47", W 43".
Right: "Declaration of Indigestion," 2008; D 34", H 47", W 43".

each artist, Eskuche was able to internalize something that nurtured his artistic maturity. The de la Torre brothers' class[3] exposed him to developing attitudes that engendered a playful approach to art-making. Schaechter's philosophy about developing narratives and ideas challenged Eskuche to think about articulating social commentary using flameworked glass.

These workshops encouraged Eskuche to seek out new approaches for exploring ideas through his flameworked glass objects. Around this time, Eskuche saw a crushed beer can on the sidewalk while walking to his studio and thought, "Hey, I'll go ahead and make a crushed can like that one there." In his studio, he made his first can from memory — recalling cans he collected during a part-time job at the racetrack in his youth. After completing a couple of dented beer cans of glass, Eskuche was surprised by his response to them and all the technical and conceptual questions that came to mind. What started out as fun quickly "surpassed [his] interest in most objects [he] had made up to that point."

Eskuche became intrigued by what these objects could represent metaphorically. When he showed the pieces to his friends,

he was even more intrigued by their varied, personal, and intellectual responses that the dented cans elicited. Seeing responses to the work is an exciting experience for an object-maker. While the "Jetsons" series communicated a high level of craftsmanship and beauty, these cans had the potential to celebrate ambiguous ideas and spark endless conversations among viewers.

What started out as replicating dented beer cans in glass quickly evolved into flameworking all kinds of consumer beverage containers, including mimicking Styrofoam cups, two-liter plastic soda bottles, water bottles, wine bottles, and paper cups, all in flameworked glass. Soon he was even creating glass apple cores, cigarette butts, bottle caps, and straws. To create this true-to-life lightweight hollow-ware consumer waste, Eskuche had to "draw on all the technical information [he] had [learned] about flameworking, and … reach out to the flameworking community" for inspiration. While engaged in this ambitious exploration, he was wrestling emotionally with how to use glass to communicate social criticism while downplaying the traditional attractiveness of glass.

The breakthrough occurred when Eskuche developed a lengthy menu of glass trash, primarily containers, and began grouping them in still-life settings. These became his "White Trash" series. The groupings, composed of 25 to 30 objects, are presented in front of neutral backgrounds. They captivate the viewer because they are simultaneously familiar and peculiar. By recreating day-to-day objects in monochromatic opaque white, Eskuche gives the viewer the experience of the totality of the still life instead of a focus on individual objects. Additionally, because Eskuche uses familiar objects, the viewer focuses on the idea and is often oblivious to the heroic creative and technical efforts behind the pieces. This illusion allows the viewer to contemplate Eskuche's ambiguous commentary on social gatherings and consumption.

Eskuche's further inquiries into the Glass Trash themes of commercial excess, reliance on convenience, and mass-produced, mass-marketed junk food opened up his creative floodgates. One

important evolution of his White Trash theme is his "Lifestyles of the Rich and Famous" series. This series moves from groupings to installations by incorporating ornamental end tables. The trash containers also are presented in silver, mirrorized glass. These variations further emphasize opulence and excessiveness.

Another of Eskuche's interesting artistic advancements occurs in his "Realism" series. He camouflages his flameworked blown glass with true-to-life borosilicate colors; for example, a flameworked green glass Sprite bottle and a brown beer bottle. He applied all the paper, cardboard, and wood with inks and dyes together with aluminum foil and cellophane, with the exception of the bottle labels, which Eskuche painstakingly created by hand to heighten the illusion of his flameworked trash. The results are a peculiar realism that takes advantage of fabricated found objects. This installation mimics boxes, money, Chinese takeout containers, and other fast-food trash, and visually celebrates a "morning after the party" aesthetic.

As an artist, Eskuche has the power to draw attention to the commonplace in a thought-provoking way. He is dedicated to hard work and consummate craftsmanship, but his ideas are so powerful that they obliterate all references to skillfully crafted glass. His intentions are to create "objects of mass production by hand, using time-honored craft and art traditions . . . to express a futility in the end product." So, his goal is to focus the viewer's attention on the world around them and away from his skills.

The artistic merit evidenced in Eskuche's Trash Glass was rewarded in October 2009, when he received a major commission from the Racine Art Museum to create a site-specific installation occupying 80 feet of the museum's street-level window space. Fortunately for Eskuche, the School for American Craft at the Rochester Institute of Technology (RIT) offered him an artist residency to work on the installation. This gave Eskuche the space, resources, and creative environment to develop and give birth to his ambitious ideas.

The installation,[4] titled "Matt Eskuche: Aristocracy," takes advantage of multiple media and materials — glass, plastic,

"Witness Relocation Programme," 2012; D 17", H 16", W 52".

painting, fluids, found objects, and lighting. His flameworked glass components, however, are the aesthetic and conceptual heart and soul of the project. First, the Racine commission includes his most ambitious Glass Trash installation, with more than 240 flameworked objects laid on a reworked vintage dining room table spanning 20 feet in length.[5] Another interesting aspect of his process was to recast his flameworked containers into plastic panels that were assembled into lighting fixtures. This highly original and labor-intensive process shows Eskuche's commit-ment to reinterpreting his fascination with consumer packaging excess.

As a studio artist advancing his aesthetic in glass, Eskuche stays committed to the glass community through teaching and leading workshops both nationally and internationally. Start-ing in 2005 at the Pittsburgh Glass Center, he has since taught at multiple prestigious glass centers every year — including the Studio at Corning Museum of Glass, Penland School of Craft,[6] Urban Glass, multiple centers in Japan, and Anadolu University in Turkey. These teaching experiences allowed Eskuche to grow in a way that would not have been possible

had he only worked alone in his studio. He highly values "the experience teaching brings — the people, the places, [and] the food." He fully commits himself to "trying to figure out how to offer each individual something that will forever change the way they work in a progressive, positive manner." Eskuche is also committed to getting to know the people he meets in his travels and "making lifelong friends." As a result, he is emotionally and creatively connected to a growing network of glass artists around the world.

Flameworked glass has taken Eskuche all over the world and introduced him to an amazing group of people. Over the last 13 years, he has not only built a foundation to establish a career, he has worked hard to educate and challenge himself to reach his full potential. He is dedicated to a career as both a studio artist and as a teacher. With his innovative body of work, created in a relatively short time, Eskuche has a proven track record of both giving to and receiving from glass culture.

Matt Eskuche is a young man by studio art standards. It will be interesting to see his artwork continue to evolve while having an impact on the international glass art landscape.

Notes

[1] Information in this chapter was derived from a personal friendship with Matt Eskuche, formal interviews via e-mail, telephone, Eskuche's website (*http://matteskuche.com*), and the Racine Art Museum's website (*http://www.ramart.org/*).

I first met Eskuche at the 2005 Salem Community College International Flameworking Conference. Two years later, I invited him to be my teaching assistant for a flameworking workshop at the Penland School of Craft. From the very beginning, I was impressed with his generous spirit, kind heart, and dedication to excellence.

[2] The incalmo technique involves sealing sections of different-colored glasses onto a single form. This exacting process requires hollow, shaped sections with precisely measured circumferences to be straight-sealed and blown into a unified piece. Care is required in lining up the edges in preparation for the final shape.

[3] In a conversation with Eskuche, I was impressed when he told me he had been a student of the de la Torre brothers and Judith Schaechter. In fact, I've

been following their careers for more than 20 years and have been inspired and influenced by their talent and courage in ways that would not be visible by looking at my work. My exposure to their attitudes about art-making in glass has intellectually cultivated thought-provoking perspectives about being a glass artist versus being an artist who uses glass to express him — or her — self. I recommend to students that they familiarize themselves with these dynamic artists and their approaches to art-making.

[4] The Racine Art Museum installation was completed in August, 2010, and displayed through July, 2011.

[5] This long table grouping reminded me of Beth Lipman's "Banquet," but, where Lipman reinterprets Renaissance and Baroque European still-life paintings of banquets to invoke opulence, Eskuche's installation reinterprets the trash one would find the morning after a frat party as a critique of mass-produced, mass-marketed consumer waste. I am impressed by how two very different artists can evoke such powerful human social themes with only glass vessels and containers. Having viewed the glass art landscape for more than 50 years, I am continuously amazed to experience how glass can be used as a metaphor to articulate the depth of human experiences.

[6] It is interesting to follow younger artists and to witness their growth and how they attract notoriety. Eskuche was enhancing his reputation and attracting attention not only through his work, but through teaching at prestigious glass centers. He quickly reached and mastered high skill levels, as evidenced by how his work benefited from Emilio Santini and Césare Toffolo's Penland School of Craft workshops. Soon after, he was invited back to Penland to teach his own workshop.

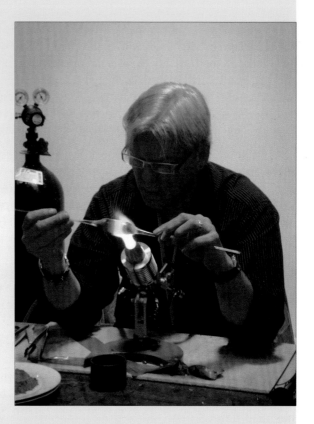

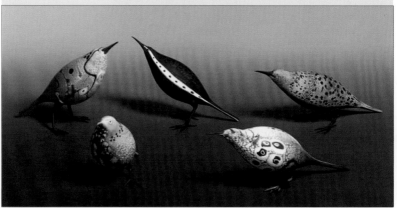

Top: Shane Fero demonstrating in Tasmania during Ausglass!
Bottom: Birds, 2009; each approximately D 3.5", H 3.5", W 6".

Shane Fero:
Mind in Flight

Shane Fero's[1] generous spirit has influenced the contemporary glass community through his artwork, teaching, and volunteering. His leadership qualities and his love of giving back have led to his becoming the president of the Glass Art Society (GAS) for an impressive two terms.

Artists who take advantage of flameworking, like Ginny Ruffner, Robert Mickelsen, Dinah Hulet, and Fero, are among the standouts whose leadership as trustees of GAS has had, and continues to have, an impact on the glass landscape. Under Fero's leadership, GAS grew more international in scope and encouraged more diversity in demonstrations at its conferences. According to GAS's executive director, Pamela Figenshow Koss, "Shane has also helped GAS build a more significant online presence. This has made it easier for glass artists from around the world to be connected as an international community." All of this was accomplished while Fero was experiencing great success with his own work as a studio artist.

This chapter celebrates Fero's journey, highlighting significant markers along the way. To quote Fero, "When I began this journey, I never imagined it would evolve into the work I do today . . . but dedication and persistence brought my work to fruition and acceptance."[2]

Fero began a lampworking apprenticeship at age 15 in Florida and continued working part-time while attending high school, then community college. From his first exposure to melting glass at the torch, Fero knew this was what he wanted to do. During these early years, Fero was developing his lampworking skills under

the tutelage of three masters: husband and wife Jerry and Lee Coker, and Roger Smith, who were taught by a chain of craftspeople in a continuous lineage going back centuries. Little did Fero know that the craft he was becoming passionate about had its roots in 15th-century Middle Europe. The tools and torches he was being trained on, equipment he still uses to this day, could be considered pre-modern technology.

Fero later attended Plattsburgh State University in upstate New York. His main academic interest was philosophy with a focus in aesthetics, epistemology, and ancient philosophy. He credits this time as crucial to his development. Fero's lifelong fascination with nature, specifically birds and animals, was heightened while living in the Adirondack Mountains, a vast protected region of lakes, streams, mountains, and forests.

On a technical level, Fero began modernizing his process by taking advantage of two distinct methods. He used gas/oxygen torches to melt borosilicate glass while continuing to use turn-of-the-19th-century gas/air crossfire burners to work soda-lime- and lead-glass hollowware. At this point in his career, his borosilicate efforts were primarily unique sculptures, and the soda-lime (and lead) glass efforts were hollow vessels that represented his design work. Slowly, over a 20-year period, Fero broke away from traditional vessel decoration techniques to use furnace glass in free-form designs. He later developed a fresh approach by adding colored shards and glass enamels to the hot, bulbous shapes, which moved him beyond the standard linear and line-and-dot designs.

Fero gained more than hand skills from his teenage apprenticeship. Because he had to discuss his glass with tourists who would be purchasing his work, he developed a keen ability to interact with potential purchasers. Fero carried this skill set into his next experience, when he opened his own gallery in Plattsburgh, called Classical Glass, in 1977. It was during this time that Fero's creative repertoire expanded to include glass versions of various species from the plant and animal kingdoms, as well as expressing the ideas he gained from his philosophy classes and his independent studies. Because Plattsburgh was a small

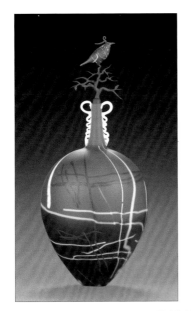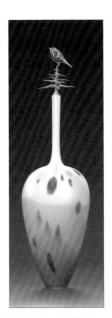

Left: "Neo-Greco," 2012; D 8.5", H 21", W 8.5".
Right: "Spruce Pine Bottle," 2012; D 7", H 26", W 7".

college town, at various times, members of the university faculty often visited his gallery. One faculty member was so impressed with Fero's commitment to glass that she invited him to deliver a lecture to the art students, open to the university and the community, on glass art and his lampworking process.

To do research for his lecture, Fero visited the Corning Museum of Glass to view *New Glass: A Worldwide Survey.*[3] This contemporary glass survey opened in 1979 and traveled to four major museums over a two-year period. At that time, the international glass art community was dominated by Americans who were using glass as a means to express their ideas. He had an epiphany as he became aware of the burgeoning Studio Glass art community: He realized that he needed to aspire to the level of work that he experienced at the exhibit. The dedication evidenced by the works of artists as diverse as John Burton, Mark Peiser, Dale Chihuly, and David Whittemore, among others, reinforced Fero's confidence that he could make a major contribution to the

Studio Glass Movement. After five hours in the museum, he purchased a complete set of exhibition slides to use in his lecture, and his preparation was complete.

The '80s represented a period of personal growth for Fero, bolstered by his stronger commitment to glassmaking as a means of artistic expression. He became more focused on a diverse list of influences, including ancient Egyptian mythology, the surrealistic art of Salvador Dali, contemporary dance, and a fascination with his dreams. During this phase, he integrated these ideas and themes into his art. He said, "I think it is very important to study a subject in depth, and to research how other people in the history of art and craft have expressed similar subjects." Focusing more on his ideas and attempting to advance art history required Fero to adapt his technical skills. When you lead with skill, you are mostly in a craft mode; when you lead with your mind, you are developing techniques and creating a new vocabulary in glass. That's exactly what Fero was doing.

When Fero was invited to co-teach a flameworking session at the Penland School of Craft with Fred Birkhill in 1988, he experienced the magic of art-making on the mountain. As Mark Peiser watched one of Fero's demonstrations, Fero's vision became a revelation to Mark, who was Penland's first glass artist-in-residence. Remembering Fero's demonstration, Peiser recounted, "Shane was making one of his surrealist personages. His process was mysterious as I watched him manipulate the [glass] subtly into exquisite balanced sculpture. It was the most compelling flameworking demo I've ever seen." After several teaching sessions and attending their first GAS conference at Penland, it didn't take long for Fero and his supportive wife, Sallie, to relocate their family to the mountain. As good fortune would have it, the Feros purchased one of the few privately owned residential properties on the Penland campus. They are now respected members of that artistic community.[4]

Belonging to a creative community such as Penland comes with artistic and intellectual benefits that are wonderfully stimulating. The major benefits include sharing ideas with a like-minded

group of people, and having an emotional support system that comes from working among talented, committed professionals.

During his time at Penland, Fero has established a circle of close friends, including Mark Peiser, Richard Ritter, Elizabeth Brim, Harvey Littleton, Kenny Carter, Rob Levine, Yaffa Sakorsky-Todd, and clay artist/philosopher Paulus Berensohn. These nationally respected artists, who work primarily in glass, challenged Fero to organize his work into themes and go beyond glass to include painting and printmaking.

In reviewing Fero's career, it is fascinating to realize how his most recent efforts have pulled his various series together in ways that produce original work. Many of Fero's technical struggles have now been won. His latest work evidences a high level of artistic freedom that is setting new standards in this centuries-old craft. Fero brings sophisticated techniques to his glass work, such as using acid etching to enhance colors, acrylic paint, and fused gold leaf. He also uses sandblasting to add dimension and visual information to the surface.

Fero's innovative techniques and interest in mythology have attracted attention and acclaim from the glass community. Peter

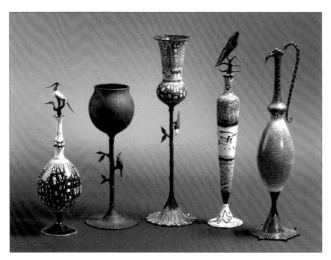

"Group of Vessels," 2002-2008; H from 8-12".

J. Baldaia, director of Curatorial Affairs for Huntsville Museum of Art, has described Fero's work as "advancing lampworking into a fine-art medium." He also described Fero's work as "engaging, dynamic, and fluid," suggesting "active psychological states and emphasizing expressionistic details of unexpected color." And he continues to be recognized and highly regarded in the glass community to which he has given so much. He was recently honored with a Lifetime Membership Award from the GAS.

What may seem simple to a casual observer is, in fact, the result of a highly skilled, labor-intensive effort. Yet, in spite of the labor and technicality of his work, Fero maintains the peace and tranquility he has encountered through his love of nature. It is a true master who disguises labor's efforts and complexity as illusive beauty. Fero's studio environment is surprisingly serene. He is like a monk in his studio work space. When you enter, you instantly sense the sincerity and spirituality of this maker's efforts. It is interesting to see how Shane Fero's Adirondack

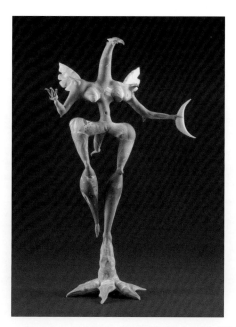

"Dragon Goddess," 2012; D 6.5", H 16.5", W 9.5".

bird-watching has culminated in some of the most poetic and delicate blown glass birds.

Notes

[1] Information in this chapter was derived from interviews with Shane Fero, years of friendship and conversation, and his website (*http://www.shanefero.net/*).

[2] I knew of Fero's work from the mid-1980s, but first met him in 1991 at the Corning Museum of Glass while attending a GAS conference. Fero was standing at a display of ancient glass and his nametag gave him away. When I introduced myself, it was evident we both respected each other's work. The conversation opener was about how variations in today's flameworking techniques can be found in a few fragments from the earliest examples of glass-making. I was impressed with Fero's historical knowledge of glass and his special interest in early lampworking history.

[3] Over a beer with Fero in Louisville, Kentucky, during the 2010 GAS conference, we discussed my book project and this chapter, along with the 1979 Corning Museum of Glass exhibit *New Glass: A Worldwide Survey*. We laughed when I told him I was rejected from that exhibit, which led us to try to outdo each other with rejection stories. Rejection stories aside, from my point of view, the Corning Museum has educated and challenged countless numbers of creative people who are interested in glass. A good case can be made that it was — and still is — one of the most important catalysts and resources in glass.

[4] During the summer of 1991, I was teaching flameworking at Penland School of Craft and took the class on a walk to Fero's studio for our scheduled demonstration. What should have been a 10-minute walk stretched into a 30-minute nature study. In season, the Penland campus is alive with native flowers, especially along the edges of the fields. When we arrived at the studio, it was exciting to see Fero working at his bench on his gas/air crossfire setup. His burners and techniques brought back my memories of watching the old-timers work hot glass during the '60s in southern New Jersey. Smiling, Fero handed me a 25-mm soft-glass tube and invited me to pull a point. It's fun for me to remember pulling the point dead-center and trying to be cool by saying "beginner's luck." Fero was impressed and said, "Stankard, you have good hands," and continued to give me generous compliments in front of the students. As a teacher, I felt proud, especially for having arranged this learning experience that showcased Fero as a master in his unique environment using his 19th-century equipment.

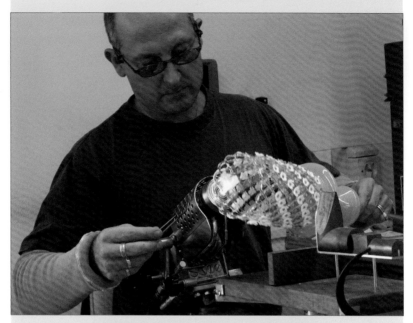

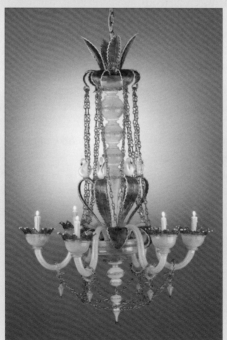

Top: Césare Toffolo at work.
Bottom: "Miniature Chandelier," 2009; H 40 cm, W 27 cm.

Césare Toffolo:
The Future of Tradition

When describing his work and his place in the Venetian tradition, Césare Toffolo[1] says, "I don't make copies of ancient glass pieces; I'm inspired by them. And I don't think the borosilicate material that I use diminishes the charm of Venetian thought; it offers more opportunities to better express it." Toffolo, through inventiveness and knowledge of furnace working, was the first flameworker to integrate basic furnace-working hand tools to form borosilicate glasses and techniques at the bench.

This seemingly simple action reversed the strong influence that scientific glassblowing technology has had on creative flameworking over most of the 20th century. Toffolo's exquisite goblets, vases, and figures are on the verge of challenging Murano's identity as primarily a place and tradition of furnace glassblowing. His success is advancing traditional work within the glass culture, and his process predicts the future now that flameworking has begun a new chapter in the ongoing history of Venetian glass.

Toffolo grew up on the island of Murano, the center of Venetian glass for more than 1,000 years, and his family — grandfather, father, and uncles — all worked in glass at Murano's famous glass factories. His family members not only worked in the factories, they were leaders and innovators. His grandfather co-founded the celebrated Venini Factory and was maestro there for many years. Toffolo's father, Florino, worked in the Venini factory, mastering goblets by age 17. During World War II, he was a prisoner in Germany and put to work as a scientific glassblower. After the war, he returned to Murano and established his own

factory, which was the first in Murano's history to produce scientific apparatus. He then adapted the scientific glassblowing techniques to creating traditional Venetian glass art at the flame. The family's history and success has both inspired and challenged Toffolo to not only participate in the tradition but to be an innovator and leader.

Toffolo was introduced to glass early and was playfully creating small animals by age 11. At 14, he began an apprenticeship in his father Florino's studio. By entering into an apprenticeship as a teenager, Toffolo followed not only his father's and uncles' footsteps, but the path of centuries of Murano glassmakers. Of this time, Toffolo says he made hundreds, sometimes thousands, of pieces for different companies, including small blown-glass vases. This practice and repetition could only have honed his skills, making them instinctual. But Florino did not limit Toffolo's learning to the torch. He would take Toffolo to studios around Murano that used different techniques because he wanted Toffolo to experience the variety of ways to make glass and not to feel, as a flameworker, that what he did fell outside tradition.[2] In addition, Florino brought Toffolo to see where glass tools and molds where made so he would more fully understand the process. But Toffolo would only work for his father for three years, as Florino died when Toffolo was seventeen.

At 18, Toffolo established his own glass studio in an antique glass factory called Fratelli Toso and was soon collaborating with Italian and European designers. Amazingly, the factory's archives, which contained hundreds of drawings from different eras, were left behind when Toffolo moved in. He considered these drawings "an important school for the knowledge of classic Murano glass" and was inspired by and reinterpreted many of the designs. These reinterpretations did not simply use the drawings to recreate the old pieces; he channeled the designs through the working characteristics of the flameworking process to produce artistically heightened variations of the traditional ornamental components of Venetian glass. By the time he was 21, Toffolo's studio was successful and had begun serious production with the help of three assistants.

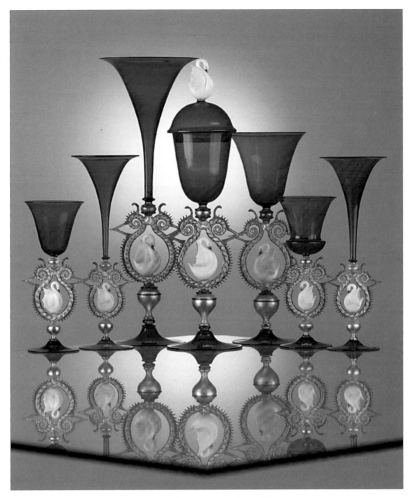

"Tipetti Blu con Cigni."

Aside from his father, who introduced him to glass and a sense of pride in his family's heritage in the Venetian tradition, Toffolo cites two mentors who played a leading role in his growth as an artist. First, after Florino's untimely death, Livio Rossi, a close friend of Florino's and a fellow glassmaster, "adopted" Toffolo and continued to guide him in the traditional Venetian ways. Then, at age 29, Toffolo became friends with Venetian master Lino Tagliapietra. Tagliapietra's influence was neither technical

nor artistic. He recognized Toffolo's mastery and introduced him to the world of opportunities outside Murano. Tagliapietra had already taught at Pilchuck Glass School and, through that experience, was introduced to the creative energy of the Studio Glass Movement. By recommending Toffolo to teach flameworking at Pilchuck, he paved the way for Toffolo to astound the international glass community with his high skill level and ability to reinterpret the Venetian glass tradition with a bench burner. This exposure to the American glass culture was a major development in Toffolo's career and would ultimately change his philosophy of working with glass.

Toffolo's creativity and inventiveness can be seen in his interpretations of traditional furnace techniques and use of furnace tools, at the torch with borosilicate glass, resulting in a heightened expression of Venetian objects. In *Flameworking with Césare Toffolo*, a DVD produced as part of the Corning Museum of Glass Master Class series, Toffolo applies traditional glassblowing tools to preparing work at the torch. The idea that a delicate glass point can be scored and snapped with traditional furnace working hand shears to open the sealed end, or that long metal tongs (jacks) can be used to flare the glass tubing in a way that the carbon-rod technique could not compete with, is informative.

Through the exposure he has received as a result of being highly regarded, Toffolo has challenged the glass community to consider the compatibility of flameworked borosilicate glass with tradition. His introduction to the more versatile borosilicate glass, primarily used in industry, may have been a stroke of luck. He was handed some 20-inch long rods by a representative of a West Coast colored borosilicate manufacturer and, because of his curiosity and creativity, immediately saw new possibilities. This more versatile material was not a shortcut to make his life easier; it was an opportunity to push the tradition beyond the working characteristics of soda-lime glass. When looking at Toffolo's goblets,

"Granelli di Sabbia;" H 42.5 cm, W 30 cm. ▶

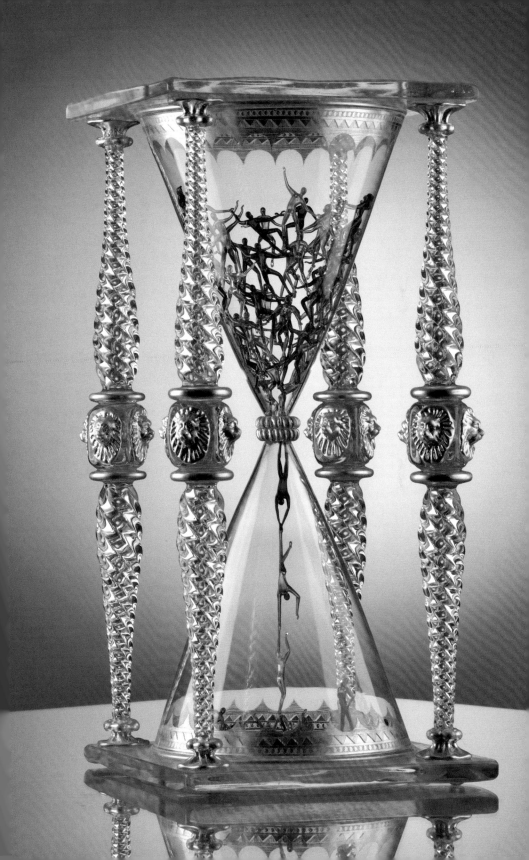

you can see how they adhere to the parameters of the Venetian tradition but also expand the tradition's possibilities.

Traditional Venetian glass designs had been developed over many centuries to be ideal for furnace soft glass production. These glasses are elastic and remain workable, capable of being manipulated by tools, for extended periods of time when compared to most glass from the furnace. The rich colors and working properties of Venetian glass produce distinctive hand-blown objects that are recognized, celebrated, and collected around the world. Venetian glass is also recognizable because of the specific techniques developed by Venetian glass masters, such as filigree, cane-working, gold leaf application, incalmo, and enamel painting.

Toffolo's preference for borosilicate glass has allowed him to bring a fresh artistic point of view to the Venetian tradition, primarily by exploring the working characteristics and creative opportunities of this modern material in the context of the centuries-old Venetian aesthetic and techniques. His most laudable skill is his ability to blow large-diameter glass tubing into hollow-ware at the torch. The torch-blown hollow-ware provides Toffolo with a platform for his intricately flameworked ornamentation and components. The resulting work is rooted in the Venetian style but, because Toffolo is a master flameworker, he heightens the visual beauty by bringing unprecedented detail and complexity.

Toffolo divides his body of work into two main parts — classical glass and glass art. His classic glass includes the "Traditional" series, an impressive collection of hollow-ware — goblets, compotes, candlestick holders, and vases — that demonstrate his high skill level, most notably with filigree and gold leaf. In a single goblet, Toffolo incorporates many techniques. Because of this reality, he believes Venetian glass is a great starting point for modern glass students because even a simple vessel can accommodate techniques like gold leaf, filigree, incalmo, zanfirico, inclusions, and applications.[3]

His "glass art" consists primarily of imaginative pieces that incorporate small, colorful figures into blown forms, such as vases, balloons, and hourglasses. The result is theatrical — the figures

bring action, narrative, and a surreal quality to otherwise static and literal forms. Toffolo's "little men" can be interpreted as a metaphor for his own life as a contemporary man living and working in Murano. He describes the work as "reflecting contemporary man who walks and lives surrounded by the classical in a city that is itself a classical work of art."

His most recent body of work, "Venetian Figures," invites the viewer to consider and experience the festivities of Venetian culture in ways goblets, vases, and other forms cannot communicate. These male and female figures in full, formal 19th-century dress and Carnival-like masks show how borosilicate glass can set higher standards for hand-worked glass figures. The level of detail and beauty in the garments, which include intricate patterns, has never been achieved with soft glass. Moreover, the proportions of the body and level of detail in the overall features produce a seriousness that is a significant departure from the cartoonish efforts of the past, which were made at the furnace.

Left: "Reliquiario Bolle," 2009; H 38.5 cm, W 11 cm.
Right: "Colori;" H 50 cm.

Toffolo's wife, Teresa, has managed his career from the beginning. As Toffolo's focus moved beyond his own body of work to developing a platform to nurture the creative growth of their two sons, Emanuel and Elia, Teresa's duties expanded to include managing Toffolo Studio. Toffolo Studio is a new and exciting organization that allows Emanuel and Elia to produce traditional work under Toffolo's guidance. Each is focusing on their personal interests, Emanuel perfecting insects and Elia producing jewelry and blown incalmo vessels. But Toffolo's influence goes beyond his children. He, along with Vittorio Costantini and Lucio Bubacco, have inspired a younger generation of flameworkers who want to move beyond production in order to be known for bringing "something new and creative" to the "classical sphere" of Venetian glass.

Toffolo, like his father who left the island of Murano as a young man, made a career-changing odyssey. Toffolo first connected with the American Studio Glass Movement in 1991, at age 30, when he was invited to teach at Pilchuck. This was a time when American Studio Glass artists were benefiting from their nontraditional approach to glassmaking. This experience provided Toffolo with "a different mentality to approach glass, more artistic, the purest conception that has not just changed [his] way of thinking in glass but [provided] new opportunities for expression."

The American Studio Glass Movement is known for pushing material limits through inventive processes, an approach that requires a lot of free-form experimentation. This could bring accusations of "wasting glass" from production factories in Europe and Asia where glass is produced for the marketplace. Glass artists in the US (and those who visit the US) are fortunate to have subsidized public access studios and college and university art programs that allow creative people to experiment, and basically play, with glass. This freedom is one of the hallmarks of the Studio Glass Movement's creative success. For Toffolo, who was raised doing production work in his father's factory, tapping into this attitude was a major career development and gave him the confidence to pursue making his more fanciful pieces.

"Venetian Figures," 2012; each approximately H 16 cm.

With his blend of tradition, craftsmanship, and imagination, Toffolo has captured the attention of an international audience that is huge by Murano standards. By traveling to exhibit and teach in Europe, Japan, and America, he has won over thousands of admirers, including the Murano glassmakers who congratulate him as he walks along the canal or when they visit his gallery. Not all are attracted to his creative accomplishments using flameworking, though; a few have negative feelings about the process. Ironically, if a few traditionalists have a prejudice against this approach, the vanguard of Murano's elite makers recognize his achievements, together with upward of to date 15,000 and increasingly more flameworkers in the US who celebrate the beauty of his work and are inspired by his accomplishments. Toffolo's blown goblets and vessels could easily be the most-admired blown borosilicate glass in the world.

Toffolo's international stature has grown because of his professionalism and inspirational, highly skilled demonstrations. He is one of a very few artists who have become ambassadors of the Venetian glass tradition to the international glass community.[4] His work — with its uncompromising quality — demonstrates the evolution of his tradition into the 21st century. He has achieved

this progress in part by attending annual international functions, like the Glass Art Society conference and Salem Community College's International Flameworking Conference, as well as using the Internet as a platform to communicate ideas and exchange images with artists around the world. Toffolo has remarked that he "feel[s] part of one community" and that this connection has helped him, and many other artists, grow "technically and intellectually much more quickly than in the past."

Toffolo's vision both confronts and celebrates the cultural components that are ingrained in Murano's glass history, namely competitive skill and inventiveness. By taking advantage of the flameworking processes with 20th-century borosilicate glasses, he is reinterpreting the masterworks of the past. His exploration pushes the boundaries of flameworked glass and reveals inventive and nuanced techniques that predict a new future for Venetian glass. This 21st-century technique is resuscitating tradition through his "Classical and Glass Art" series with poetic results.

Césare Toffolo's lasting fame will come in the future, when his skill and aesthetic accomplishments will be discussed in the context of past masters who have contributed to the Venetian glass story.

Notes

[1] Information in this chapter was derived from interviews and conversations with Césare Toffolo and his wife, Teresa Toffolo. Additional information was taken from Toffolo's website (*www.toffolo.com*).

My first meeting with Toffolo came while he was exhibiting in North Jersey, about 10 years ago. He came down to visit me at my studio. As I do with many of my foreign visitors, I took him to Penn's Pizzeria for a Philly cheese steak sandwich. Over lunch, and while sharing my environment with him, I sensed his dedication to his work, as well as his respect for things made well. We had a touching conversation in which we connected over our relationship with tradition: mine being French floral paperweights, Toffolo's being Venetian glass. I seldom have a conversation that can be considered "inside baseball" with another artist who is so emotionally involved with advancing a tradition in a way that invents a new language for glass.

[2] I can relate to feeling isolated as a flameworker. In the early years of the Studio Glass Movement in the United States, the focus was furnace working

and the movement's pioneering insiders relegated flameworking to an inferior "hobby" or "craft" status because it was tied to kitschy tourist souvenirs. One of the main tenets of Studio Glass was to break from the past and use glass in the service of fine art. In Murano, on the other hand, traditional giftware was the primary focus. There, flameworking wasn't used because it didn't fit into their centuries-old tradition.

[3] This highlights an interesting cultural difference between American and Venetian glassmakers. American glassmakers have no real tradition; much has been borrowed from France, Italy, Germany, and elsewhere, but not out of respect for tradition. American glass appropriates from everywhere and anywhere in the service of an idea — whatever it takes to realize a concept. This is best exemplified by the Studio Glass Movement, which denied tradition in order to invent a new language to make art in glass. On the other hand, Venetian makers are strongly rooted in tradition and before a maker can be innovative, he or she must first master traditional skills.

[4] From my perspective as a flameworker who has experienced negative biases toward the process, I find it ironic that Toffolo and Lucio Bubacco's work is celebrated internationally as the best of contemporary Venetian glass. I would think both, in their early days, had to be confident and defend their creative points of view on an island that has furnace-worked for centuries.

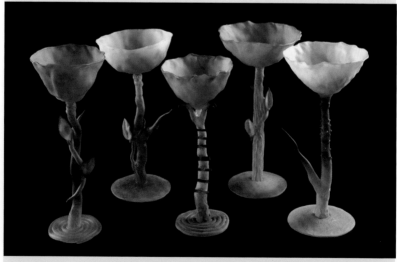

Top: Jay Musler working in the studio.
Bottom: "Wineglasses."

Jay Musler:
Inventing New Realities

Jay Musler[1] brings to contemporary glass a creative point of view and personal vision unlike any who came before him. His innovative approach to making things evolved out of boredom with production glassblowing and a need to forge his own path to creative independence.

Musler's artistic awakening occurred in the San Francisco Bay area in the late 1960s and early 1970s. He moved to Berkeley to attend California College of Arts and Crafts to enroll as a glass major and study under Marvin Lipofsky, but his art education was not limited to the studio. Musler was influenced by the high energy, highly experimental art scene pulsating all around him. Then, in the early 1980s, his career was catapulted by a grant from the National Endowment for the Arts, which helped advance his invented process and fund international travel for artistic inspiration.

The iconoclastic body of Musler's work has earned him an international audience and is represented in some of the most prestigious museum glass collections in the world. He receives this attention by bringing nontraditional techniques to his glass artmaking. His mixed-material techniques allow him to internalize his interests in masks, boats, bowls, wine glasses, panels, and sculpture recreated in highly personalized ways.

❧

Musler's journey begins when his high-school art teacher, Larry Foster, guided him to a career in glass. Musler took Foster's ceramics class as a junior. With Foster's encouragement, Musler entered a piece from that class in the Sacramento County Fair. The work won best of show for ceramics sculpture, and the experience gave Musler confidence and inspiration as a maker.

The student showed a great deal of enthusiasm for glass-blowing. After some practice, he made a vase and became even more excited about the creative possibilities of working with glass. Foster recognized Musler's energy — and knack for making things — and recommended he enroll in a summer course with Marvin Lipofsky[2] at California College of Arts and Crafts (CCAC), now California College of the Arts, in Oakland, California. Musler's interest in glass continued to grow during the summer course. He was so hooked, in fact, that he decided to leave Sacramento and enroll as a fulltime student in CCAC's newly established glass major.

In the summer of 1968, Musler moved to Berkeley. This was a life-altering experience. At the time, even though Sacramento was the capital of California, it was a quiet, conservative town. In the late 1960s, Berkeley and the broader San Francisco Bay area, on the other hand, was the hub of counter-culture ideas, exploding with experimental creative energy. Already passionate about art and ideas, Musler got swept up in the music, architecture, painting, photography, and "different ways of thinking and different ways of living." Musler thrived in his new environment and was especially active in attending concerts and art exhibits in nearby San Francisco.

Moving away from home, family, and friends was a courageous step in Musler's artistic journey. His exposure to art-making through craft, as guided by Foster, gave him the vision of leaving the world he knew behind to immerse himself in art and artmaking as a lifestyle.

In Marvin Lipofsky, Musler found another art teacher to help guide him through the next phase of his creative journey. Lipofsky, head instructor of CCAC's glass program, ran an open and experimental classroom and encouraged students to follow their own interests. While most of the students in the glass program spent their time blowing, Musler was more interested in constructing glass sculpture. He began experimenting with materials — incorporating window glass, wood, and neon into his work. He also started exploring the coldworking processes, as well as sandblasting

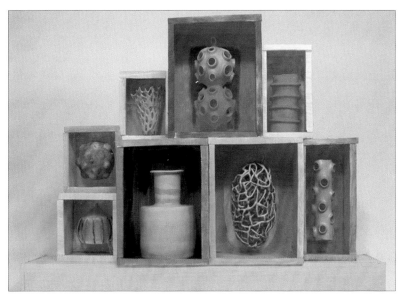

Untitled; lampworked glass, oil paint, and wood.

and painting glass. It is interesting to note that Musler's mature body of work takes advantage of many of the same techniques and attitudes he explored experimentally under Lipofsky.

To promote significant art made from glass, Lipofsky brought in established artists from across North American and Europe to demonstrate and talk about their work and diverse techniques. This was an important opportunity for students like Musler, who believed in the creative possibilities that were being realized in glass art-making. At this stage in the Studio Glass Movement, glass was considered more of a novelty material by the broader craft community, but Lipofsky used his connections in the early movement to share examples of contemporary glass art with his students. Musler's commitment grew through this exposure to upper-echelon artists and their ambitious work, which suggested endless possibilities in glass art-making.

After three years of art school, Musler left to take a job at Maslach Glass in Marin County, California. He worked in production for almost a decade, creating architectural pieces and

stemware. While working at Maslach, Musler was exposed to the flameworking process when a jeweler visited the shop and commissioned glass teardrops. Though he had not seen anyone do flamework, he volunteered and quickly mastered the teardrop. Ironically, Musler would have to wait another seven years to see professional scientific glassblowers crafting glass apparatus using the flameworking process to make chemical glassware. He was amazed to learn the full extent of the craft and to see various torches and glass-turning lathes being used to fabricate glass.

While working in production glass, Musler reconnected with his passion for being creative by coldworking and painting found glass in the garage of his small San Francisco apartment. Many of his artistic influences in this period were ceramic artists, such as Robert Arneson and Peter Voulkos, and others at the center of the "funk movement"[3] that was sweeping the Bay Area in 1960s and '70s. However, Musler was also influenced by Dick Marquis, who had a studio in Berkeley in the late '70s and taught glass art at the University of California-Berkeley. Although Marquis was a master glassblower who focused on Venetian techniques, his work during this period took advantage of construction, found objects, coldworking, and gluing.

These influences show up in Musler's early work. Though he was working as a production glassblower, on nights and weekends, he was making art that reflected and built on his experiments as a student at CCAC. One could assume that he benefited creatively from nine years of glassblowing, but it was in his garage studio that he separated his production life from his creative life.[4] In this limited environment, Musler had very little equipment and his work was the result of a more labor-intensive, constructive approach. Basically, he was foraging for surplus glass — notably bell jars — to cold-work, carve, and paint. Some may think of these environmental restrictions as creative limitations, but Musler credits them with helping develop and setting the parameters for his distinct style.

In Musler's career, the period from 1978 to 1983 may have been the most important years in terms of developing his significant

Top left: "Starburst," 2007; D 5", H 10", W 5".
Top right: "Blue Bunny," 2007; D 3.5", H 11", W 4.5".
Bottom left: "Breezy," 2004; D 3.5", H 9.25", W 6.5".
Bottom left: "Ball & Chain," 2004; D 3.5", H 10", W 7".

and well-known work. In 1978, he attended his first Glass Art Society (GAS) Conference, GAS VIII, in Monterey, California. This marked his first encounter with the strength and energy of the Studio Glass Movement. He also met Tom Buechner,[5] founding director of the Corning Museum of Glass. Buechner saw examples of Musler's cold-worked, painted glass and encouraged him to submit slides to Corning for an exhibition he was jurying. This exhibition was being organized into a major traveling show that surveyed contemporary glass art internationally. Musler was excited by this opportunity to submit work to the most respected glass museum in the world, and one of his first pieces, "Woven Bowl," was accepted. The exhibition, *New Glass: A Worldwide Survey*, was a major event that brought a sense of community to Studio Glass artists around the world.

Corning hosted the 1979 GAS Conference to celebrate the opening of *New Glass: A Worldwide Survey*, and Musler attended as an exhibited artist. This marked his first trip to Corning — a major turning point in his career. Aside from experiencing 273 glass objects and having the opportunity to interact with artists from 28 countries at the conference, he spent a great deal of time exploring the museum. He was particularly drawn to an avant-garde collection of Swedish glass from the 1920s — sandblasted vessels with engraved imagery. He credits encountering these vessels with helping him "find his voice in art" because he could imagine expressing himself with that process.[6]

Musler's acceptance into the *New Glass* exhibition was closely followed by an even more life-changing event — in 1982, he received a $25,000 grant from the National Endowment for the Arts. This grant allowed him to step back from a growing number of commitments made to galleries,[7] and gave him the financial freedom to reflect on how he wanted his career to unfold.

With the grant money, Musler made his first trip outside the US, traveling throughout Mexico to look at art. He was inspired by Mexican folk art, especially masks, which were tied to ancient spiritual rituals. After this trip, he returned to his San Francisco studio with a small collection of masks. This led to experimenting

with and reinterpreting abstract elements in borosilicate glass distilled from the folk-art masks. He also used the grant to purchase a sandblaster and cutting equipment. This allowed Musler to sandblast all of his components, "to get the kind of surfaces [he] wanted," and prepare them to be painted. Purchasing this equipment reinforced his commitment to his unique creative vision.

Another development during this significant time period was Musler's attendance at the 1983 GAS Conference in Tucson, Arizona.[8] He was excited to meet Therman Statom, an internationally respected artist who is famous for his large-scale sculptural installations in glass. Musler was interested in Statom's process of using plate glass, silicon, and paint, and inspired by Statom's courageous approach to art-making in glass. Unlike his experience with the Swedish artists at Corning who wouldn't share their knowledge of glass enameling, Statom was open to sharing his techniques with Musler and invited Musler to his Los Angeles

Untitled; flameworked glass on plate glass, painted.

Untitled; flameworked glass on plate glass, painted.

studio at the end of the conference. Musler was inspired by the artistic success Statom experienced with plate glass, but wanted to take the process "in a new direction." Back at his own studio, he taught himself how to cut, glue, slump, sandblast, and paint the plate glass, transforming it into a personal aesthetic that would lead to his highly regarded "Boat" series.

In the early 1980s, Musler's studio was located near Mission Creek in San Francisco. The creek was, at that time, dotted with "sunken, abandoned boats." When taking walks along the creek, Musler became fascinated with the visual complexity of the disintegrating boats. He also connected to the boats' symbolic qualities — in various world cultures, boats were used as symbols in burial mounds and as metaphors for subconscious travel. Musler constructed boats using innovative techniques, which included his unique response to interpret the world around him through the flameworking process. He used cut strips of sandblasted and painted plate glass, as well as flameworked forms, to build

idiosyncratic objects that referenced the boat form isolated and abandoned.

Starting in the mid-1980s, Musler began to rely more heavily on flameworking and purchased a used lathe, which led to building more visually complex organic components to include in his work. As his influences expanded to include neo-German Expressionism and Surrealism, he realized flameworking would allow him to create a more potent visual language to express wider conceptual ideas. His interests in contemporary painting, coupled with patterns found in nature, came together in visually striking ways in his flameworked objects. This illustrates how flameworking, as a process, can unite diverse references into a singular vision.[9]

Musler also felt comfortable with the solitary nature of flameworking as a process, because it allowed him to work the glass on an intimate level. On many occasions when Musler's creative energy is heightened by new illusions, he would sleep in his studio. He would wake up in the middle of the night or early in the morning to continue exploring. During these quiet moments alone in the studio, Musler was rewarded with many of the conceptual breakthroughs that have become his signature work.

Musler's far-ranging artistic influences and inventive processes distinguish him as a singular artist, whose work transcends craft, material, and process. In celebration of the 50th anniversary of the Studio Glass Movement, *The Urban Glass Art Quarterly* invited nine jurors to provide an overview of international glass and select the 50 contemporary artists whose work will stand the test of time. Not surprisingly, Musler is included, and the image chosen to exemplify his career is a flameworked goblet, sandblasted, painted, and adorned with a surrealistic basket of multicolored flowers. This single image demonstrates why Jay Musler has been so celebrated and influential — he has brought to glass a whole new appearance, and a whole new intelligence, that redefines the parameters of this ancient and mostly utilitarian material.

Notes

[1] Unless otherwise noted, information in this chapter was derived from interviews with Jay Musler, years of friendship and conversation, and his website (*http://www.jaymusler.com/*).

[2] Marvin Lipofsky is a major voice in the Studio Glass Movement and avidly promotes glass as fine art. He was a member of Harvey Littleton's first master class — in 1962-1963 — and went on to teach and head the glass program at CCAC for 20 years. Information about his work and career can be found at *www.marvinlipofsky.com.*

[3] The Funk Movement was, in part, a reaction against Abstract Expressionism. Proponents of the Funk Movement sought to bring reality and accessibility back into the art realm. Some Funk Art took on social and political topics of the time, often satirically. This movement encompassed multiple media, including painting, ceramics, and found objects, and was largely based in the San Francisco Bay Area (*http://public.wsu.edu/~delahoyd/20th/funk.html*).

[4] In the course of interviewing Musler, I was struck by how important his early days in the garage studio were to his future. I can easily imagine how comfortable Musler would have been in this quiet space, because it fits his contemplative personality. The same also can be said for his process, which is more about deliberation than a fast-paced, team-oriented, hot-glass operation. Moreover, I relate to Musler's garage days on a personal level, having spent the first six years of my career working alone in my utility room and then my garage.

[5] Tom Buechner's influence on contemporary glass has positioned him as one of the few de facto leaders of the Studio Glass Movement. From his early days as founding director of the Corning Museum of Glass to establishing the *Journal of Glass Studies* and the *New Glass Review*, Buechner was emotionally invested in the future growth and reputation of glass in the art world. He was also a proponent of excellence in glass, regardless of process. In the mid-'70s, during a Corning Museum of Glass seminar, Harvey Littleton was belittling the flameworking process as trite to a small group when Buechner responded, "Harvey, you don't blame the process for stupid work."

[6] I thought it was humorous when Musler mentioned approaching Swedish artists at the conference who were using glass enamel paint to decorate their vessels. He wanted to know how they did it. The Swedish artists replied, "Oh, we can't tell you; it's a secret." This mentality isn't unusual in the glass world. Starting out, I experienced this secretive attitude when asking a few established paperweight-makers about the process and was told it was a

secret. Being confronted with this secretive approach could be a blessing in disguise. Instead of doing something the same way it has been done before, you are forced to recreate it through trial-and-error and experimentation. This ultimately leads to making the work personal and establishing an original point of view.

[7] I visited Heller Gallery in 1983 and was admiring Musler's work, which was being shown with the work of Kreg Kallenberger and Steve Weinberg. As I was standing in front of a Musler sculpture, Mike Heller told me he had just gotten off the phone with Musler who had canceled all of his upcoming shows because he had received a National Endowment of the Arts grant and was taking time out to develop new bodies of work. I remember being very impressed by this. At the time, a chance to exhibit at the Heller Gallery was a major opportunity, and it still is. The Studio Glass Movement was attracting a lot of attention from museum curators and collectors, so showing at Heller often meant great exposure, which promoted sales. I was impressed by Musler's cancellation because to me it demonstrated that he was dedicated to an artistic vision that had nothing to do with commercial success.

[8] That same year, I met Musler in Tucson, Arizona, during a GAS Conference reception held at the Tucson Museum of Art. The museum mounted a survey exhibition of contemporary glass art curated by a young Susanne Frantz, who would become an influential leader in the contemporary glass art community. I remember having a conversation with Musler and Frantz about a negative bias within the glass art community toward the flameworking process. To my surprise, they didn't share my perception of any bias. They helped me realize that the bias I perceived coming from the glass art community was not about the flameworking process, but more because the glass being produced with that technique was mostly traditional and anonymous giftware.

[9] While exhibiting with Musler at the Marx Saunders Gallery during SOFA Chicago in the late '90s, I was fascinated when Musler told me about a small scientific glassblowing company near his Berkeley studio, and how on occasion he would visit the scientific glassblowers to be taught new "tricks." He would then take the "trick" back to his studio, and experiment with the technique. Eventually he would develop a component into one of his themes or start a new series. Coming from a scientific glass background, it's fascinating to see how innovative his work is when the basic forms are distorted and reshaped by the use of a lathe combined with a bench torch.

❧

Top: Ginny Ruffner.
Bottom: "3D Floral Painting" — Aesthetic Engineering
Series, 2010; 22" x 16" x 22".

Ginny Ruffner:
Uncompromising Spirit

The reality of Ginny Ruffner's[1] career has evolved beyond the realm of glass art. A pioneer and leader in the Studio Glass Movement equal to Littleton, Lipofsky, or any other prominent artist, she, as a creative force, has brought flameworking into the world of fine art. Her need and commitment to be creative in life has not only transformed glass but touched countless numbers of people by inventing a personal language that articulates the depth of human emotion in sculpture. At times, her signature work becomes maquettes for large-scale, site-specific metal and glass sculptures; at other moments, she scaled down to the small and delicate. While working on the creation of "Urban Garden," a monumental, mechanized sculpture in downtown Seattle that is 27 feet tall and weighs almost 10,000 pounds,[2] she continued creating the small-scale flameworked artwork that has distinguished her career. In fact, the attention Ruffner received from her innovative work gave her the confidence to pursue her artistic vision fearlessly as she creates now, mostly in glass and metal.

Raised in Atlanta, Ruffner earned BFA and MFA degrees in drawing and painting from the University of Georgia (UG). As a master's student, Ruffner began experimenting with ways to get light into her paintings. Her first thought was neon. To learn neon-working techniques, she sought the help of an old-timer who ran a small neon shop out of his garage near the UG campus. She learned enough about neon to include some basic elements in her paintings. Although the neon elements didn't satisfy her creative vision for bringing more light into her work, she was enamored of the inherent qualities of glass as a material.

Coincidently, Ruffner's art history class began discussing the work of Marcel Duchamp at about this time. Ruffner immediately connected with Duchamp's work "The Bride Stripped Bare by her Bachelors, Even," a multimedia work comprising images on three glass panes that presents an abstract narrative. Studying this work reinforced Ruffner's interest in bringing light into her artwork and the idea that glass could be the vehicle to realize her vision.

Ruffner started painting on flat glass, seeking out plate glass in the trash or wherever she could find it. As her exploration in glass as a canvas progressed, she began thinking about what she could do to the glass itself. Without any technical guidance from the UG faculty, she began drilling holes in the plate glass, cutting the glass, and figuring out ways to present it. Her need and determination to take on and solve hands-on, technical problems predicted Ruffner's future as a sculptor who constantly seeks innovative ways to express herself. The impact glass had on Ruffner's years as an art student was striking — she entered the MFA program to study painting, but finished with an exhibition titled *Glass Constructions*. The exhibit was composed of wall-hung works assembled from transparent panes of painted glass.

Armed with her master's degree, Ruffner returned to Atlanta with a commitment in mind to rent studio space to pursue her art and finding a job that allowed her to use her creativity. She also stayed committed to working glass in a creative way and taught herself how to make stained glass, which led to commissions. However, after encountering some "intriguing" glass objects during a visit to a local mall, Ruffner felt an attraction to the glass and a desire to learn the process of making such art. She identified the maker of the objects, Frabel Glass Art Studio, and immediately called to ask for a job. Frabel told Ruffner that they couldn't hire her because she didn't have any glassblowing experience. Undeterred, Ruffner found a competitor, Lillie Glassblowers, that hired her as an apprentice glassblower and glass engraver. After spending a year on mastering these basic crafts at Lillie, she called Frabel again to tell them she still wanted a job and was now an

"experienced glassblower." Her persistence paid off — Frabel offered Ruffner a job and she worked there for five years, from 1978 to 1983.

During these early years after art school, Ruffner dedicated all of her resources to renting studio space and buying the equipment and materials needed to advance her artmaking. Learning flameworking at Frabel allowed Ruffner to move her studio from a spare bedroom in her apartment — which restricted her artmaking to flat glass — to a storage unit with a concrete floor and a roll-up door so she could work hot glass at the torch. Moreover, working with Lille and Frabel gave her the skills and knowledge to acquire the equipment and materials that she needed.

Ruffner's persistence — in terms of both getting a job at Frabel and continuing her artmaking — paid off when, in 1982, Marvin Lipofsky, one of the early pioneers of the Studio Glass Movement and head of the glass art program at the California College of Arts and Crafts (CCAC), invited Ruffner and a few other Frabel lampworkers to lead a workshop in his program. What impressed Lipofsky was that Ruffner had an MFA degree in painting and the desire to use her technical skills and artistic maturity in the service of glass artmaking.[3] Leading the workshop in Lipofsky's glass program introduced Ruffner to the "other glass world"[4] — as opposed to the type of commercial production done at Frabel, the one in which studio artists seek to put their work in an art historical context that celebrates ideas as the primary justification for the work.[5]

Ruffner was totally comfortable in the upper echelons of artmaking with craft. Once she understood the scope of the Studio Glass world and how quickly it was expanding, she was very successful at expressing her fine art vision through the lampworking process, a process about which little was known and that few artists were accessing. The 1980s saw great expansion in the glass world, in terms of gallery and museum exhibitions, collectors seeking one-of-a-kind sculptures, art schools creating glass art programs, and the establishment of public-access studios specific to glass.

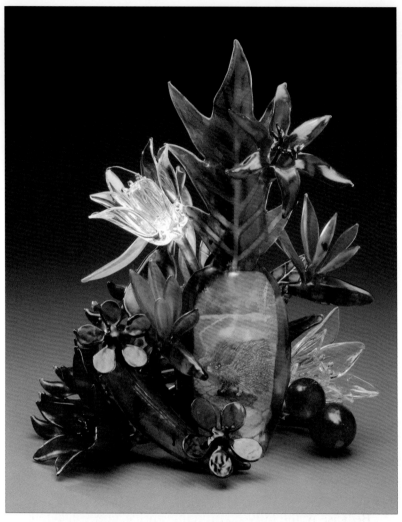

"The Shared Gene of Porcupines and Pineapples" — Aesthetic Engineering Series, 2012; 20" x 18" x 17".

The same herculean drive Ruffner brought to Atlanta to establish herself as a working artist she brought to promoting herself on the glass scene. In 1983 through 1985 alone, she lectured, taught seminars, and led workshops at the Summervail Craft School, Tyler School of Art, Pilchuck Glass School, Pratt Fine Arts Center, New York Experimental Glass Workshop (now

Urban Glass), and Glass Art Society Conference in Corning, New York. At the same time, Ruffner was exhibiting at premier glass galleries such as Habatat in Michigan, Heller in New York City,[6] Traver-Sutton in Seattle, and Fay Gold in Atlanta. When talking about Ruffner's energy in the 1980s, artist and curator Graham Nash, said, "She was a freight train and you were a deer in the headlights."[7]

After teaching the first lampworking session at Pilchuck in 1984, Ruffner moved to Seattle in 1985 to live and establish a glass studio. In the mid-'80s, Seattle was becoming an important concentration of artists working in glass comparable to anywhere in the world. Not only was she welcomed and respected in this vibrant community, she brought a unique vision, both technically and conceptually. Dale Chihuly recognized her "carving out a niche of her own, totally unique."[8] He also saw her creative courage that she was "not afraid to do new things she has to go out on a limb for."[9]

Ruffner's presence at Pilchuck and in her Seattle studio challenged glassworkers to rethink their negative bias toward flameworking, often called the bastard child of glassblowing. By flameworking, sandblasting, and painting her work, she was able to build a vocabulary of symbols to engage in an intellectual pursuit of beauty while pulling from and building on art history. Unlike much of the glass being made at the time, Ruffner was not making objects or vessels — her work was non-functional sculpture that evolved into three-dimensional paintings that invited viewers to explore concepts and experience narratives.

Because of the respect Ruffner's work attracted and the demand for her art, she developed a staff of talented assistants to help realize her visions. This gave her the freedom to continue to pursue new ideas and more ambitious series. Her first solo show at the Traver-Sutton Gallery in 1987 — a collaborative event with novelist Tom Robbins — established her as force in the upper echelon of the vibrant Seattle glass scene and as someone to pay attention to in the art world generally.

Ruffner's approach to artmaking in glass came into focus in the late 1980s. Her work in this period began to identify and

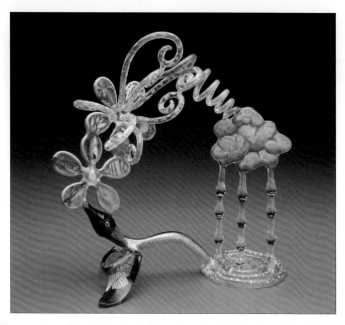

"How Rain Gets in Clouds" — Aesthetic Engineering Series,
2009; 17" x 16" x 9".

explore some of the subject matters that she would revisit time
and again throughout her artistic journey — beauty and creativ-
ity. Her flameworked glass sculptures attempt to articulate, in art,
these broad concepts, which philosophers have struggled for cen-
turies to flesh out in language. Ruffner's approach to presenting
these complex issues is mindful of her audience. She "respect[s]
the viewer and provide[s] them a way to connect with the art" by
building sculptures that fuse symbols, color, and narrative.

Ruffner's "Beauty" series, exemplified by "Beauty as Drama
#141,"[10] anthropomorphizes beauty with a "headless, armless,
winged"[11] figure from Greek mythology. The "Beauty" series takes
the figures on visual "adventures through art history"[12] to explore
periods and concepts, to highlight the virtues of beauty and show
that it is a subjective idea that changes "over time" and "over
cultures."[13] This piece takes full advantage of Ruffner's artistic
interests and technical skills. It is fabricated from borosilicate

glass, sandblasted, and painted with vibrant colors to depict winged-beauty figures pulling a chariot. Above the figures are banners bearing the Greek drama masks, Comedy and Tragedy. The piece suggests forward motion by the extensions of the banners that are flowing behind them.

"Beauty as Drama #141," moreover, illustrates the genius of Ruffner's work. Although she is exploring academic and historical attitudes, her presentation is thought-provoking and witty. Always seeking to invite viewers to engage with her ideas, she realized that using a human form would "humanize" art history and make its themes more recognizable.

In 1990, Ruffner created an installation for the Renwick Gallery of the Smithsonian American Art Museum, in Washington, DC, entitled *Possession of Creativity*.[14] This show illustrates

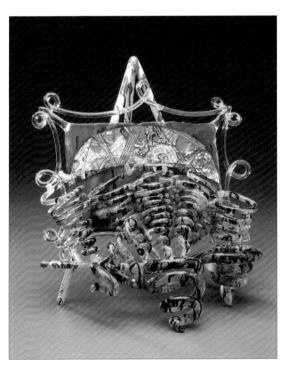

"Learning To Be A Tornado" — Aesthetic Engineering
Series, 2012; 17" x 18" x 19".

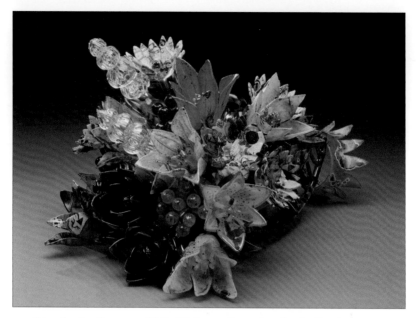

"Art Is the Queen of My Universe" — Aesthetic Engineering
Series, 2012; 19" x 26" x 18".

how her body of work relies less on flameworked glass to execute
her vision. This installation also predicts how Ruffner would use the
symbols she gave form to in her flameworked sculpture in less-con-
stricting parameters. For example, the centerpiece of the Renwick
installation was an 18-foot x 9-foot x 9-foot steel tornado adorned
with 1,000 flameworked glass rain drops, symbolizing creativity.

Fast-forward through 21 years and dozens of site-specific
installations, and Ruffner's most recent and monumental sculp-
ture, "Urban Garden," still uses symbols and vibrant color to com-
municate visual information to viewers. In "Urban Garden,"
Ruffner used flowers and water to "reflect ... Seattle [as] a beau-
tiful, growing, flourishing place."[15]

In 1992, Ruffner was involved in a serious car accident that
left her in a coma. Initially, doctors told her family she wouldn't
wake up. When she did, doctors told her family she would never
walk or talk again, let alone live as an independent artist.[16] These

grave diagnoses challenged her competitive spirit to prove them wrong and rebuild her life and career based on courage, creativity, and persistence.

But the effort to rebuild would prove long and arduous. Basically, she had to start from the beginning and relearn everything about her life. She described this mental state by saying, "My mind was like a big empty house that you knew you used to live in."[17] Her physical injuries also kept her in a wheelchair for five years. According to Ruffner, during her recovery, her physical therapist quickly learned that "the best way to get me to do something was to tell me I couldn't do it."[18]

What makes Ruffner's story so heroic is that, instead of putting the brakes on her career, she saw the accident as an opportunity to reinvent her life as an artist and redefine a personal vision that put the concept of creativity at the center of her life. As evidenced through her "Balance" and "Patterns of Thought" series, her first flameworked sculpture after the accident, she strengthened her commitment to flameworking as the primary way to express her ideas during this time. Ruffner had already proved she could break flameworking's traditional scale barrier; however, during her recovery, flameworking was the ideal technique, because she could produce work in a size that was easier to hold from a wheelchair.

She was also able to employ the personal and artistic vocabulary she had created with flameworking to express new ideas and feelings. "Balance" used the idea of relearning to walk to explore broader concepts of balance in life. "Patterns of Thought" was her way to reconnect with more abstract concepts of both creating and recognizing beauty.

Over the past 20 years, Ruffner has depended less on her flameworked sculpture and continued to expand her modes of expression by taking advantage of large glass, cast-bronze, and fabricated-metal components to create large-scale multimedia sculpture. More recently, she began actively pursuing writing and received a fellowship from the Hedgebrook Writer's Retreat. At the same time, her artwork reached a wider and wider audience.

Ruffner has been very generous to her audience. She shares her knowledge of glass artmaking by teaching workshops on process and by involvement in not only the Seattle art community, but the international glass community as a past president of the Glass Art Society.

Ruffner exemplifies art-making as a calling. Throughout her life, she has been uncompromisingly dedicated to the creative side and accepted obstacles and challenges as the normal course of life of a studio artist. Like many great artists in history, she uses obstacles to push her work in directions where few would go. She is an extremely talented and intelligent person whose interest in art history and conceptual breakthroughs in art — such as Duchamp — has inspired her to celebrate the spirit of creative triumphs in her work. She has a fascination with and respect for glass as a material, but her passion for art and art history generally has led her to be open to using a variety of materials and techniques to interpret her visions. The honors for her extraordinary career have been many and inspire the thousands of glass art flameworkers who see her career as the vision of what is possible, as they sit behind their torches melting glass.

Notes

[1] Unless otherwise noted, information in this chapter was taken from e-mails and telephone interviews with Ginny Ruffner.

[2] Glen R. Brown, "Ginny Ruffner's Seattle Garden," International Sculpture Center, *http://www.sculpture.org/documents/scmag12/julaug_12/julaug12_features6.shtml.*

[3] Oral history interview with Marvin Lipofsky, July 30–August 5, 2003. Archives of American Art, Smithsonian Institution (*http://www.aaa.si.edu/collections/interviews/oral-history-interview-marvin-lipofsky-12658*).

[4] Like Ruffner, I discovered the other glass world that Lipofsky referred to, known as the Studio Glass Movement, and was challenged to explore contemporary ideas and build on art history's past. In my case, without an art school background, I intuitively focused on the decorative arts in the glass category. It was exciting to experience the glass movement in the late '70s and throughout the '80s as a high-energy and fast-paced art movement that was nourished by hundreds of millions of dollars being spent on building collections of contemporary glass art.

⁵ While the CCAC workshop was Ruffner's first foray into teaching glass, it was not her first teaching experience. She taught painting and art history as an adjunct instructor at Dekalb College in Atlanta in 1977.

⁶ I first saw Ruffner's work at the Heller Gallery late in 1983. As a flameworker, I was delighted to see flameworked borosilicate glass on the pedestal with other sculptural works. I was eager to meet Ruffner and excited to follow her career. Seeing her work for the first time also made me feel proud of the glass world. In what was at that time a scene dominated by male blowers, Ruffner represented a new approach and perspective to artmaking in glass.

⁷ Karen Stanton, *Not So Still Life.* Shadow Catcher Entertainment, 2010 (hereinafter, *Still Life*).

⁸ *Still Life.*

⁹ *Still Life.*

¹⁰ Ginny Ruffner, "Beauty as Drama #141," Glass Pavilion, Toledo Museum of Art (1990).

¹¹ Oral history interview with Ginny Ruffner, September 13–14, 2006, Archives of American Art, Smithsonian Institution (*http://www.aaa.si.edu/collections/interviews/oral-history-interview-ginny-ruffner-1355*) (hereinafter, Ruffner Oral History).

¹² Ruffner Oral History.

¹³ Ruffner Oral History.

¹⁴ I visited the Renwick Gallery in 1990 specifically to see Ruffner's installation and was startled by the courageousness and scale of the idea. I assumed that I would be seeing a body of work that was mainly flameworked objects presented on pedestals, so I was surprised to find that her creative vision was independent of her commitment to glass as a material and flameworking as a process.

¹⁵ *AACG News*, Art Alliance for Contemporary Glass (October 14, 2011), *http://contempglass.org/news/entry/ginny-ruffner-urban-garden-sculpture-installed-in-seattle*.

¹⁶ Ruffner Oral History.

¹⁷ *Still Life.*

¹⁸ *Still Life.*

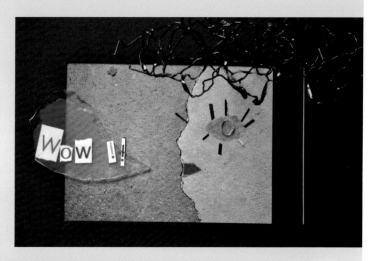

Top: Anna Skibska: a portrait in glass.
Bottom: "Golden Alchemy," 2008; installation of 96 orbs,
each 12" in diameter.

Anna Skibska:
Sparkle of the Soul

In the glass world, Anna Skibska's[1] career and approach to art-making is an anomaly. She came to glass as an artist with no knowledge of the International Studio Glass Movement and no training in crafting glass. She does not see herself as part of the glass movement because she doesn't connect artistically with glass-centric conversations and the technology embraced by glassmakers. Although her creative vision is independent of the glass community, her approach to working glass at the torch, now identified as the "Skibska Technique," has influenced creative people in glass programs worldwide. Her technique and style have freed flameworking, a highly economical way to melt glass, from only producing small-scale objects. Through Skibska's pioneering work with glass as a sculptural medium, she has shown how the flameworking process can create large-scale sculptures capable of exploring broad philosophical and artistic concepts.

Skibska's journey as a sculptor is documented in the Corning Museum of Glass's annual survey publication, *New Glass Review,*[2] with examples of her innovative early work. Susanne Frantz, curator of 20th-century glass at Corning from 1985 — 1998, played an important role in attracting attention to Skibska's work. After seeing images of the work Skibska submitted to the *New Glass Review*, Frantz reached out to her with an encouraging note that highlighted Skibska's outsider status in the glass world — "Who are you? We love your work. We don't know anything about you."

Because Frantz, along with the other three *New Glass Review* jurors, recognized the merit of the then-unknown artist living and working in Poland, Skibska's work was ultimately selected to be included in *New Glass Review* four times between 1987 and

1997. These four works dramatically demonstrate Skibska's evolution from using flat-glass construction for creating image-based, mostly two-dimensional works, to using flameworking to create sculptures on a monumental scale.[3] The sculptures give witness to a body of work that affected not only glass art but also the wider international art landscape.

Skibska's first piece, "Cat," appeared on the radar screen when it was selected by *New Glass Review* 9. Skibska created "Cat" shortly after she received her degree in painting, glass design, and graphic design from the Academy of Art in Wroclaw, Poland. It built on her painting and design training and used glass as a canvas to capture the indifference of a cat. The cat's tail makes this presentation notable as a work of art. This jagged-edged length of cut flat glass hangs by wires from the primary plate, suggesting a dangling tail that gives life to the cat in a very inventive way.

Skibska's earliest work offers an edgy flat-glass construction. Her 1988 submission used a basic gas/air torch to melt broken bottle shards into pulled thin rods that she then hot-sealed together in an organic cross-hatch. This approach evidenced a new way of making sculpture and was a major breakthrough in flameworked hot glass. What makes Skibska's innovative approach to creating glass sculpture so brilliant is the capability of her processes to produce large-scale, site-specific installations. Beyond scale, her direct approach to melting glass at the torch, analogous to drawing, allowed Skibska to celebrate and explore space, light, shadow, and time.

Two years later, a breakthrough work in glass, "Sweater of Dog," appeared in *New Glass Review* 11. "Sweater of Dog" suggested yarn in the process of being woven by knitting needles. This piece is significant to Skibska's evolution as a sculptor because it shows how she began to view flameworked hot glass as a way to add dimension to her designs. Skibska used the process to recreate yarn in glass, true-to-life in its apparent softness and flexibility, resulting in a *trompe l'oeil* illusion. Skibska could not have known then that the success of her technique in this small work

"Stairs."

would pave the way for a new visual language in glass, capable of monumental, site-specific installations.

The third work, "Tympanum,"[4] demonstrates Skibska's confidence in her process as well as a conceptual development and a new reality for glass. It appeared in *New Glass Review* 14. "Tympanum" is exclusively flameworked and measures 11.5-feet x 7.5-feet x 11.8-inches. In the broader hot-glass world, a single, self-contained work of this scale was very unusual; in the flameworking community, it was totally unprecedented. The form, suspended from the ceiling by wires, is also lit in a way that emphasizes the inherent qualities of glass and creates a shadow that becomes a dramatic part of the overall experience of the sculpture. This work does not reference an object or image but stands alone as an architectural abstraction that captures Skibska's interest in space, light, shadow, and time.

The last of the four works, "Moon," included in *New Glass Review* 19, builds on Skibska's explorations in scale, space, and light. "Moon" is composed of two hanging flameworked forms,

each more than 15 feet in height. This work, again, is presented with controlled lighting that creates a shadow, highlighting the delicate lattice-forms as they embrace space, which heightens the illusion of oneness.

Both "Tympanum" and "Moon" make a major break from Skibska's two earlier works. While "Cat" and "Sweater of Dog" drew attention for their "ironic point of view" and "playful sense of humor,"[5] her later works are admired for their dramatic architectural presence and historical art allusions.

Being included in *New Glass Review* four times in the course of 10 years gave Skibska important exposure and served as a platform to present sculpture beyond the usual table-top–scale art that the flameworking technique is known to produce. Now an internationally respected artist who works in glass, Skibska's vision and public installations are an interesting counterpoint to those of Dale Chihuly.[6] Both artists are responsible for work that is uniquely suited for public spaces. The major difference between the two is that Chihuly's colorful glass is produced by Chihuly Inc., an organization of upward of 100 people. Chihuly Inc. has attracted and/or trained specialists who craft hot-glass components, cold-work the pieces, design the packaging for shipment around the world, install, and photograph the work decorating the space. Another dimension of Chihuly's vision is to exploit marketing and promotional techniques that promote awareness of his genius behind the production of colorful glass sculpture created for the general public.

By contrast, Skibska works quietly in her small Seattle studio, creating glass sculpture that matches Chihuly's scale with a heroic solo effort. Unlike Chihuly's aesethic, this is based on how glass forms through the glassblowing process, Skibska stumbled upon glass serendipitously in her search for a material to realize her artistic/emotional vision. The result is a spiritually contemplative body of work that takes advantage of the working characteristics of glass in the service of an idea. Her approach to glass art-making was trial and discovery. The key to her early success was curiosity and persistence as she experimented with ways to

"Nothing has Happened," 2005; installation of cubes from 24
to 49 inches per side.

find how glass could advance her vision. This resulted in an inno-
vative approach to working hot glass with a torch and led to a
highly personal body of work. Skibska's process challenges art-
ists, especially a new wave of students in BFA and MFA glass art
programs around the world to explore larger scale work.

At 19, Skibska enrolled in the Architecture Department of
the Academy of Art in Wroclaw. Studying architecture was a com-
promise with her family. She grew up in an austere environment,
with a mother who was concerned about her ability to support
herself financially and wanted her daughter to pursue a stable
and defined profession, while Skibska wanted to be an artist. She
found a way to get as close to her passion for art-making as pos-
sible and still honor her family's wishes. Skibska recognized ar-
chitecture as one of the five "crowns" of traditional art, along
with painting, music, sculpture, and poetry. However, she felt ar-
chitecture under a communist regime had little room for indi-
vidual creativity. She described the communist approach as building
one "cube of concrete" after another and quickly grew disillusioned.

Out of boredom, she moved to the Art Department to study painting and graphic design.

Skibska credits a critique she received from a professor and highly respected Polish graphic artist, Eugeniusz Get Stankiewicz (Get), with helping define her early artistic goals. Get asked students to bring sketches to show him. After intently considering Skibska's sketches, Get advised her to look at the "edges." A two-dimensional work has a limited number of fine edges, but, if the work is expanded into three dimensions, it could have countless edges that capture space that would otherwise be invisible, which would and make it significant. Skibska recalls being "physically shocked" by the critique — she felt the merit of the idea and intuitively knew it was worth pursuing. She describes feeling as if this brief conversation "shuffled [her] life . . . like a deck of cards."[7]

After internalizing Get's critique, Skibska was enlivened by the concept of thin lines capturing space and began experimenting with ways to realize this idea. A couple of years later, when taking out the trash, she noticed broken plate glass leaning against the dumpster. She instantly connected glass with the idea of edges, brought the broken glass up to her apartment, and began to teach herself how to cut, glue, and "stretch" the glass as a way to "wrap up *her* space."

Not only did Skibska connect with glass as an artist seeking a material to express her ideas, glass had a place in her child memories of creating "wunderboxes " — dioramas and assemblages — out of found materials. As a young child, Skibska was fascinated with her mother's jewelry but the family was forced to sell the jewelry to help cover the medical costs of caring for Skibska's father. Then, Skibska's mother sat her down and explained, "Anna, now you have to make your toys."

Skibska draws a contrast between her family's monetary means, which were "quite austere," and her creative needs, which were "extravagant." This dichotomy resulted in Skibska spending

Untitled, 2005; installation of 10 cocoons, each approximately 118" in length. ▶

her time searching for interesting objects — including rocks, dry insects, leaves, marbles, shells, and broken glass — to use in her elaborate dioramas and assemblages. Perhaps as an indication of her future life as an artist, Skibska describes her creative output like a child by saying, "Everything in my hands became material to create a new story, which stoked curiosity — firstly my own, and then that of others."

There is a relationship between Skibska's creative play as a child and her constant search for expression as an artist. What makes Skibska's accomplishments remarkable is her belief in the techniques she has developed on her own. Because she discovered[8] her approach through trial and error, she is intimately aware of its physical parameters. Skibska says her approach was born out of "nothingness and impatience." When she committed to glass as a vehicle for her creative vision, she had no training in traditional glassworking techniques and she did not seek out a flameworker or any other glass person to teach her basic craft. Instead, she got hold of a blowtorch and experimented with stretching the glass into thin strands. This led to bending the strands and attaching them to others to capture space and build forms.

As an artist, Skibska is idea-oriented and has no need to "master" techniques, in the craft sense of the word. Her discovery is versatile enough to allow her to explore endless variations on her signature explorations in glass. While Skibska focuses her process on space, time, and light, not on glass as a material, she has explored translating her ideas with other materials and techniques, but has found that glass best captures the spirit of 70 percent of her creative vision.

Because of her philosophical approach to art-making, Skibska's process and work transcends conversations about flameworking and glassmaking techniques. For Skibska, the studio is a holy place that is quiet and spare, largely devoid of technology.[9] In her workspace, she approaches her art-making with humility and reverence for the possibilities. She repeats the same "performance" day after day, year after year. But this repetition is not about pattern and routine; it is about putting herself in a

place — physically and mentally — with an openness and inquisitiveness that allows for spontaneity. According to Skibska, this openness to spontaneity is what keeps her from falling into "deadly routine" and can turn "a Tuesday into a magic Tuesday." The intimacy of this process allows her to focus on reinvention, which is essential to her creative life. In her words, this allows her "to grasp the sparkle of the soul."

Because of her continued enthusiasm for Skibska's work, Susanne Frantz[10] contacted the Pilchuck Glass School outside of Seattle, Washington, in 1993 to recommend Skibska as a teacher. Teaching at Pilchuck caused a major awakening for Skibska, because it demonstrated that glass art-making in America had a strong creative community and a large and growing audience. Moreover, a number of galleries and museums had a glass focus and welcomed her sculpture as an original fine-art entry into the glass world.

The Pilchuck experience introduced Skibska to Seattle and the glass scene in the Northwest. Then, in 1996, while in Poland with the Seattle glass scene on her mind, she applied for and received a research grant from the Soros Foundation to complete a residency at the Pratt Fine Art Center in Seattle. After finishing her residency, Skibska established a studio there[11] and taught sculptural glass-making at Pratt in 1997 and 1998. Her connection to Pratt was celebrated in 2004 when Pratt named its flameworking studio the Anna Skibska Flameworking Studio in her honor.

Now, 20 years after Skibska first began exploring working glass with a gas/air torch, she has an impressive list of accomplishments. Some of her most impressive accolades correspond to her site-specific public installations. By 2012, Skibska had installed more than 20 public sculptures in major international cities, such as Paris, France; Athens, Greece; and Seattle, Chicago, and San Diego in the US. Through these public installations, her vision has brought a sense and wonder — both emotional and intellectual — to countless people around the world.

Since Skibska first taught at Pilchuck in 1994, more and more artists have been building large-scale works with techniques

referred to as "networking," "weaving," "latticed," or "spun glass." Whatever you call it; this technique can be clearly traced to Skibska, then a young, idealistic artist in Poland searching for a way to articulate a vision of wrapping space in still time. While Anna Skibska doesn't think of herself as part of the International Studio Glass Movement, a survey of contemporary glass demonstrates that she is not only embraced by the glass community, she is a pioneer within it.

Notes

[1] Information for this chapter was gathered from interviews conducted with Anna Skibska and Susanne Frantz through telephone and e-mail; a video produced by *iNCONTEXT.TV* (*http://vimeo.com/43334220*); interviews with Elizabeth Hylen, reference and outreach librarian at the Corning Museum of Glass, Rakow Research Library; the online articles "For glass artist Anna Skibska, a creative abundance grew from communism's scarcity" by Erin Concors (*http://www.eastvalleytribune.com/article_5da55b03-e571-5706-8582-331195c043ed.html*) and "Enter the e-Wunderkammer" by Anna Skibska (*http://www.vanguardseattle.com/2012/10/04/enter-the-e-wunderkammer/*); and Skibska's website (*www.annaskibska.com*).

[2] The *New Glass Review* annually surveys the international glass art scene by inviting artists to submit up to three slides depicting their work. Four jurors, two permanent and two guests, select 100 works to be published in the magazine that celebrate "newness" and "excellence." Launched in 1979, the *New Glass Review* was one of the few early opportunities for artists working in glass to obtain international exposure.

[3] Images of all of the works selected for publication in *New Glass Review* from 1979 to the present can be viewed on the Corning Museum of Glass's website (*http://www.cmog.org/research/publications/new-glass-review#.UNxMMuTAe8A*).

[4] A tympanum is a triangular, decorative, architectural element that appears above the entrance to a building.

[5] These attitudes were articulated by Susanne Frantz in her juror comments in *New Glass Review* 11, published in 1989.

[6] While reviewing images of Skibska's public installations, I was reminded of Chihuly's efforts. When I considered the contrast between Skibska's and Chihuly's artistic approaches and works, I found the differences and similarities enlightening because their works demonstrate the diverse possibilities of glass as a material and an outlet for creative expression. I first met Dale

Chihuly in the mid-'70s as I became more involved in the contemporary glass world, and would connect with him at various functions. I was fascinated by how he appeared self-contained and confident in the context of his work. Chihuly is an American original, bold in the celebration of himself as an artist working in glass. He found a voice that captured the essence of process as performance and art-making as a vehicle to reach celebrity status.

[7] Beyond his critique of her sketches, Skibska was inspired by Get's approach to life as an artist. Like many students in fine arts programs, Skibska hoped to be known as an accomplished artist. Her interactions with Get, however, impressed upon her the superficiality of that goal. She realized that to make significant work, an artist needs to avoid the "pedestal" and remain an eternal "student and seeker."

[8] Skibska didn't invent stretching glass with flame; this has been done for thousands of years. What she brought to the contemporary sculptural scene was a new language. By reinventing simple and direct hot-glass-working techniques, she opened up creative opportunities, including accessibility, scale, and the opportunity to translate broad, philosophical ideas into glass. During the fall of 2000, I visited Heller Gallery and was mesmerized by the scale of Skibska's suspended, minimalist geometric forms titled "Soft Crystal Rocks." I remember being very curious about her coverage in *New Glass Review*, but it wasn't until I saw her work in person that I recognized Skibska's technique had the potential to greatly expand the sculptural opportunities of glass.

[9] The new trend among younger flameworkers, particularly those using borosilicate glass, exploits torches that can produce more than 500,000 BTUs in environments that require major exhaust systems and heat-protective gear. In my 50 years of involvement with glass and glassmakers, I have never experienced a purer form of creative glass-making than Skibska's. It is inspirational to see such a direct channel between her soul, her hands, and her art.

[10] In addition to being curator of the Corning Glass Museum, Susanne Frantz was on the International Council of the Pilchuck School of Glass.

[11] Skibska maintains studios in Seattle and her home city, Wroclaw, Poland, which serves as her European base.

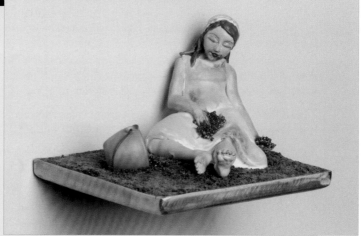

Top: Carmen Lozar sculpting at the torch.
Bottom: "Sweet Sleep," 2006; D 4", H 3.25", W 5".

Carmen Lozar:
Idiosyncratic Worlds

Carmen Lozar[1] is at the forefront of a new generation of glass artists who were introduced to flameworking in university art programs. These programs encourage artists to focus on art-making strategies, using whatever processes and materials are needed to realize their ideas. Lozar and other art-school-educated flameworkers don't feel self-conscious about the reputation of their process for producing kitsch, because this stereotype says nothing about their work or creative vision. Lozar is not focused on becoming a flameworking "master," in the vocational sense, because technical proficiency is not the most valuable part of her creative process. In her studio, and as a teacher at Illinois Wesleyan University,[2] her strength is developing ideas.

Lozar has produced a body of small figures, vignettes, and mechanical works that appear at first glance to represent child-like dream states. But upon a closer look, they are peculiar, surreal, and – at times – may suggest vulnerability and peril. Lozar says her work has arisen out of her "love of small, delicate objects and imagery." She grew up in a home where making things was encouraged and respected. Her mother had a passion for puppetry and theater, and her father collected model ships. They also loved curious objects and searched for them at garage sales, antique stores, and craft galleries. Creating handmade objects was encouraged and held in the highest esteem. Lozar recalled that it was ok "if I needed to cut apart the living room rug for an art project, if it seemed legitimate [to my parents]."

Lozar says she first encountered glass in 1995 as a student at the University of Illinois Champaign-Urbana's hot shop. Working under the tutelage of Professor William Carlson,[3] a nationally

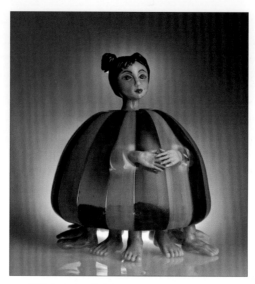

"This Way," 2011; D 7.5", H 8.5".

respected artist who works in glass and stone, Lozar was attracted to the glassblowing process by the energy and team-oriented efforts of the other glass students. The results, however, didn't seem to fit her personality; she was inclined to pursue objects with more "intricacy and delicacy." When Lozar noticed a torch "sitting unused in the back of the studio," she asked Professor Carlson if she could try it out. He told her she was "welcome to fool around with it." Lozar connected with the flameworking process's immediacy and versatility. However, the Illinois program did not offer flameworking courses, nor were there faculty or community members with flameworking expertise.

At Professor Carlson's suggestion, Lozar looked for a flameworking workshop to learn the basics. Based on her student status and portfolio, she received a scholarship to attend a one-week workshop at the Studio at the Corning Museum of Glass, taught by Emilio Santini. The Corning experience gave Lozar confidence and a creative platform to begin her artistic journey. While working toward her BFA, she continued to pursue opportunities to learn more about her craft and the creative community of the glass

world. Lozar interned at Bullseye Glass Factory in Portland, Oregon, and attended the Pilchuck Glass School as a recipient of the Saxe Award, a prestigious, artistic-merit based scholarship.

During Lozar's senior year at Illinois, the Marx Saunders Gallery[4] in Chicago hosted a public exhibition of students' glass, in which Lozar's work appeared. This exhibition marked her first sale and demonstrated to her the importance of the artist/gallery relationship in terms of providing the artist the freedom to create in the studio, while the gallery represented the work in the marketplace.[5]

After graduating from Illinois with a BFA in Crafts, Lozar embarked on a courageous two-year journey traveling to China, Thailand, Indonesia, and India to "explore Eastern traditional art." Her travel experience allowed Lozar to immerse herself in different cultures and places. By moving away from her comfort zone, she heightened her sense of aesthetic awareness and deepened her connection to universal human emotions.

Upon her return to the United States, Lozar relocated to Tucson, Arizona, and began exploring ways to combine flameworking and casting. In 2000, she was accepted into a residency program at Corning, where her work attracted the attention of Alfred's

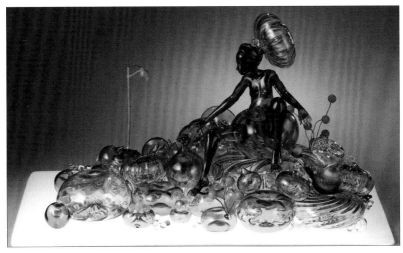

"Summer;" D 12", H 12", W 19".

glass faculty. She was encouraged to apply to Alfred's MFA program and was accepted. Her time at Alfred marked a significant turning point, mostly because of her interactions with Fred Tschida,[6] a nationally respected glass art educator. Tschida's enthusiasm for working glass and appreciation of the material's virtues inspired Lozar to exploit reflection, light, and viscosity to celebrate mystery through her work. With Bill Carlson's "do a test" approach, emphasizing experimentation as a means of problem-solving, she was able to benefit from Tschida's teaching philosophy. During her MFA years, Lozar began to identify herself not as a craftsperson, but as an artist who works in glass. She had some residency and workshop experience before, but this self-identification allowed her to see and pursue all of the possibilities the art and glass art communities had to offer.

After completing her MFA, Lozar spent endless hours of studio time advancing her flameworking skills, mostly by trial and error. She was recently honored as the featured artist at Salem Community College's International Flameworking Conference (IFC).[7] In the lecture that followed the award ceremony, Lozar talked about learning as you go versus spending time doing repetitive production glass-making. She discussed the virtues of discovering interesting techniques through nuancing an idea, but admitted that doing production would have been a big help to learn skills at the torch. She said, "I never even knew it was an option and, in the degree programs, production of the same piece over and over was not ever discussed; it simply was not on the table."

Typically, glass-working processes, especially flameworking, are considered craft. In these processes, people enhance their skill levels through the repetition of production work, whether it's vases, goblets, components for larger pieces, or decorative fixtures. Production glassworkers gain a reputation and get more complex assignments by mastering specific skill sets. Lozar's career has advanced, by contrast, through pursuing ideas. She has enhanced her skills by inventing techniques to realize her sculptural visions in glass.

After her IFC lecture, Lozar engaged in a question-and-answer session with students and conference attendees in which

she described her creative process. Lozar is constantly engaging the world and looking for the seeds of a concept. In her day-to-day life, she listens to people talk, reads, and seeks out images that can become "sparks." Once she has isolated a concept that she connects to emotionally, she nurtures it by "sitting still . . . to let [her] mind wander." Lozar considers these reflective moments

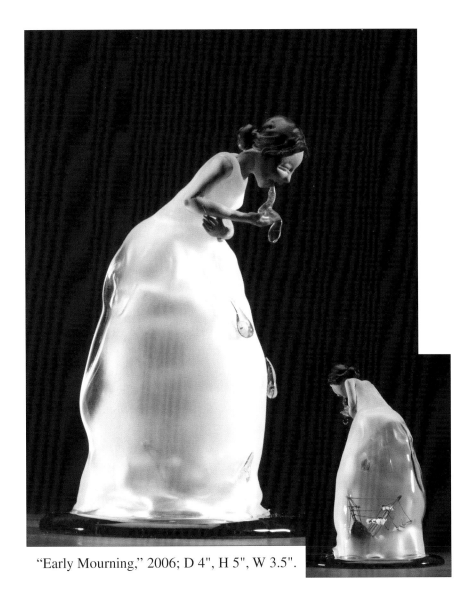

"Early Mourning," 2006; D 4", H 5", W 3.5".

to be her most imaginatively productive. Once the idea starts to solidify, she looks to books, images, and art history to help identify the parameters of her creative process. Next, she starts sketching, to work through the aesthetics of the piece while anticipating its technical challenges.

With Lozar's broad fine-arts background, she brings a passion for small, detailed objects and a love of the challenges and opportunities offered by glass as a material. She is advancing a body of work that combines flameworking, casting, mixed media, and found objects. Her pieces have taken on an increasingly narrative quality that Lozar attributes to being exposed to puppetry and theater by her mother. Whether the piece is a single figure, a scene, or just an object, all of her work is driven by human emotion and psychological relationships, often from a female perspective.

Lozar's formal art training has challenged her to engage in a visual dialogue with art history. She also finds inspiration in many contemporary artists, particularly the edginess of Kara Walker's narrative silhouettes; Damien Hirst's bold, aggressive, and wide-ranging body of work; and the emotional engagement of Olafur Eliasson's experiential environments. Although these diverse artists mainly work in large-scale formats, Lozar has been inspired by the conceptual innovations they have brought to the artistic landscape. These influences can be seen in her tableaus: Some are kinetic and encourage viewer interaction; others feature figures and characters in distorted environments; and almost all are thematically ambiguous.

Carmen Lozar's artistic approach is unlike others featured in this book. Hers allows for developing emotions and ideas that are essential to her being, and that distinguishes her body of work. The work attracts serious consideration because it offers complete ideas and presents glass in an attractive way. Once drawn in, however, viewers are challenged by the peculiarity of the theme as they discover the details. Her small works often allude to human excesses, such as gluttony, voyeurism, longing, and fear. Curiously, the personalities that inhabit her worlds seem either

oblivious to or comfortable in her threatening environments. With such an unconventional approach and engaging body of work, it's exciting to consider where Lozar will take glass next.

Notes

[1] Information in this chapter was derived from a personal friendship with Carmen Lozar, formal interviews conducted via e-mail and telephone, Lozar's website (*http://carmenlozarglass.com*), and documentation of Lozar's lectures at the 2008 International Flameworking Conference.

[2] In addition to her national commitments as an exhibiting studio artist, Lozar has served as an adjunct assistant professor at Illinois Wesleyan's Ames School of Art since 2006.

[3] William Carlson has taught at, and chaired, the art departments of the University of Illinois Urbana-Champaign and the University of Miami. He has received numerous awards for his work as both an artist and an educator, including the Distinguished Craft Education Award of the James Renwick Alliance of the Smithsonian Institution in 2004.

[4] In August, 2009, the Marx Saunders Gallery was renamed the Ken Saunders Gallery.

[5] In November, 2011, I was exhibiting my work at the SOFA Chicago art fair and attended the opening of a two-person exhibition at the Ken Saunders Gallery featuring Lozar and Hiroshi Yamano. The two bodies of work complemented each other beautifully. Hiroshi is known for his highly detailed blown-glass work that celebrates the Japanese natural world, and Lozar's work represents idiosyncratic presentations of everyday scenes. From an artist's perspective, it was exciting to see Lozar's new body of work and how it builds on previous sculptures.

[6] Fred Tschida is professor of Glass and Neon in Alfred's Department of Sculpture/Dimensional Studies.

[7] Robert Mickelsen introduced me to Lozar as an artist and teacher. At Robert's recommendation, we invited Lozar to be a presenter at the 2005 International Flameworking Conference. Based on the success of her presentation and the integrity of her work, the IFC Advisory Committee invited her to be the Featured Artist in 2008. The Featured Artist has her work exhibited at the conference, delivers a lecture, is honored with a reception, and presents a demonstration.

Top: Vittorio Costantini working in his studio.
Bottom: A selection of insects, 1985 to 2005.

Vittorio Costantini: In the Detail

At 19, Vittorio Costantini[1] bought a lampworking torch and an illustrated book of insects with the idea of someday earning his own livelihood. While lampworking was new to him, Costantini was already a seasoned glass-worker. At age 11, Costantini got his first job as an apprentice in one of Murano's glass factories. By 19, he had moved up the ranks in several glass factories and mastered a variety of furnace working techniques. Costantini knew glass would be his life's work. He was fascinated with lampworking and viewed the process as a way to be independent of the conformity and creative limitations of factory life. As a child, Costantini loved the natural world, especially insects, fish, and birds, and began experimenting with the torch during free time, trying to replicate interesting images using his insect book as a guide.[2] His first pieces were an ant and a fly. These unlikely subjects were notable because they demonstrate Costantini's unself-conscious curiosity. They also illustrate Costantini's independence; he was not trying to make work for the market place. Instead, he was fulfilling his own creative need and personal passions.

Costantini was born and grew up on the island of Burano, a small island north of both Venice and Murano in the Venice Lagoon. Like many islanders, Costantini is the son of a fisherman and a lace-maker. As a boy helping his father, Costantini developed a love of nature, particularly the small creatures that inhabited the island. It was natural for him as a glass worker to turn to lampworking when seeking an outlet for his creative interests. The process is perfectly suited for small scale work and allows the maker to pursue a high level of detail.

Costantini left school at 11, eager to learn the centuries-old craft of Murano glassmaking. To do this, he had to take a forty-five-minute boat ride to and from Murano every day. While he describes his factory experience as important to him, the opportunity for a young boy to develop a variety of skills is very limited. The maestros only teach the young boys single skills that are easy production tasks that contribute to the overall process. About his early work experiences, Costantini said, "When I began working as an assistant, the children who worked in the glass factories were treated like slaves, due to a few ignorant maestros." A naturally curious person, Costantini wanted to learn more, but this was only possible if he "[stole] with his eyes." Lack of interesting tasks was not the only problem. As a person from Burano, Costantini faced significant career limitations because in "the 1950s and 1960s it was impossible to become a maestro unless you were of Muranese origin." Recognizing the severe career and creative limitations of the factory environment, along with difficult years of uncertain employment due to strikes and protests, he bought a torch. Buying a torch was about gaining freedom both in terms of the pieces he dreamed of making and the pace at which he learned, and even discovered, new techniques.

For more than a decade, Costantini maintained his factory job while experimenting at the torch on nights and weekends making insects. He began selling his small creatures and eventually realized that if he wanted to be able to support his family with his own work and avoid producing the ordinary items for the tourist trade, he would have to make a "quantum leap." This would require Costantini to commit full time to his personal efforts in order to realize the level of quality in detail and originality that he found in nature. At 30, he moved to Venice to open his own shop and studio. Over the next seven years, Costantini was able to phase out his production as his entomological models attracted more and more critical attention. What distinguishes Costantini's

"Jellyfish," 2006; H 20 cm, W 15 cm. ▶

work is the intricacy of the detail. Every leg joint, antenna, foot, and spur is seamless. The totality of all of the details is a creature that is magically believable.[3]

In the early 1980s, he was invited to participate in two major Venice art exhibitions. First, in 1981 he exhibited at Vetro Murano Oggi (Murano Glass Today). Then, in 1982, he showed at Mille Anni Arte Del Vetro (A Thousand Years of Art in Glass). The honor of being invited to participate in these surveys and the enhanced public exposure strengthened Costantini's commitment to create one-of-a-kind specimens and to send his work to worldwide venues.[4] At this point, after nearly two decades of supporting himself with production work, Costantini was able to dedicate full-time to his complex and time-consuming entomological objects.

Over the next 18 years, Costantini continued to refine his signature insects but as he invented more techniques, he was also able to expand his repertoire to include a wider range of highly detailed natural subjects. Costantini's first American exhibition occurred in 2000 at a Northern New Jersey gallery called Mostly Glass. This introduced Costantini to the vitality of the American glass community. At Mostly Glass, he met other glass artists, collectors, and enthusiasts.[5] Costantini was also able to tap into the energy and the serious work of the nearby New York City glass scene. This experience led to Costantini joining the Glass Art Society (GAS) and returning to Corning the following year to attend the GAS conference.

Up until the 2001 GAS conference, Costantini's world was centered in Venice. At that time, the flameworking community in Venice was small and shrinking. The Corning Conference introduced Costantini to a committed, high-energy community of international glass artists, gallery owners, collectors, and enthusiasts. Also, the Venice glass community is very secretive, and Costantini was amazed with the amount of information shared through lectures, demonstrations, panels and technical displays at the GAS conference. Another important component of this experience was meeting other glass artists, especially flameworkers,

Left: "Fam. Cerambycidae, Cephaloidae," 2009; L 8 cm.
Center: "Fam. Scarabaeidae, Polyphylla variolosa," 2009; L 5 cm.
Right: "Fam. Lucanidae, Cyclommatus metallifer," 2008; L 10 cm.

whose careers Costantini had been following through glass publications. He was touched when he realized these artists knew his work and were equally excited to meet him.

Attending the 2001 GAS conference positioned Costantini, already a master with a personal body of work, to take advantage of all the international glass community had to offer. In 2002, he gave a demonstration at the GAS conference in Amsterdam, and the invitations to teach and lead workshops began pouring in from around the world. In just a few years, Costantini led demonstrations or workshops at the National Glass Centre in Sunderland, England; the Kanaz Forest of Creation in Japan; and the Corning Studio, the Penland School of Craft, and the Pilchuck School of Glass in the United States. Costantini has thrived in these teaching engagements because of the open, collaborative environment and interactions with young, energetic artists who share his passion for glass. Most recently, Costantini was the featured artist at Salem Community College's 2013 International Flameworking Conference.

Traveling and teaching have had another important impact on Costantini's career. Always a keen observer, he has been able

"Lionfish and Seashell," 2004.

to encounter and study the flora and fauna of each place he visits. Additionally, he has visited aquariums and botanical gardens around the world. All of these experiences have bolstered his child-hood passion for the small creatures and the intricacies of an ever expanding list of specimens.

Costantini's career exemplifies not only dedication to a vision but a belief in that vision. His commitment to interpreting small creatures and mastering minute details in glass has allowed him to produce heroic efforts that have attracted a worldwide audience. Though his unique interests have placed narrow parameters on his work, Costantini has found freedom within those parameters and took advantage of them to invent techniques and articulate a personal visual vocabulary. His journey shares a commonality with artists celebrated in this book. Starting from a humble beginning, but with a focused dream, Vittorio Costantini's work has evolved to a level of excellence seldom seen in glass.

Notes

[1] Information in this chapter was derived from a personal friendship with Vittorio Costantini, formal interviews conducted via e-mail, Costantini's

website (*www.vittoriocostantini.com*), and a 2005 career profile in the *Penland Book of Glass.*

[2] In my interview with Costantini, I smiled when he mentioned his first efforts to be creative were attempts to replicate images from an illustrated book of insects. In 1969, I purchased a small, paperback field guide titled *Golden Nature Guide to Native Flowers* for $2.50. I used this book to guide my beginning efforts to replicate nature in glass. I find it interesting that creative people who did not have the advantage of an art school education tend to gravitate to the natural world around them and view their success by accurate portrayal of the subject. This approach to flameworking as a creative outlet demands a high level of craftsmanship and inventiveness to pull off the *tromp l'oeil* effect of, "Is it real?"

[3] While sharing my collection of Costantini's work with others, I have inadvertently broken limbs or antennae from the body. Initially, I assumed I could repair the damage without a trace. When I started melting the glass for my first repair attempt, I recognized immediately I wouldn't be able to replicate his touch. The work is so personal to Costantini that I wouldn't be able to do the work justice. Having learned my lesson, I just boxed two beetles in cotton to ship to Costantini for repair.

[4] I was introduced to Costantini's glass work at the Corning Museum of Glass retail shop in the mid-1980s, and over 27 years I have purchased over 50 examples of his work. In 2011, my wife Pat and I donated 20 insects to Salem Community College with the entire collection promised to the school. I can still recall the sense of wonder I felt encountering his beetles and on occasion enjoy watching the students express that same level of interest. Over the years, his work has been a favorite of visitors to my home and studio.

[5] While Costantini was exhibiting at Mostly Glass, the gallery's owner, Sami Harawi, called to let me know a Venetian master and his wife, Graziella, were interested in meeting me and visiting my studio. At the time, I was a collector of Costantini's work, so I was excited to meet the artist behind the pieces in my collection. Costantini, his wife, and a bilingual glass artist from Brooklyn whose work I also respect, Alison Ruzsa, made the two-hour trip to South Jersey. We had a very enjoyable visit. Though we did not share the same language, I was amazed at how easily Costantini and I could communicate through our shared glass experiences.

Epilogue

In the introduction, I wrote, "This is the book I wish I could have had at the beginning of my creative journey." When writing *Spark the Creative Flame*, my goal was to "pay forward" information that would challenge makers with diverse creative approaches. As a teacher, my writings, demonstrations, and lectures give me the opportunity to interact with hundreds of enthusiastic glassmakers. These experiences are a blessing. I'm proud of and care about the glass and larger craft communities. I want to say to those makers who didn't have the means to go to art school that self-directed education can be equally effective in reaching your full potential as a maker. With *Spark the Creative Flame*, I've identified a curriculum that lays a foundation for lifelong learning relevant to a career in the arts, and provided examples of artists who have implemented similar approaches in their own careers.

This book demonstrates that acquiring knowledge is the life blood of an artist's career. It also highlights the challenges associated with material demands and the emotional strength needed to solve one technical problem after another. What unites the artists celebrated in these chapters is a commitment to a vision that unfolds over time into a signature body of work, unique to both glass and art.

While writing my first book, *No Green Berries or Leaves: The Creative Journey of an Artist in Glass*, I was able to reflect on the struggles and sacrifices in my own life's journey. What I discovered while interviewing and working with the 12 artists in *Spark the Creative Flame* is that such herculean efforts and sacrifices are the common thread in most artistic journeys. I view the benefit of this book as one way of providing perspective and encouragement to all who need to be creative. It can be done.

I am well aware of the growing number of artisans, upward of 10,000 to 15,000 makers, who are flameworking borosilicate glass into functional and decorative paraphernalia. Many of them are experiencing economic success with production work and are beginning to experiment and go beyond the demands of the marketplace to create one-of-a-kind efforts. This new reality — self-employed craftspeople working on the creative side — has strengthened the flameworking community, making it the most energized segment of the glass world.

This book offers an alternative strategy to using production as a means of attracting attention to your work. As a teacher, I'm keen to connect students to their creative spirits — to go beyond routine vocational instruction. The artists celebrated in these pages have grown beyond a vocational mentality to inventing or reinventing techniques to realize their ideas. Their achievements and philosophies are presented in ways that highlight the mix of challenges, good fortune, tenacity, and deep-seated faith in their abilities to realize their visions as they established their careers. What motivated these artists to reach the levels that they have was not economic stability, but advancing their visions through the nuances of the material and process.

Over the last five years, I've been reflecting on quality and originality, and have wrestled with the goal of trying to pin down the ingredients of significant work so I can convey them to my students. In the end — and having known it in the back of my mind all along — I realized there is no way to neatly package a formula for success. Instead of a simple formula, *Spark the Creative Flame* offers a view of great work through a biographical lens. This book represents an honest look at the lives and dreams of multiple and diverse makers creating respected work. This is the resource I wish I could have had 50 years ago, because it goes beyond an artist's signature objects and examines the evolution of great work from germination to maturity.

☙

Index

Note: Bracketed page numbers identify the complete page range of Paul Stankard's written appreciations for the named artists.

∾